In 1948 my father gave me a reprint of Audubon's
Birds of America, *inscribed, "To David, Chief Birder of the*
household, on his eleventh birthday."
I dedicate this book, with love, to Dad's memory.

D.M.L.

AUDUBON'S WILDERNESS PALETTE

The Birds of Canada

David M. Lank, C.M., F.R.S.A.

KEY PORTER BOOKS

Canadian Cataloguing in Publication Data

Lank, David M., 1937–
 Audubon's wilderness palette

Includes index
ISBN 1-55013-978-9

1. Audubon, John James, 1785–1851. 2. Birds – Canada – Pictorial works.
3. Painting, Modern – 19th century – United States. 4. Painting – Ontario – Toronto.
5. Metropolitan Toronto Reference Library. I. Audubon, John James, 1785–1851.
II. Title.

QL685.L28 1998 598'.0971 C98-930788-3

The publisher gratefully acknowledges the support of
the Canada Council for the Arts and the Ontario Arts
Council for its publishing program.

THE CANADA COUNCIL | LE CONSEIL DES ARTS
FOR THE ARTS | DU CANADA
SINCE 1957 | DEPUIS 1957

We acknowledge the financial support of the
Government of Canada through the Book
Publishing Industry Development Program for
our publishing activities.

This book is published in conjunction with Audubon's Wilderness Palette: The
Birds of Canada, a national touring exhibition made possible by Canada Trust. Project
concept and development: Arts & Communications.

Key Porter Books Limited
70 The Esplanade
Toronto, Ontario
Canada M5E 1R2

Printed and bound in Canada

98 99 00 6 5 4 3 2 1

CONTENTS

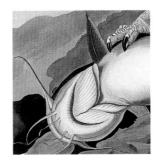
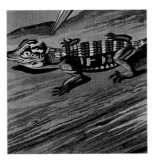

John James Audubon, pioneer woodsman, naturalist and brilliant painter, documented the unspoiled wilderness of North America in the nineteenth century, prophetically pointing to a time when many species of birds would become endangered or extinct.

The artist's wide-ranging travels took him, in Canada, along the St. Lawrence River and to the northern reaches of Newfoundland and Labrador; in the United States, he went south to the mouth of the Mississippi and the Gulf Coast, and westward into the Great Plains. En route, he did life-size portraits of seabirds and waterfowl, songsters, birds of the woodland and forest, keenly observing their characteristic behaviour, movement and habitat. Created prior to the camera and high-resolution telescope, Audubon's work astonishes us today with its technical virtuosity, sheer beauty and amazing scientific accuracy.

Canada Trust is proud to present the first national touring exhibition of Audubon's Wilderness Palette: The Birds of Canada, drawn from the Toronto Reference Library's rare folio, one of five copies in Canada. Canada Trust is committed not only to helping preserve the environment through Friends of the Environment Foundation, but also to reinvesting our resources back into the communities we serve. By saving this priceless collection and touring some of its finest images, we have enabled thousands of Canadians to share and admire Audubon's historic and artistic legacy.

W. Edmund Clark
President and C.E.O.
Canada Trust

In December of 1902 Dr. James Bain, Chief Librarian of the Toronto Public Library, lobbied hard for the purchase of an original copy of John James Audubon's *The Birds of America*. In his report to the Library Board, Bain stated it was an

> exceedingly rare first edition printed from the copper plates and coloured under Audubon's personal supervision. While such a book cannot become one very frequently consulted owing to its size and the danger of injury to the plates, yet it is the final tribunal to which ornithological questions are referred and its possession gives a high standing to any library which may have a copy.

The Board heeded his words and approved the purchase from the estate of George William Allan, a former Toronto mayor and prominent philanthropist. The price was $1,900—such an enormous sum in those days that the executors allowed the Library to make its payments over a five-year period.

By 1985 our copy, still bound in its original four volumes, had become so fragile that the Library was forced to restrict public access to it. In order to ensure its continued availability, an appeal was launched to finance conservation of the work. The public enthusiastically responded to this plea, donating sufficient funds to allow the 435 hand-coloured prints to be disbound, cleaned, repaired, matted and rehoused. In 1990, after four years of painstaking work, the complete copy of *The Birds of America*—one of only five in Canada—was ready once again for viewing, research and exhibition in the Library's gallery.

More recently the Toronto Reference Library, under severe budgetary pressure, was forced to consider selling some of its treasured collections, including the Audubon first edition. In response, the Library Board initiated a fundraising campaign. Canada Trust stepped forward and its generous gift has not only ensured that *The Birds of America* will remain intact at the Toronto Reference Library, but has also made possible an extensive exhibition tour. Now this magnificent collection can be enjoyed by people across the country.

Dr. Bain would be proud.

Frances Schwenger
C.E.O.
Toronto Reference Library

TORONTO PUBLIC LIBRARY

INTRODUCTION

Wilderness and wildlife have dominated Canada's history. In the 1830s, when John James Audubon came to this country, much of the original wilderness was untouched, even in the South, and in his paintings and text he marvelled at the scope of nature's abundance. Times have undoubtedly changed, and the once overwhelming numbers of animals, birds and fish have diminished. Nevertheless, there are few places left in the world today where the spirit of the outdoors is still so much in evidence as it is in Canada.

The outdoors is an integral part of Canadian lives, and as such has had a profound influence on our artistic traditions. *Audubon's Wilderness Palette* celebrates one of the most significant aspects of this tradition, the art of John James Audubon, both in its own right and in its influence on the subsequent history of animal painting. Placing his life-size birds in their natural settings, he used bird art as a vehicle to portray a North America that most Europeans of his time would never see, and one that we shall never see again. And by observing his subjects minutely, he captured aspects of natural history that often elude even the naturalists of today. Audubon saw what others had seen, but understood what others had not. He was blessed with a pen that could be as eloquent as his brush, describing a wonderful America that has vanished.

The tradition of wilderness art is far older than Canada, the country, which only came into political existence in 1867. In 1497, John Cabot raised the flag of Henry VII on Cape Breton Island, and by that action became the claimant to the title of discoverer of Canada. His impressions of the wildlife were recorded on the so-called "Paris Map," dated 1544, which bears an inscription near today's Nova

Scotia: "It is a very sterile land. There are many white bears and very large stags like horses, and many animals; likewise there is infinite fish, sturgeons, salmons, very large soles a yard long, and many other kinds of fish, and the greater number of them are called baccallaos [cod]; and likewise there are in the same land hawks black like crows, eagles, partridges, linnets and many other birds of different kinds."

The English had mapped and claimed the Atlantic coasts, but it was the French, under Jacques Cartier of St. Malo, who probed the interior up the St. Lawrence. In his *Journal* of May 1534, Cartier described great auks, "whose numbers are unbelievable unless one has seen them." But, he concluded, "along the whole of the north shore I did not see a cart-load of earth... I am inclined to believe that this is the land that God gave to Cain." Labrador would one day have a similar effect on Audubon. On the eve of his departure back to the United States, he wrote: "Seldom in my life have I left a country with as little regret as I do this."

Audubon at least found much new material for his study of birds, which relieved "the wonderful dreariness of the land." In the summer of 1833 he travelled in what he called Labrador (comprising the present-day Lower North Shore of Quebec, Labrador and Newfoundland). During the trip he completed, or virtually completed, twenty-three paintings. Audubon's art belongs in as broad a context as possible, beyond the unnecessarily artificial divisions traditionally placed between art, science, literature and history. Through his pictures and writings, he becomes a vehicle to transport us back through time.

Audubon changed forever the way we see the natural world, or, more specifically, the role of humanity in the natural world. Evaluating Audubon's role in the development of art is made more complicated by the aura that history has bestowed on the man himself. Who was Audubon? *The Dictionary of American Biography* accurately states: "Perhaps the most popular naturalist of America has so long been a figure of sentiment and idealism, and as a man and as a scientist has suffered so from the touching up of enthusiastic biographers, that it has been difficult to divorce the romance of fiction from that of truth in what was in any case a most colourful and adventurous life." There is reason to believe that even his wife, Lucy, did not know his true origins, for she wrote in an official biography, published in 1869, that "the naturalist was born on his father's plantation, near New Orleans, Louisiana, on May 4, 1780."

The first issue of *The Audubon Magazine*, which appeared in February 1887, repeated as gospel the statements of Lucy Audubon. There were enough historical facts to give the whole an air of truth, but in fact almost every detail was wrong. Audubon's "official" biography by his granddaughter Marie perpetuated the myths, and even stated as fact unsubstantiated claims by Audubon that he had

studied at the studio of Jacques-Louis David, the court painter of both Louis XVI and Napoleon.

Audubon never specifically lied about his origins. Technically, all his claims were accurate, but intentionally misleading. At the very least, he did little or nothing to clarify matters. Little wonder: he believed that the truth would have tarnished his image. In his 1828 *Journal* he wrote: "The cloud that still hangs over my birth requires silence."

In reality, Audubon was born on April 26, 1785, in Les Cayes, in what is today Haiti. He was the illegitimate son of a minor French naval officer and Jeanne Rabin, whom Jean Audubon met in Santo Domingo. After his mother's death, John James and his siblings returned to France, where the ever-patient and remarkably understanding Mrs. Audubon accepted her husband's illegitimate offspring as her own. He became an American citizen only in 1812.

To trace the development of animal art prior to Audubon lies beyond the scope of this introduction. Suffice it to say that in the early 1800s the best bird artist working in the New World was Alexander Wilson, who was combing the woods of North America for new species. His birds were more lifelike than any that had come before, and from an ornithological point of view they tended to be reliable. Wilson showed up in Kentucky, looking not only for new birds but also for subscribers to his ambitious *American Ornithology*. He happened into a frontier store belonging to Fernand Rozier and his partner, John James Audubon. Audubon, a legendarily bad businessman, was actually signing up to become a subscriber when Rozier discreetly interrupted the proceedings. Speaking in French, he pointed out that Audubon's own drawings and paintings far surpassed anything that Wilson had done. Then and there the seed was planted in Audubon's mind: he would publish his own collection.

From the chance meeting with Wilson to the final publication of *The Birds of America*, Audubon's career was extraordinary. He crisscrossed Eastern North America, endured countless trials and tribulations, and left a path of disappointment and triumph wherever he went. Despite many professional and private vicissitudes, he would ultimately publish his monumental book in England, and the history of animal art would be changed forever.

Originally, Audubon had hoped to have his bird paintings accepted by the American scientific community, and to have the plates engraved in the United States. Whether the engravers would have been capable of translating Audubon's work remains unknown, because American engravers and publishers, for the most part, met him with open hostility.

The one exception was the encouragement he received from Prince

Charles Lucien Bonaparte. A nephew of Napoleon, he was a scientist whose chief interest was zoology. After Wilson's death, Bonaparte published *American Ornithology, or the Natural History of Birds Inhabiting the United States not given by Wilson* (1825–1828). The plates for the so-called "Continuation of Wilson" were also engraved in Philadelphia. In the "Continuation" there is a plate of the boat-tailed grackle, or, as it was then known, the great crow blackbird. The male in the foreground shows an improved understanding of the muscle and bone structure compared to the renderings of Wilson, but the form is still quite stylized, the lines too fluid. The female, on the other hand, is full of tension, well proportioned, and lifelike. The two birds were painted by Audubon, the first of his bird portraits to appear in print.

The engraver to whom Audubon had wished to entrust the work was Alexander Lawson, who had done the plates for Wilson and Bonaparte. Lawson, however, took an immediate and deep personal dislike to Audubon. After looking at his originals, Lawson was positively scathing in his condemnation: "I think your work extraordinary for one self-taught, but we in Philadelphia are used to seeing very correct drawing." Then, turning to Bonaparte, who was with Audubon during the visit, Lawson added: "You may buy [the originals] but I will not engrave them . . . Ornithology requires truth and correct lines—here are neither."

Audubon was furious at this slight, but in later years he recalled, with considerable restraint, that Lawson found his paintings "too soft, too much like oil painting" for engraving. The truth was that Lawson had been Wilson's teacher; he also had a vested interest in the success of Wilson's and Bonaparte's books, and therefore realized the threat that was posed by Audubon's clear superiority.

Thus it was that on the advice of Gideon Fairman, another Philadelphia engraver (who admitted his own inability to handle the job), Audubon turned towards England in 1826. It was not in London, however, that he first made his mark. After stops in Manchester and Liverpool, Audubon arrived in Edinburgh. No city could have been further removed from Mill Grove, Pennsylvania, or Henderson, Kentucky, the places where his unsuccessful business career had started and quickly ended.

Audubon cut a rather dashing figure in Edinburgh society, dressed in buckskins and sporting shoulder-length hair. Showmanship alone would not have won the day; the intellectuals and Edinburgh society were far too sophisticated for that. This was, after all, the Edinburgh of Sir Walter Scott; Charles Darwin was studying at the university and attended a lecture that Audubon gave on North American birds.

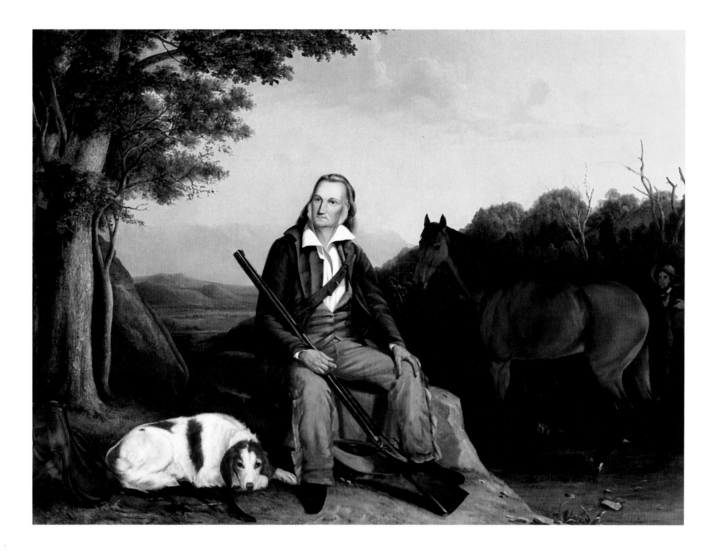

Audubon the Naturalist PAINTED A FEW YEARS BEFORE HIS DEATH BY SONS JOHN AND VICTOR.
COURTESY OF THE DEPARTMENT OF LIBRARY SERVICES, AMERICAN MUSEUM OF NATURAL HISTORY

Nothing in the European experience had prepared the people of Edinburgh—or of Europe for that matter—for Audubon's birds, which were exhibited at the Royal Institution in November 1826. And what birds they were! Life-size, from the largest whooping crane to the smallest hummingbird, they were ornithologically correct and placed in their proper ecological settings. The impact was dramatic. As Audubon wrote to his wife in December, "My situation in Edinburgh borders almost on the miraculous."

Above all, the birds were absolutely alive. But it was the settings that struck most observers as representing a real break from the past. A French critic, Philatère Chasles, was moved to emote: "Imagine! A landscape wholly American, trees, flowers, grasses, even the tints of the sky and waters, quickened with a life that is real, peculiar, trans-Atlantic. It is a real and palpable vision of the New World, with its atmospheres, its imposing vegetation, and its tribes which know not yet the yoke of man." The critics reacted to the paintings as art, not merely as animal art or a scientific exhibit—and, of course, they were right.

It was art, not science, that attracted most people. In the early decades of the nineteenth century, interest in natural history was largely confined to the urban, educated and wealthy. A large number of ministers wrote books on "natural history," but their outpourings were almost all dedicated to the assumption that everything in the natural world was proof of God's greatness. In 1829, the year after Audubon started publishing his *Birds*, the formal prospectus announcing the founding of the Zoological Society was issued with a revealing first sentence: "Zoology, which exhibits the nature and properties of animated beings, their analogies to each other, the wonderful delicacy of their structure, and the fitness of their organs to the peculiar purposes of their existence, must be regarded not only as an interesting and intellectual study, but as a most important branch of Natural Theology, teaching by the design and wonderful results of organization the wisdom and power of the Creator."

Given this situation, Audubon needed to attract wealthy art lovers, not amateur scientists. The project was on a scale never before attempted, either in size or in scope, and it desperately needed cash flow. Upon completion, the 435 double elephant folio plates would contain no fewer than 1,065 figures, depicting more than four hundred species, plus thousands of botanical portraits, and vast numbers of insects, shells, trees and other appropriate ecological elements. Subscribers were essential, for the cost of producing such a book would be prohibitive.

Animal art can be divided into two eras: before Audubon and after Audubon. Once he showed the way, there were many very competent artists who adopted his method of depicting more or less life-size birds in lifelike poses, placed in some kind of setting. This artistic revolution ushered in the golden age of natural history illustration, and made it possible for scores of other artists to earn their livelihoods through full-time devotion to animal painting, something Audubon had failed to achieve for himself in his early career.

Irrespective of Audubon's influence within artistic circles, the direct impact on a wider public of his monumental work was more limited than his subsequent fame would indicate. Fewer than two hundred sets of his folios were completed, and virtually all of them ended up in aristocratic collections, or in the libraries of natural history societies with exclusive memberships, or in inaccessible national museums. The common man was denied exposure to Audubon's masterpieces.

The success of the folio edition of the *Birds* had demonstrated that a miniature version for broader distribution represented a fine commercial opportunity. Audubon decided therefore to publish what he called "La Petite Édition." Technically, it is known as the octavo edition, a description based on the manner in which the original sheets were folded after the printing was completed. In

practical terms the octavo edition measures approximately 8 by 10 inches (20 x 25 cm). It was published in seven volumes between 1840 and 1844, and contained five hundred hand-coloured lithographs, accompanied by an extensive text which described each bird and its habitat. Audubon liberally sprinkled the text with personal anecdotes that cast a fascinating light on many aspects of frontier life in America during the first half of the nineteenth century.

The first edition of the octavo attracted 1,202 subscribers. This success ultimately led to at least six more official, and several pirated, editions through the 1860s. Starting with the sixth edition, at least thirty of the plates were completely redrawn by John Woodhouse Audubon, who added extensive new decorative backgrounds of his own. In many cases, the plates from this "third state" are among the most successful of all the paintings attributed to Audubon, even though they were actually done after his death.

With the passage of time the uniqueness of Audubon's approach in the folio plates has been somewhat exaggerated. Some of the characteristics we ascribe to his plates can in fact be found in the art of his predecessors. His birds were usually portrayed with environmental elements appropriate to the species, but the same can be said for the birds of Mark Catesby's pioneering *Natural History of Carolina, Florida and the Bahama Islands*, which first appeared in two folio volumes in 1731, almost exactly one hundred years earlier.

When Audubon first arrived in England he saw the large folios of Prideaux John Selby, whose birds were life-size up to the golden eagle and the heron. A little-known book by Robert Sweet appeared in 1823 with life-size plates of warblers in lifelike poses amid appropriate floral settings. The artist E. D. Smith knew his birds, and almost certainly painted from life, and yet so little known is Smith that he is not even listed in *The Dictionary of British Bird Painters*.

Another painter that history forgot was Lady Elizabeth Gwillim, the talented wife of a senior English civil magistrate who was stationed in India in the early 1800s. To while away the time she painted several hundred Indian birds, not only life-size and in their proper ecological settings, but also with great attention to scientific accuracy. Lady Gwillim's "Birds" was never published, and she died, totally unknown, before Audubon came on the scene. Had her work been reproduced during her lifetime, she would have been recognized as one of the true pioneers in ornithological art.

Audubon was not the first to paint birds life-size or to paint them in lifelike poses; nor was he first to place them in ecological or environmental settings. How then can we explain the impact that he had? No answer is complete, but he *was* the first to combine all these elements and to exploit their inherent

possibilities for dramatic artistic expression. Above all, because he was a great artist, Audubon was able to transmit his sense of excitement and understanding of birds not just as objects of scientific draughtsmanship, but as living, breathing creatures, alive as individuals and as inhabitants of the strange wilderness that captured the European imagination. He was far, far ahead of his time. Art and science had come together.

The plates had one thing in common: at the bottom left were the words, "Drawn from Nature by J. J. Audubon." This simple claim is at the root of much of the criticism and misunderstanding of Audubon's achievement, because it is not totally accurate. His years in the wilderness had given him unparalleled exposure to the birds in the wild, but in *My Style of Drawing Birds*, Audubon explained how he wired the dead specimens in lifelike poses on a grid, and then placed them in the proper settings. For him, "from Nature" meant using recently dead models and his own profound knowledge of their lives and habitats, which could be recalled perfectly when needed. In many cases, the birds and the settings were painted at different times, in some instances many years apart, and then combined in the final composition.

It comes as a surprise that Audubon actually killed the birds he painted. He repeatedly wrote of killing dozens of birds, from which he selected the very best as models for his paintings. It is important to put this in a proper context. In Audubon's day, the quantity of wildlife was inconceivably vast. The conservation movement as it is understood today was still far in the future. If ignorance led the uneducated to slaughter, then the mistaken belief in the inexhaustibility of species led the wealthy to equal excesses. Records show that one Louisiana "sportsman" personally shot no fewer than 69,087 snipe between 1867 and 1887, plus several thousand other birds "killed incidentally."

During Audubon's visits to England at the beginning of Queen Victoria's reign, and back home in the endless forests of America, little concern about wildlife was ever expressed. But the turning point came halfway through the 1860s, with the immediate cause being the unbearable scale of destruction occasioned by the latest fashion in women's hats, which involved the wearing of substantial portions of the plumage of wild birds. In the United States, game wardens were shot protecting the last nesting sites of the egrets, whose nuptial plumes were so eagerly coveted.

In those days of relative plenty, Audubon was not opposed to hunting for sport, food or commercial gain; he had hunted for pleasure himself. Nevertheless, he showed in his writings that the seed of conservation had already been planted in his mind. He was appalled by the slaughter in one morning of forty-eight

thousand golden-bellied plovers by some market hunters who had asked him to join them near Baton Rouge. He saved his most withering condemnation for "the Eggers" of Labrador and Newfoundland, who caused unbelievable havoc among the nesting colonies that Audubon visited during his trip to the Gulf of St. Lawrence in the summer of 1833.

Despite these tentative signs of awakening protectiveness, Audubon could not be called a conservationist in the modern sense. It is also worth remembering that during the nineteenth century more "science" was learned through the sights of a gun than through a microscope. Audubon was famous for being a crack shot, the birds often ending up in his paintings and in his dinner.

Most of Audubon's birds were in fact drawn from nature, but by no means all of them. He had purchased ninety-three skins from Thomas Nuttall and John Kirk Townsend, who had collected them during their western trip in 1834, almost eight years after Audubon had embarked on his publishing venture. Obviously, none of these birds were drawn from nature. There is, however, an explanation, if not a justification. Audubon had hoped to depict all American species, but new ones were constantly being discovered, and time was pressing. Nine years had passed since the outset of publication, and Audubon rather selfconsciously defended himself against grumblings from the subscribers about the endless delay in the delivery of the final plates. He wrote: "As to the time necessary for finishing my Work, I have only to observe, that it will be less than the period frequently given by many persons to the maturation of certain wines placed in their cellars, several years previous to the commencement of my work, and which will not be considered capable of imparting their full relish until many years after the conclusion of *The Birds of America*."

Several species were drawn from specimens presented to him by Arctic explorers serving in the Royal Navy. Certain other birds were not drawn by Audubon at all. The lower figure of the immature herring gull is the only subject definitely attributed to Audubon's talented assistant, George Lehman. Audubon wrote to his wife on December 8, 1831: "I have put Lehman at Drawing Birds... and he draws them beautifully after they are put in Position by myself." Lehman supplied the background view of the entrance to St. Augustine harbour, and in the plate of the lesser yellowlegs the wonderful background of the South Carolina swamp, and probably the bird too. Lehman, a Swiss artist from Lancaster, Pennsylvania, painted flowers, plants and backgrounds. At his best, however, Lehman was marvellous. It was he who painted the city of Charleston in the background of "The Long-billed Curlew." In "The Meadow Lark," Lehman's clump of wild grasses and flowers would have pleased Albrecht Dürer himself,

whose early-sixteenth-century study of a large clump of turf is perhaps the best-known botanical painting of all time.

Another talented assistant was Joseph Mason, who painted the floral backgrounds for no fewer than fifty of the plates. Mason, who at the time was thirteen years old, had been one of Audubon's pupils at his Cincinnati art academy. A third significant background painter was Maria Martin, who supplied the blossoms for "Bachman's Warbler," a nice touch, as Maria Martin would later become the second Mrs. Bachman. She also supplied the horned lizard in "The American Egret." Finally, Audubon's two sons, Victor and John Woodhouse, who were accomplished artists in their own right, supplied several backgrounds and even some birds.

The quintessential group effort is "Swainson's Warbler," on which appears the standard statement that the plate was "Drawn from Nature by John James Audubon." The azalea and the butterflies were painted by Maria Martin, and the bird itself was painted by Audubon's son, John Woodhouse Audubon. This delightful "original Audubon," done in 1832, contained absolutely no work by John James.

Just as Audubon had artistic help for backgrounds and botanical elements, he also needed outside expertise to have his original paintings transferred onto copper for printing. Originally, the plates for the *Birds* were to have been engraved, printed and coloured under the supervision of William Lizars, the leading professional in Edinburgh who had done the folio plates for Selby's giant book (to which we referred earlier). Lizars in fact engraved the first ten plates for Audubon, but a work stoppage by Lizars' colourists forced Audubon to turn to Robert Havell, Jr., in London. Havell's name is forever linked with *The Birds of America*, for having "engraved, printed and colored" the 435 double elephant folio plates.

Fully a third of the plates contained some Havell elements not found in the original watercolours. *The Birds of America* was, therefore, a cooperative effort requiring the input not only of Audubon, but also of assistant artists, engravers and wonderfully skilled hand-colourists, to say nothing of explorers and collectors who supplied the skins that Audubon frequently used to draw "from Nature." But these are not weaknesses. The *Birds* was and still is the greatest bird book of all time. Audubon was fully responsible for perhaps three-quarters of the plates, and for the rest the concept, layout and overall "feel" were firmly in the hands of the master.

Down through the years, one complaint above all others continues to be voiced: Audubon's poses are stiff. Many of the critics have never seen the folio

plates, let alone the original watercolours, and base their opinions on reproductions of various sizes and quality. Audubon himself, however, anticipated the criticism of his own contemporaries, who would be faced for the first time with his unprecedented approach to animal art. In the "Introductory Address" of his *Ornithological Biography* of 1831 he wrote: "The positions may, perhaps, in some instances appear *outré*; but such supposed exaggerations can afford subject of criticism only to persons unacquainted with the feathered tribes; for, believe me, nothing can be more transient or varied than the attitudes or positions of birds." Some unquestionably do look contrived, but many of them were specifically chosen by Audubon to show what he himself called "the necessary characteristics [to satisfy those] closet naturalists." We have here, in effect, the precursor of the field guide.

Complaints are levelled, too, against Audubon's gothic penchant for the grotesque. In the *Edinburgh Journal of Science* in 1828 he wrote: "My plan was then to form sketches... each representing, if possible, each family as if employed in their most constant and natural avocations..." To harp on the grotesque is to overlook the gentle. The essential link between predator and prey is often bloodily depicted, but it is only a complement to the loving interaction of the passenger pigeons, or the promise of a budding flower. Seldom in Audubon do we encounter mere scientific illustration devoid of feeling.

How can one sum up Audubon and his contribution?

Ironically, Audubon may have supplied the perfect epitaph for himself and his art. In 1828, he visited the gentle genius from Newcastle-upon-Tyne, Thomas Bewick, whose wood engravings in their own way revolutionized animal illustration. Audubon was familiar with Bewick's *History of British Birds*, and was so impressed that he had named a species of wren after Bewick. Wrote Audubon: "He began to show me, as he laughingly said, how easy it was to cut wood; but I soon saw that cutting wood in his style and manner was no joke, although to him it seemed indeed easy... Assuredly you will agree with me in thinking that in his peculiar path none equalled him. There may be men now, or some may in after years appear, whose works may in some respects rival or even excel his; but not the less must Thomas Bewick of Newcastle-upon-Tyne be considered in the art of engraving on wood what Linnaeus will ever be in natural history—though not the founder, yet the enlightened improver and illustrious promoter."

Science is in its essence transitory. Nature goes on forever. It was Audubon's unmatched understanding of Nature that gave eternal colour to his wilderness palette.

THE WILDERNESS CORNUCOPIA

Audubon painted and wrote of a land that was, to the Europeans of the 1800s, totally unfamiliar and almost unbelievable, for they had never seen it. We, too, find his descriptions unfamiliar and almost unbelievable, because we will never see it again. Through ignorance, greed and wilful destruction, humans have in less than a century and a half destroyed much of the North American wilderness. Through Audubon's work, we can travel vicariously back to an America that has vanished. In Audubon's day, Europeans and North Americans alike assumed that the natural resources were so great as to be inexhaustible: cutting down a tree from the world's greatest forest was as insignificant to them as taking a cup of water from the ocean is to us. First the forests, then the wetlands, and finally the grasslands were destroyed. In the process an immense quantity and diversity of wildlife was lost. No longer would flocks of passenger pigeons literally eclipse the sun. No more great auks would be clubbed, then cut up for use as bait on cod-lines. Ruffed grouse would not be regularly served to hundreds of diners at elegant restaurants, nor would a single market sell eight thousand mallards, shot by hunters on one lake in one season. In Colonial times, bounties of three cents per dozen were paid on red-winged blackbirds, and by the 1820s the migration of the American coot was welcomed in the Southern States as a winter-long source of a staple food for an entire segment of the poorer population. Written records from the nineteenth century confirm that the numbers of birds commonly found in North America were beyond estimation. The Audubon plates in this section depict species whose numbers once defied counting, but which today are either extinct or sorely reduced.

PASSENGER PIGEON
Ectopistes migratoriu

The passenger pigeon is the quintessential symbol of extinction in North America, and this reason alone would justify placing Audubon's painting among the most important in the history of wildlife art. In the autumn of 1813, he personally witnessed a flock so dense that the birds literally eclipsed the noonday sun, and continued to pass in undiminished numbers for three days in succession. It is estimated that the flock contained more than one billion birds. His vividly detailed description of the tumult and chaos, of the hunting and wastage, ranks among the greatest examples of American nature prose. How strange, therefore, that Audubon would have chosen so peaceful a pose of the solitary pair to depict a species whose multitudes created a noise likened to "a hard gale at sea passing through the rigging of a close-reefed vessel" and "a roar of distant thunder." So loud were they that the firing of guns could not be heard even as the constant slaughter continued. With uncanny prescience, Audubon wrote: "I have satisfied myself, by long observation, that nothing but the gradual diminution of our forests can accomplish their decrease." The first record of the passenger pigeon is in Jacques Cartier's diary for July 1, 1534, when he saw countless *ramiers* or wood pigeons, the European species with which he was familiar. On his second voyage, in 1536, he saw them at Hochelaga, where Montreal stands today. Samuel de Champlain reported on July 12, 1605, that he encountered "countless numbers of pigeons" at what is now Kennebunkport, Maine. At their height there were perhaps as many as five billion pigeons. The last great nesting took place in 1878 near Petrosky, Michigan. It covered 350 square miles (906.5 km²) and contained an estimated 136 million birds. As Audubon had feared, the woods were broken up and, deprived of food, the flocks never recovered. Individual birds were taken at Tadoussac on the lower St. Lawrence in 1889, in Toronto in 1891, St. Boniface in 1893 and Winnipegosis in 1898. The last authenticated sighting was on March 24, 1900, in Pike County, Ohio. In September 1914, the last passenger pigeon, Martha, died in the Cincinnati Zoo. The bird that outnumbered all others in history was extinct. As Aldo Leopold wrote in his *Sand County Almanac*, never again would they "clap their wings in thunderous applause of mast-laden woods."

Havell No. LXII

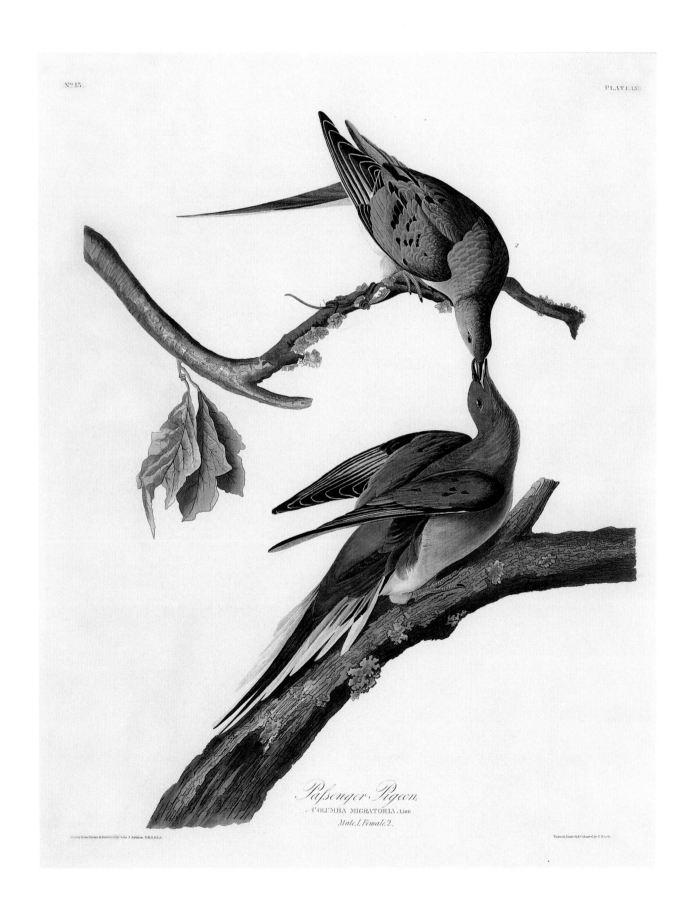

Passenger Pigeon.
COLUMBA MIGRATORIA, Linn.
Male 1. Female 2.

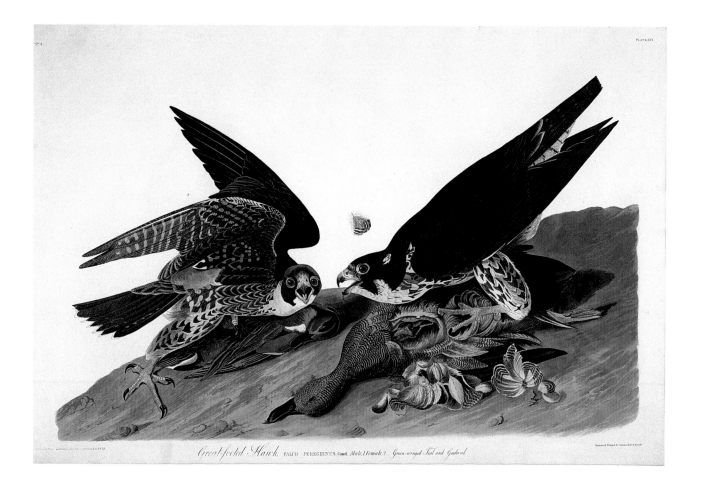

Great-footed Hawk. FALCO PEREGRINUS, Gmel. Male,1 Female,2. Green-winged Teal and Gadwal.

PEREGRINE FALCON

Falco peregrinus

Audubon called them gluttons and pirates, and shot them whenever he could. In one of his more graphic plates, as if to emphasize his antipathy, he shows them gorging on green-winged teal, blood dripping from their beaks, feathers flying. The meal also explains why, until quite recently, the alternative name of the peregrine was the duck hawk. With the possible exception of an Asian swift, the peregrine is the fastest bird in the world, capable of speeds estimated at over 275 miles per hour (442 kmph) as it flashes down on its prey. Persecution, poisoning and disruption of nesting sites reduced once-plentiful numbers to the point of extinction. In 1968 two of the three distinct races of North American peregrines—the American and the tundra—were placed under the protection of the Endangered Species Act. The Peale's peregrine of British Columbia and the Queen Charlotte Islands does not migrate and, having been spared DDT poisoning, remained relatively plentiful. DDT itself was finally banned in Canada in 1971 and the United States in 1972. Today, they are off the endangered list in the East, but remain threatened. Thanks to captive breeding and the placement of urban hacking boxes, peregrines who once watched from cliffs now watch from skyscrapers for unwary pigeons. It was precisely this predilection for pigeons that caused the military to slaughter every peregrine in sight during wars when homing pigeons carrying sensitive messages kept on being intercepted. Protected in North America, the migrating falcons still are threatened by pesticide poisoning on their winter range in Argentina, where DDT builds up in the food chain. It takes up to three years for the poison to reach fatal levels in the falcons. Conservation needs international cooperation. In Audubon's day, the common name was the great-footed hawk. For emphasis, he contrasted the oversized yellow talons against the dark body of the dead teal. The talons, however, are not the falcon's only weapon: its real killer is speed. Peregrines stun their prey by collision in mid-air; death is instantaneous. Sometimes the prey is clutched in the talons, but on other occasions the dead bird is allowed to drop to the ground, and the falcon descends to enjoy a leisurely meal.

Havell No. XVI

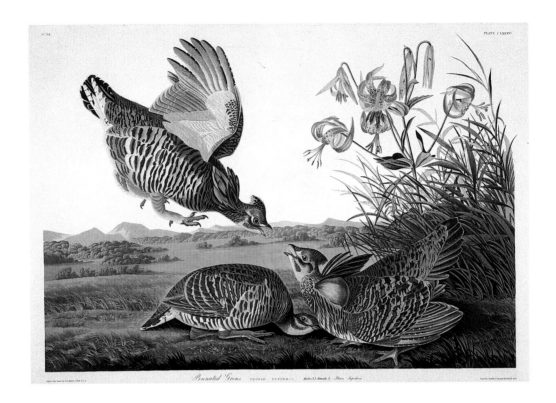

GREATER PRAIRIE CHICKEN
Tympanuchus cupido

This is one of the few plates of which Audubon personally painted all the elements—the plants, the birds and the landscape. The background, he said, was his attempt to portray "our original western meadows." The scene was painted near the Great Lakes in 1824 when the pinnated grouse, as the prairie chicken was called, was incredibly abundant. In 1873, Chicago markets sold six hundred thousand of them at $3.25 per dozen, and as late as 1893 the village of Spooner, Wisconsin, sold more than twenty-five thousand in the local market. Today, the prairie chicken is rare and seriously threatened by habitat loss across its entire range. The larger, darker, eastern variety, known as the heath hen, was so common and cheap that workers in the Boston area were contractually promised that they would not have to eat hen more than "a few times a week." Even after the birds had begun their obvious decline, limited hunting was allowed on the island of Martha's Vineyard. Foxes were introduced for sport, and pet dogs disrupted the nesting patterns. Accidental fires repeatedly ravaged the habitat. In 1930, what proved to be the last bird was trapped and banded. Two years later it reappeared on the "booming field," and on March 11, 1932, it was seen for the last time. Where for millennia there had been the sound of the mating call, now there was silence. Darwin, in his 1859 *On the Origin of Species*, wrote: "We need not marvel at extinction; if we must marvel, let it be at our own presumption in imagining for a moment that we understand the many complex contingencies on which the existence of each species depends." The official obituary of the heath hen, which appeared in the *Vineyard Gazette* on April 21, 1933, was poignant: "Somewhere on the great plain of Martha's Vineyard death and the heath hen have met. One day, just as usual, there was a bird called the heath hen, and the next day there was none."

Havell No. CLXXXVI

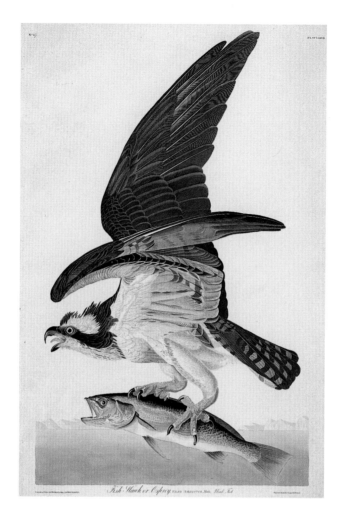

OSPREY
Pandion haliaetus

"Osprey" seems to be a corruption of *ossifraga*, or "bone-breaker" in Latin. Despite the fact that the "ossifraga" of Pliny (AD 79) and other classical writers was almost certainly the bearded vulture or lammergeyer, the name has stuck. Unique among birds of prey, the osprey lives almost exclusively on fish snatched live from the water. Audubon's break with traditional bird portraiture is nowhere more evident than in his painting of the osprey. Here drama and art transform science. The foreshortened lower wing is virtually unprecedented in animal art. The attention to the grasping with the fourth talon reversed, the highly detailed rendering of the rough texture of the toes designed to grasp slippery fish, even the forward direction of the weakfish to aid in aerodynamics—all of these point to extensive first-hand knowledge on the part of the artist. And there is a palpable sense of air acting under the wings as the bird lumbers aloft. In the nineteenth century, ospreys were abundant over a range that covered most of the continent. Nesting by hundreds of pairs of these gregarious hawks at the mouth of the Connecticut River attracted birdwatchers from around the world. Increasingly, concentrated levels of pesticides mounted the twentieth-century food chain and attacked the calcium-producing ability of the birds. Egg shells too weak to support the weight of the nesting parents doomed the osprey to calamitous decline. Today, with the banning of DDT, the osprey has rebounded dramatically.

Havell No. LXXXI

PLATE. CLXXXIX

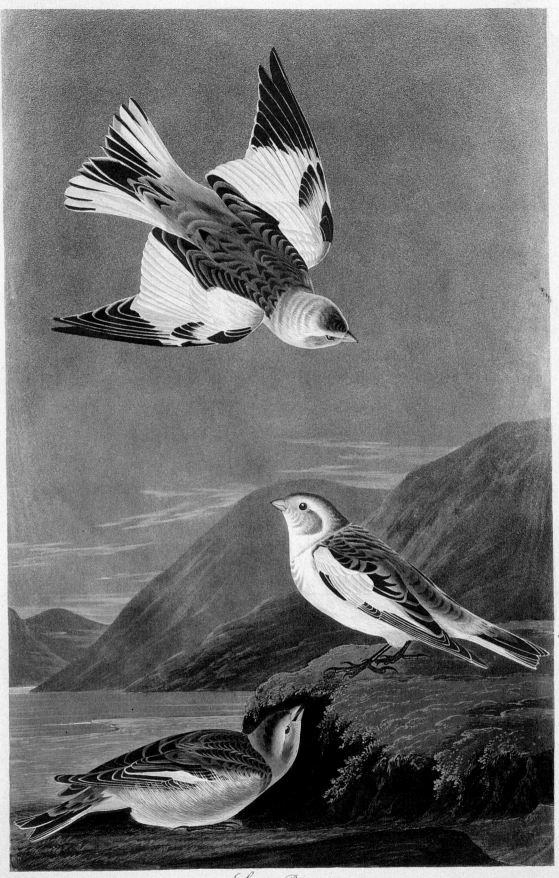

Snow Bunting.
EMBERIZA NIVALIS. Linn.
Adult.1.2. Young.3.

Drawn from Nature by J.J.Audubon. F.R.S. F.L.S.

Engraved, Printed & Coloured by R. Havell, 1831.

SNOW BUNTING
Plectrophenax nivalis

Audubon wrote: "As soon as the cold blasts of winter have stiffened the earth's surface, and brought with them the first snow-clouds, millions of these birds, driven before the pitiless storm, make their way towards milder climes."

The snow bunting, or as it was so charmingly called in Colonial times, the snowflake, is in winter our whitest songbird, with only the black wingtips, elbows, flank patches and central tail spear for contrast. There is a touch of honey on the back of the head, cheeks and shoulders. The beauty of the individual birds is lost in the greater beauty of the flock, what Audubon called "compressed squadrons." Turning as one, as Audubon said, "with amazing swiftness," the birds first show the touch of colour on their backs, giving some contrast against the snow. But when they flash their white undersides, the entire flock seems to disappear in the snow-filled air. The Inuit considered them a delicacy, and because the bird is circumpolar, so did the Lapps. Audubon reported that in the early 1800s they were shot "in immense numbers" as they were easily approached and, worse, "their flesh is savoury." Unfortunately, the slaughter continued for another century: as late as 1903, eighty thousand snow buntings were found in a single cold storage warehouse in one of our eastern cities, according to a report from the then head of the fledgling Audubon Society. In the 1770s, Pennant was amazed that these seed-eaters could be so numerous in Greenland, "where vegetation is nearly extinct." Audubon placed his birds in just such a spot, a barren Arctic landscape with only a hint of moss to soften the weathered rocks and mountains.

Havell No. CLXXXIX

Nº42.

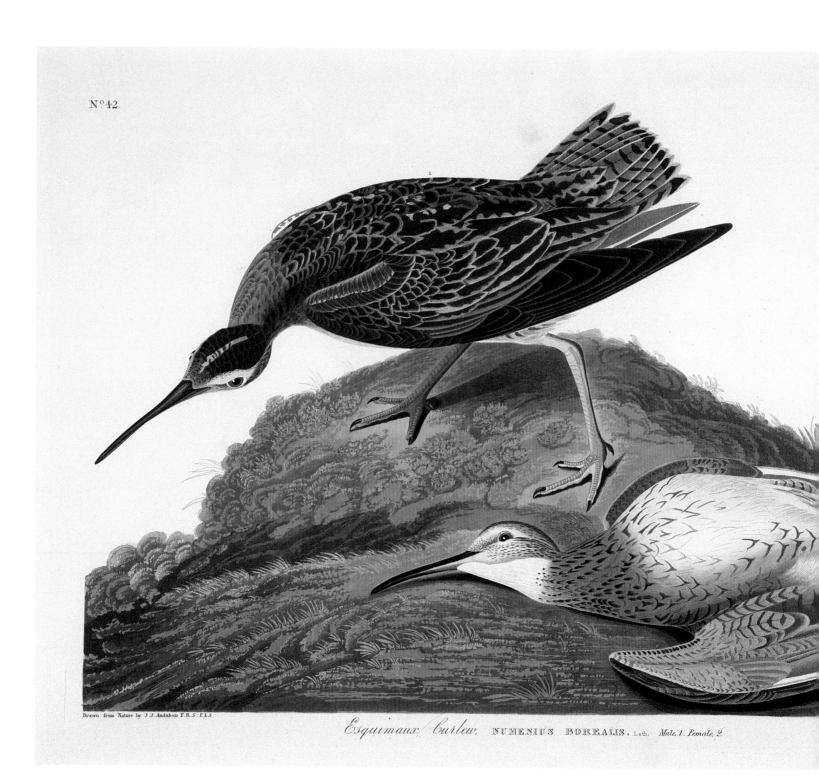

Drawn from Nature by J.J.Audubon F.R.S .F.L.S

Esquimaux Curlew, NUMENIUS BOREALIS. Lath. *Male 1. Female, 2.*

PLATE CCVIII

Engraved, Printed,& Coloured, by R.Havell, 1834.

ESKIMO CURLEW
Numenius borealis

" 'The Curlews are coming!' This is as much a saying here as that about Wild Pigeons in Kentucky!" That is how Audubon characterized the migration of what was once the most numerous of our shorebirds. His *Journal* for July 29, 1833, gives a graphic description: "During a thick fog, the Eskimaux Curlews made their first appearance in Labrador, near the harbour of Bras d'Or. They evidently came from the north, and arrived in such dense flocks as to remind me of the Passenger Pigeons . . . The birds at length came, flock after flock . . . and they continued to arrive at Bras d'Or for several days in flocks which seemed to me to increase in number." Audubon and his party hunted the flocks, and found that the curlews "were extremely fat and juicy, especially the young birds, of which we ate a good many." The Eskimo curlews were first discovered in 1772 when Hudson's Bay Company traders at Fort Albany in James Bay and Fort Severn in Hudson's Bay shipped salted birds back to London. The Smithsonian Institution reported in 1915 that within living memory twenty-five or thirty hunters would kill as many as two thousand birds a day for the Hudson's Bay store at Cartwright, Labrador. Their numbers were so huge that sixty years earlier Audubon refused to believe the tales of Labrador fishermen. "The accounts given of these curlews," he wrote, "border on the miraculous." When the flocks reached settled lands, the birds were so easy to kill with sticks that young boys sold them at six cents apiece. By 1874, Elliot Coues could still report "flocks of three to many thousands." Despite an annual slaughter that left too many corpses to be carried to market, the birds returned every year until 1875, when the flocks suddenly plummeted. It was assumed that the birds had merely taken a different migration route to Argentina, where the decimation continued on the pampas. Remnant flocks continued to be wiped out until the 1880s. In 1882, two hunters shot eighty-seven birds on Nantucket. By 1894 only one bird was found for sale in the Boston markets. The last recorded bird shot in the United States fell on April 17, 1915, in Norfolk, Nebraska. Curlews were seen at Battle Harbour north of the Straits of Belle Isle on August 29, 1932. One bird was seen in Texas in 1962, and one in Barbados in 1964. Within two centuries of their discovery, the bird that rivalled the passenger pigeon in numbers was gone. Audubon confessed that he found "them difficult to represent." How prophetic that on August 10, 1833, in Labrador, he painted one of the Eskimo curlews dead.

Havell No. CCVIII

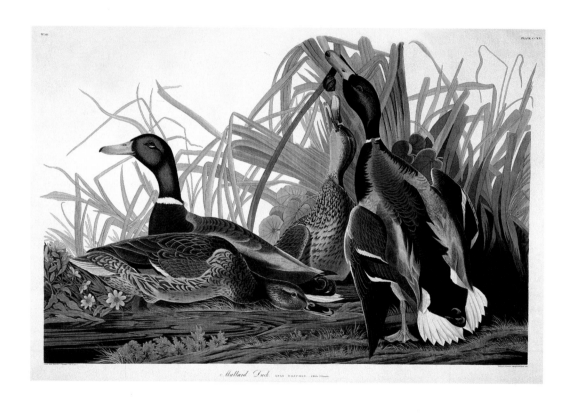

MALLARD
Anas platyrhynchos

Inhabiting the whole of the northern hemisphere, the mallard, of all the ducks in the world, has been of greatest importance to humanity, as the progenitor of virtually all domestic ducks. Audubon recognized the ancestry, and noted "how brisk are all his motions compared with those of his brethren that waddle across your poultry yard. The Duck at home is the descendant of a race of slaves." In the early 1820s, the numbers were astounding. Audubon wrote: "In the Floridas, they are at times seen in such multitudes as to darken the air, and the noise they make in rising from off a large submerged savannah is like the rumbling of thunder." In 1893 a single gunner from Big Lake, Arkansas, sold eight thousand mallards, while the total number sent to market that year from this one location exceeded 120,000. Audubon described the mallard as "glistening with emerald green, his amber eyes glancing in the light." Over 90 per cent of mallard food is vegetable, and so the taste of the flesh has inspired chefs across generations. As only government officials can, someone actually counted 102,400 seeds of the primrose willow in the stomach of one bird. If these were planted one foot apart in each direction, this would seed two and a half acres (1.1 ha). Mallards are not only prolific, they are also promiscuous. They have been known to breed with pintails, baldpates, green-winged teal, blacks and, especially, gadwalls. Audubon rightly conjectured that Brewer's duck—which he also painted—was a mallard–gadwall hybrid. It is tempting to ascribe a certain intelligence to birds, the mallard being no exception. Like some large gulls, they frequently do a "rain dance," rapidly patting their feet on soft mud in imitation of raindrops, creating vibrations that bring worms to the surface. Similarly, they furiously tread water, and the resulting currents loosen worms from the swirling mud. They are also clever enough to spend the winter in the lower half of the Mississippi Valley, well to the south of the line of ponds that freeze over. A poignant footnote: with the completion of the mallard, Stewart, the chief colourist of Havell, died. After contributing so brilliantly to the first 221 plates, he was buried in a pauper's grave.

Havell No. CCXXI

WHOOPING CRANE
Grus americana

Audubon's intention to portray every American species life-size met a challenge with this bird, the tallest in North America. The whooping crane stands 52 inches (132 cm) and has a wingspan of 87 inches (221 cm). Somehow this avian giant had to be accommodated on a copper printing plate measuring less than 39 by 25 inches (99 x 63 cm). Audubon depicted the bird bending down to eat a baby alligator, but even this clever composition required that the tail feathers of the bird extend beyond the printing surface, into the white margin. In Audubon's day, the whooping crane was common, reportedly nesting as far south as northern California. Hunters could not resist the easy targets of migrating flocks, but it was land use, drainage, introduction of livestock, and the human population explosion that sharply reduced the birds' numbers. Perhaps 90 per cent were wiped out between 1870 and 1900. Whooping cranes had been found wherever suitable habitat existed but, one by one, the southern nesting sites were destroyed; agricultural drainage, for example, changed the bottomlands of the Rio Grande in Texas from a crane marsh to a desert. The last known nesting site in Canada was discovered by Fred Bradshaw, a game warden, on May 28, 1922, at Muddy Lake, Saskatchewan. Bradshaw killed the chick, now Tag 30393 in the Royal Ontario Museum collection. Another thirty years would elapse before another nest was found. By 1946, when a systematic search for nests was undertaken, Muddy Lake was bone dry. By the 1950s there were only seventeen wild birds left, stalking regally in the shallows of their southern wintering grounds along the Aransas Wildlife Refuge off the Texas Gulf Coast; their northern nesting sites were unknown. As soon as the birds arrived for the season, all drilling and pumping operations were suspended by Continental Oil, which owned the petroleum rights under their last sanctuary. For this act, Continental received a special award from the National Audubon Society. Their nesting grounds were finally discovered in 1955, in Canada's northern Wood Buffalo National Park, and the tide turned. Scientists collected eggs to be transferred to foster-parent sandhill cranes and for captive breeding programs at various zoos. Geographic distribution was considered essential: if all the birds were concentrated at Aransas, the entire flock might be wiped out by one hurricane. New and, hopefully, self-sustaining populations have been established on different wintering grounds. Conservation efforts that were started in the mid-1930s have finally paid off. While not yet out of danger, the population has rebounded to several hundred birds. The whooping crane has been snatched from the jaws of extinction.

Havell No. CCXXVI

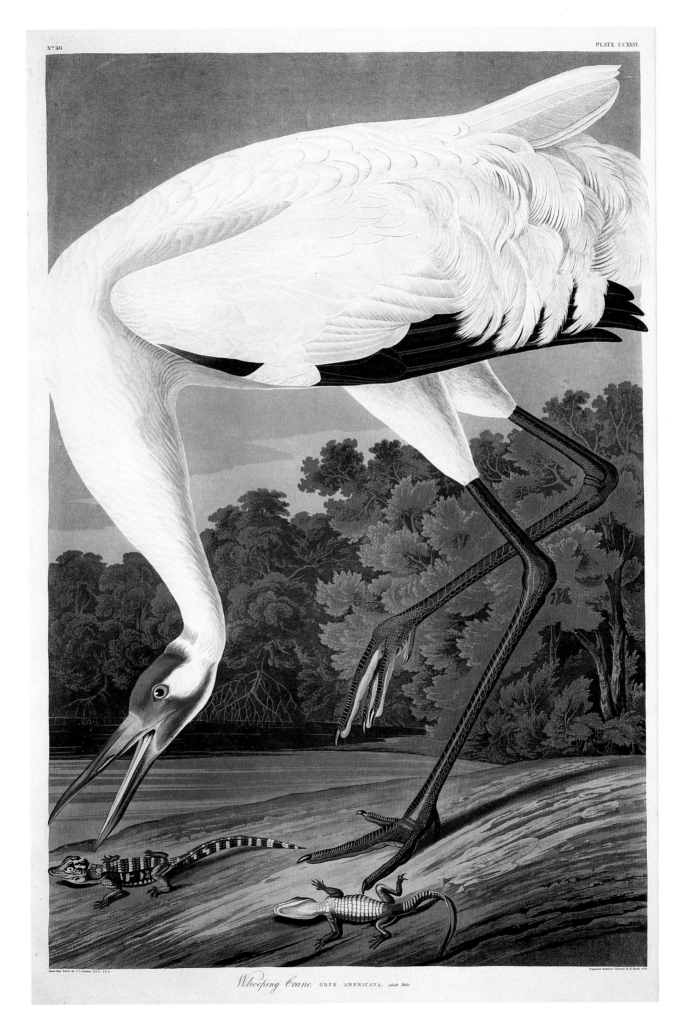

Whooping Crane. GRUS AMERICANA. *Adult Male*

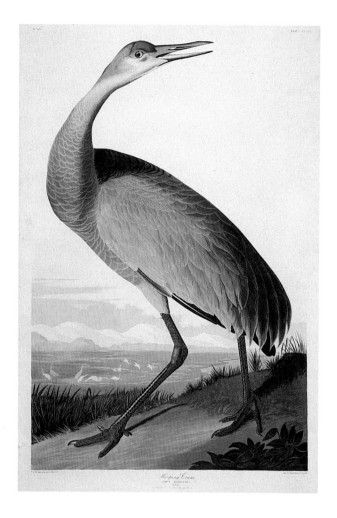

SANDHILL CRANE
Grus canadensis

As a scientist, Audubon was careful but not infallible. In addition to painting a handful of what turned out to be nonexistent species, he was sometimes confused by plumage that varied according to the season and the maturity of the bird. For example, he insisted that the immature bald eagle was a distinct species, which he dubbed the "Bird of Washington." He also assumed that the grey sandhill crane was the immature phase of the white whooping crane. In this painting, he had Havell add several miniature white "adult" birds, in the background. There is a delightful irony about this painting. When the wild whooping crane population had been reduced to fewer than twenty birds, the drastic step was taken of removing eggs from nests in Wood Buffalo National Park and placing them under sandhill crane foster parents. The experiment has added a significant number of whoopers, and has helped bring them back from the brink of extinction. Audubon's "immature" has become today's parent. But now all is not well with the sandhills. Drainage of their wetland habitat has greatly reduced their range. In a poignant prediction, Aldo Leopold, in his *Sand County Almanac*, wrote: "Some day, perhaps in the very process of Man's benefactions, perhaps in the fullness of geologic time, the last crane will trumpet his farewell and spiral skyward from the great marsh ... And then, a silence never to be broken, unless perchance in some far pasture of the Milky Way."

Havell No. CCLXI

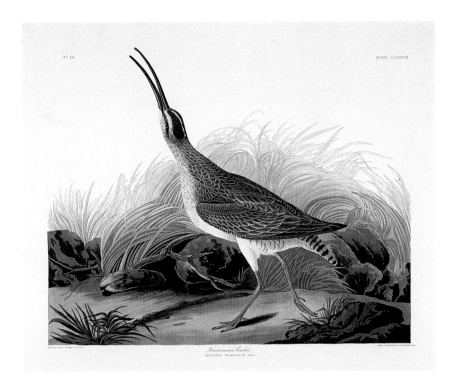

WHIMBREL
Numenius phaeopus

Until very recently, this elegant species was called the Hudsonian curlew, reflecting one of the nesting areas where it was once common. Today, it is considered a North American variant of the Eurasian whimbrel. Audubon had so little personal knowledge about this shorebird that he had to rely on extensive quotations from Alexander Wilson and Thomas Nuttall, two nineteenth-century naturalists who agreed on two things: that the volume of the birds' combined raised voices was almost beyond belief, and that their numbers were huge. In 1905 scores of thousands were reported to be massing in South Carolina in resting flocks covering forty or fifty acres (16.1 to 20.2 ha) along the Atlantic coast. During migrations, the usually solitary or paired birds combined in scattered U-shaped flights of twenty or fifty. Passing in rapid succession, flocks containing a thousand or more birds were seen over Toronto as recently as 24–26 May 1910. From Alaska and the Eastern Arctic down to their wintering grounds in Patagonia at the tip of South America, the birds were relentlessly hunted, poisoned and deprived of habitat by land modification; their numbers plummeted. The Marshall Islands selected this plate for their 1985 Audubon commemorative stamp. It might easily have turned out to be a memorial to the bird itself, and yet today the whimbrel is considered the commonest of the three American curlews. The Eskimo curlew, whose numbers Audubon compared to the passenger pigeon, may be extinct, and the long-billed curlew, our grandest shorebird, has been sadly reduced to a rump population, protected at least a little while longer by the isolation of their northern nesting grounds. So the whimbrel wins almost by default. Artistically, this is one of the subtlest of Audubon's plates. The curve of the beak is repeated in the swaying grasses, heightening the figure's forward movement. The bill is starkly silhouetted against the sky, and being slightly open it emphasizes the characteristic call that Audubon found "exceedingly vociferous."

Havell No. CCXXXVII

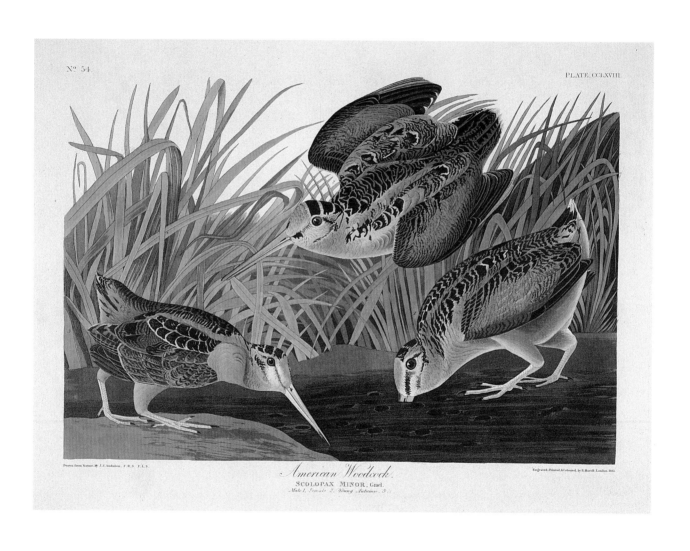

AMERICAN WOODCOCK
Philohela minor

Audubon's plate clearly shows how the woodcock earned its other common name, the bog-sucker. Migrating strictly by night, the birds arrive in the northern nesting areas in early spring, when snow still lies in the swampy forests that are its preferred habitat. In inclement weather, woodcocks are unique in their habit of both birds sitting simultaneously on the nest. They search for food with their long, flexible bills, probing under wet leaves or in mud for worms, trusting the extremely sensitive tip of the beak to feel for the vibrations caused by their prey. A series of closely concentrated borings in the mud betrays the presence of woodcocks; it also indicates that they do not always get their worm on the first try. They spend so much time embedded in the muck that evolutionary adaptation has shifted their eyes far to the back of the head, so that a cautious alert is maintained even at their most vulnerable moment. Closely related to the snipes, they were considered favourite game birds. Several lithographs featuring woodcocks, produced by Currier & Ives as late as the 1870s, attest to their popularity. Believing implicitly in the protection of their cryptic brown coloration, they would sit still as a rock until the gunner was almost upon them, then explode up in a twisting flight that would frustrate even the most expert marksman. The hunt led through tangled underbrush and oozing mud, but the tasty flesh of the woodcock made it all worthwhile. Thousands were slaughtered by sportsmen who used the glare of torches at night to confuse the birds into staying put. One kitchen item that speaks eloquently of the abundance of birds in early America is the small tin reflecting oven that stood on the hearth of every humble frontier home and most city dwellings. It was usually a foot (30 cm) or so long, and about a foot high, with a curved canopy to concentrate the heat and an enclosed pan below to catch the prized drippings. On the cooking wall would be six or eight metal hooks, on which small game birds would be impaled. Woodcock by the millions would be cooked this way every year. How good were they? Audubon wrote wistfully in 1832 from Edinburgh, Scotland: "When a jug of sparkling Newark cider stands nigh, and you, without a knife or fork, quarter a Woodcock, ah Reader!—But alas! I am not in the Jerseys just now ... I am ... without any expectation of Woodcocks for my dinner, either to-day or to-morrow, or indeed for some months to come."

Havell No. CCLXVIII

BLUE-WINGED TEAL
Anas discors

Audubon considered the blue-winged teal one of our most beautiful ducks. In describing the blue wing patch, he said it "glistens like polished steel . . . the dancing light of a piece of glass suddenly reflected on a distant object." The quantity of waterfowl in the nineteenth century was beyond counting, but the drainage, during Audubon's lifetime, of an area of wetland equal to all of New England, plus unbridled market hunting, caused a precipitous decline. Even as critical marshes continue to be drained, modern conservation efforts have reflooded millions of acres, allowing some populations to rebound. There is little chance, however, that anyone will again write, as Audubon did: "I myself saw a friend of mine kill eighty-four [Teal] by pulling together the triggers of his double-barreled gun." Before the numbers drastically declined in the 1880s, this would not have been a difficult feat, considering that the ducks migrate in very dense groups. Although the teal—both blue- and green-winged—are among the smallest of the tribe, the blue-winged winters farther south than any other of our surface-feeding ducks, spending the season in the northern reaches of South America. Artistically, this particular plate has received more than its share of criticism. The wings seem stiff and unnatural. Here is a case where Havell, the engraver, significantly harmed the original concept. In the watercolour the two birds are seen flying very low over a pond—so low, in fact, that the background grasses project above the lower bird. This pose is completely consistent with Audubon's own description of the scene he painted: ". . . before alighting, these Teal pass and repass several times over the place, as if to ensure themselves of the absence of danger." His birds were, in effect, gliding on set wings towards an imminent landing in their safe haven, a pond—which is their preferred habitat. By placing the birds against the sky, and replacing the background pond grass with a distant scene of bays and cliffs, hundreds, perhaps even thousands of feet below, Havell distorted the entire concept, artistically and environmentally—far more than Audubon distorted the wings. In the fuller context, the criticism loses much of its validity, a phenomenon that applies so frequently to Audubon's art.

Havell No. CCCXIII

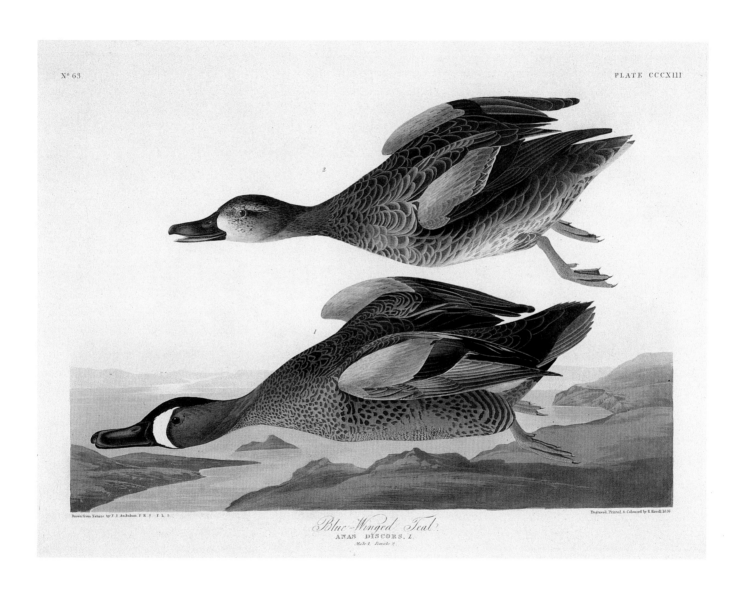

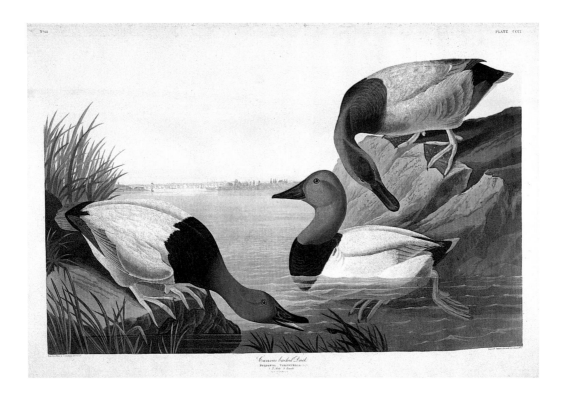

CANVASBACK

Aythya valisineria

From its opening in New York in 1819 to its demise in 1923, Delmonico's was the reigning monarch of restaurants in the young republic. In March 1880, 230 guests honouring Ferdinand de Lesseps, of Suez Canal fame, feasted on canvasback, as did guests at virtually all Delmonico's dinners during duck season. Actually, the birds were only delicious during those seasons when they fed on wild rice and, especially, wild celery—*Valisineria spiralis*, a plant food that had nothing to do with celery but which provided the Latin name for the canvasback. The numbers of canvasback were incredible. Red-heads and canvasbacks rafted in bodies miles in extent, with an estimated fifty thousand birds together. Gunners would paddle silently up to a raft of sleeping ducks and fire away, often killing a hundred birds with each blast. In *American Duck Shooting* (1901), the frontispiece was a photographic reproduction of Audubon's plate, "The Canvasback." The book comprehensively covered the shooting methods for all ducks under all conditions throughout the United States. It is chilling in its thoroughness, especially because it was written by George Bird Grinnell, the founder of the Audubon Society. His concern for the survival of ducks, however, was clear at the end: "The constant decrease of the number of our wild-fowl is a subject of frequent complaint by gunners. Two prime causes exist for the diminution…these are over-hunting, and the settling up of the country. But most gunners are unwilling to accept the logic of events and to acknowledge that the principal cause of the lessened number of fowl lies with the gunners themselves." In a letter dated April 5, 1834, to John Bachman, Audubon confirmed that he painted the male in Baltimore, whose skyline appears on the horizon in the background of the plate. Baltimore, on the Chesapeake, was the centre of the trade in canvasbacks.

Havell No. CCCI

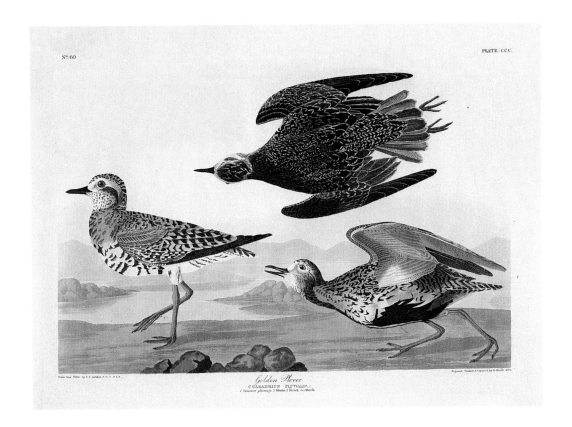

N° 60
PLATE CCC

Golden Plover
CHARADRIUS PLUVIALIS. 1.
1 Summer plumage, 2 Winter 3 Variety in March.

AMERICAN GOLDEN PLOVER
Pluvialis dominica

The wildlife in Audubon's day was abundant beyond belief. He described how market hunters near New Orleans on March 16, 1821, intercepted a huge flock of migrating plovers. One gunman alone killed sixty-three dozen, and Audubon estimated that because of the "sport" of two hundred gunners, "forty-eight thousand golden plovers would have fallen that day." He added: "The next morning the markets were amply supplied with Plovers at a very low price." The surviving birds would have continued to their wintering grounds in South America. In the 1920s, W. H. Hudson described them on the Argentine pampas, where "they blacken the ground for several acres, and the din of their voices resembles the roar of a cataract." Populations from around the non-Canadian Arctic winter in Africa and even Australia, covering an astonishingly long migratory route. In Audubon's plate, the background was added on his instructions by Havell, who also reversed the left bird in the final engraving. Heading all three birds in the same direction avoided an artistic as well as a natural collision. Audubon marvelled at their "executing intricate evolutions," hundred of birds turning as one in the same manner as a school of fish. For a split second, the individuals would turn so that their wings would be perpendicular to the ground. Upon alighting, they would run for a few steps with their wings raised over their backs. This is the scene that Audubon captured. The name "plover" relates to rain. European folklore held that, through their restlessness, these birds foretold rain; hence *pluvier* in French, *piviere* in Italian and *pluvial* in Spanish. The most evocative name is the German *Goldregenpfeifer*, literally, the golden rain piper. During Audubon's time, local American names were less elegant: prairie pigeon, frost bird, squeaker and toad head.

Havell No. CCC

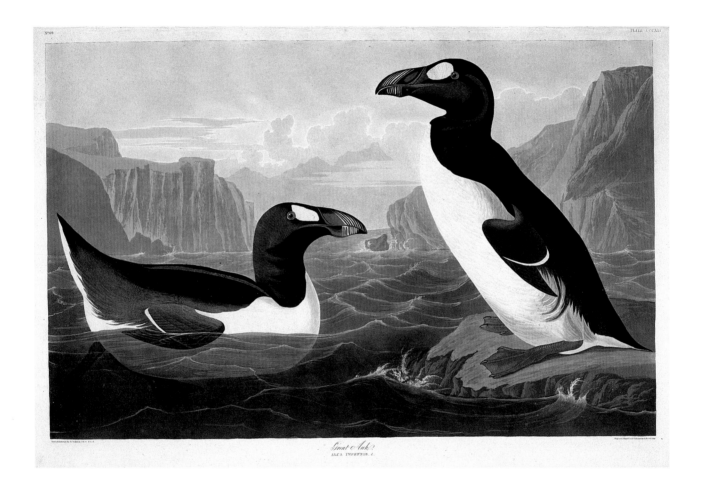

Great Auk
ALCA IMPENNIS, L.

GREAT AUK
Pinguinus impennis

"These birds are so fat that it is marvellous. We call them *apponats*; and our two long-boats were laden with them as with stones, in less than half an hour." Thus did Jacques Cartier record his encounter with the great auk on May 21, 1534. George Cartwright, after visiting Funk Island, noted in his diary for Tuesday, 5 July 1785, that "The Birds which the people bring from thence they salt and eat in lieu of salted pork." The birds in question were great auks. They were rounded up and slaughtered in inconceivable numbers, and as there was no wood on the island, the oil from the previous carcasses was used to fuel the fires to par-boil the next victims in order to loosen the feathers. Planks or even sails were laid between the gunwales of small craft and the rocky shores, and the helpless, flight-less birds were herded on board to be clubbed to death for food, feathers and fat. Even their stomachs were used as fishing-floats. Cartwright was a man of vision: "It has been customary of late years for several crews of men to live all summer on that island, for the sole purpose of killing birds for the sake of their feathers: the destruction which they have made is incredible. If a stop is not soon put to that practice, the whole breed will be diminished to nothing." Audubon never saw a live great auk, so his plate could not have been "Drawn from Nature." As mod-els he used stuffed specimens in London between 1834 and 1836. Havell tried to heighten the sense of drama of the scene by adding a background of brooding cliffs and crashing waves. There is no hint in Audubon's text that he anticipated the impending doom of this flightless species. He repeated at length the reports given to him by local inhabitants of the annual butchery, and he does comment on the slaughter of birds by cod fishermen who used the flesh as bait. He had hoped to see great auks during his visit to Labrador in 1833, but weather and time prevented him from visiting Funk Island off Newfoundland, which was one of the centres of the massacre. History has recorded that the last two auks and their egg were collected on a rocky islet near Iceland in 1844 for the private natural history cabinet of a Danish nobleman, and yet in 1850, Henry Meyer, in his *Coloured Illustrations of British Birds*, wrote: "But we cannot believe, as some authorities suppose, that the species is either becoming extinct, or even dimin-ished in numbers." Five years after their extinction, the experts were still in denial. There are only a handful of stuffed great auks left. The one at the Royal Ontario Museum is not only perhaps the best preserved but also has a remarkable history. Audubon actually owned it before it ended up at Vassar College, from which it was bought through publicly subscribed funds by the R.O.M. in 1967.

Havell No. CCCXLI

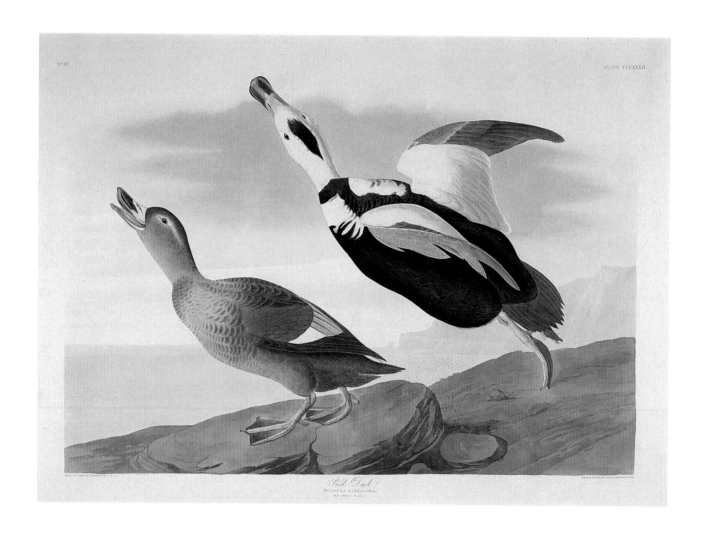

LABRADOR DUCK
Camptorhynchus labradorius

The Labrador duck has the dubious distinction of being the only North American waterfowl to become extinct so far. Almost nothing has been learned about its life and habits since it was first scientifically named and classified in 1788. Thomas Pennant used an engraving of the pied duck on the title page of his *Arctic Zoology* in 1785, but the text shed no light on this shy species. Audubon's son, John Woodhouse, was shown what was purported to be a nest at Blanc Sablon on July 28, 1833, but there were no birds to be found. We know that it was elusive, retiring, a strong flier and an agile diver. Hunting, therefore, does not appear to have been the main cause of its disappearance. Despite its fishy-tasting flesh, the birds were commonly found in the Fulton and Washington markets of New York between 1860 and 1870, sometimes a dozen hanging together. Then perhaps a week or two would elapse before any more were seen. Audubon does tell us, however, that a bird stuffer from Camden, across from Philadelphia, had "many fine specimens, all of which he had procured by baiting fish-hooks with the common mussel, on a 'trot-line' sunk a few feet beneath the surface." Audubon never saw the Labrador duck alive. Despite its name, it was found as far south as Delaware. The two ducks in Audubon's plate were given to him by Daniel Webster, the great American orator and politician, who shot them on Martha's Vineyard off the coast of Massachusetts. Webster became an original subscriber for the *Birds* but, because of failure to complete payment, ended up with only three of the four volumes. These ended up in the library of his alma mater, Dartmouth College in New Hampshire. The actual ducks ended up in the National Museum, which later became the Smithsonian, in Washington. There are fewer than forty skins still extant in the United States and twenty in Europe. In 1898, Daniel Giraud Elliot wrote: "With fearful rapidity, the places that now know them, and echo with their pleasant voices, shall know them no more forever." The second-to-last Labrador duck was shot off Grand Manan Island in 1871. The last recorded specimen fell off Long Island on December 12, 1875.

Havell No. CCCXXXII

SNOW GOOSE
Chen caerulescens

In its original classification, no bird was ever given a more evocative Latin name: *hyperborea* means "from beyond the North Wind." No name could have been more appropriate. The nesting site of the greater snow goose was discovered only in 1891, in Greenland, 77 degrees 40 minutes north, on Admiral Peary's expedition. Today we know that they also nest in Canada's Arctic archipelago. Birds along the eastern flyway arrive in mid-September at Cap Tourmenté, just below the Île d'Orléans near Quebec City. In this part of the river are several low-lying islands, one of them appropriately named Île aux Oies, "Goose Island," which for a few autumnal weeks are covered with birds. Like crests of wavelets advancing up a beach, they appear in their thousands. Slipping the air, they settle like so many snowflakes, more than three hundred thousand breaking their journey to rest on the way to their wintering grounds off Virginia and the Carolinas. They stop here to feed on the eel grass *Zostera marina*, which inexplicably almost completely died off around the world in 1935. Of course, centuries of using the dried grass as insulation for houses and as stuffing for furniture placed man in direct competition with the birds for their food. In Audubon's day the geese arrived in countless millions, but the population plummeted as the thoughtless overhunting continued. By the 1970s their numbers had been reduced to fewer than 2100 birds. In one of the great success stories of the conservation movement, protection of the birds and the regeneration of the eel grass has brought the population back from the brink of extinction. Hunting is now again permitted. With urban and industrial development having limited traditional resting and feeding areas, culling the flock is deemed essential lest the birds eat themselves out of house and home. The blue goose and the snow goose were once considered separate species; we now understand that they are colour phases of the same species. It was therefore with significant insight that Audubon combined them on the same plate.

Havell No. CCCLXXXI

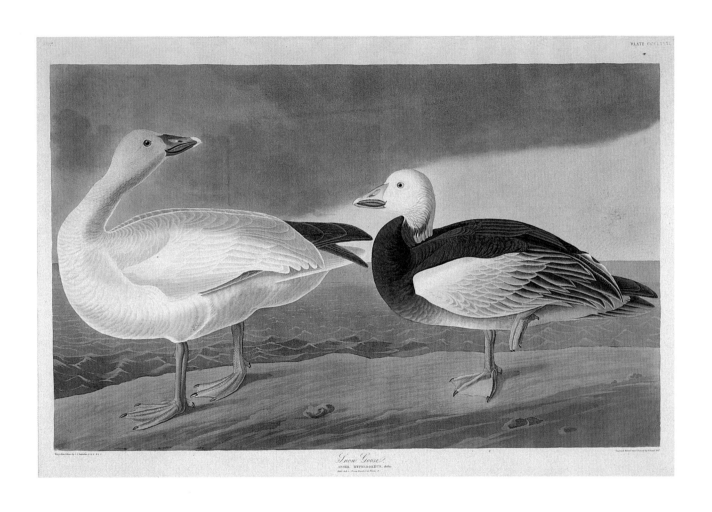

THE WILDERNESS DEPICTED

Audubon carried his growing portfolio of bird paintings to England in 1826 in the hope of finding subscribers for his projected *Birds of America*. The first major public viewing was at the Royal Institution in Edinburgh, Scotland. The effect was electrifying. From the reaction of Philatère Chasles, a French critic writing not only for *Le Monde* but also for all of cultivated Europe, it was clear that the settings were considered as impressive as the birds themselves. Indeed, one of Audubon's greatest contributions to the development of wildlife art was his placement of the birds in their proper environments. From cypress-fringed swamps to the stunted growth on the tundra, from elegant floral portraits to incredibly detailed studies of trees and insects, the backgrounds in Audubon's paintings were not only appropriate for the species of bird but in most cases could be isolated and viewed as works of art on their own. In some, specific rivers can be identified, as could rocky islands used by nesting colonies off Labrador. For some of the Arctic species, Audubon had no first-hand knowledge of the birds or their habitats, and so relied on verbal reports from others to create his landscapes. Towards the end of the project, time constraints forced him to depict several species in the same painting, with the various birds posed artificially on generic branches. Needless to say, had the critics seen those plates, their enthusiasm would have been tempered. The backgrounds of the plates in this section were either painted by Audubon himself or supplied under his supervision by his sons, John and Victor, or his assistants, George Lehman, Joseph Mason and Maria Martin. In some cases, the backgrounds were created by Audubon's engraver, Robert Havell Jr., and added to Audubon's original watercolours for the final plates.

BELTED KINGFISHER
Ceryle alcyon

Where there are fish, there are kingfishers. To anyone familiar with our streams and lakes, there is no mistaking the flight and call of this bird, our only representative of the ninety-plus species of the family *Alcedinidae*. With its massive bill and oversized head, this steel-grey loudspeaker sets the woods and waters reverberating with what Audubon described as "hard, rapid, rolling notes." The belt of rust-coloured feathers across the lower breast is found only in the female, which, unusually for the avian kingdom, makes the female more elaborately coloured than the male. The kingfishers are closely related to the exquisite bee-eaters, rollers, hoopoes, motmots and todies, all of which share unusual toes: the third and fourth are united throughout most of their length, and the third and second are joined at the base. This makes them useless for anything other than perching and, more important, for shovelling out the dirt hammered loose by the bill during the excavation of the nest tunnel, an astonishing ten or twelve feet (3 to 3.6 m) in length in some riverbanks. All too frequently, these banksides are along salmon and trout streams, where kingfishers have suffered a very bad press because of their supposed predilection for parr (infant salmon). Like most prejudices, this is overstated, as the main food consists of chub and suckers, which do far more damage to salmon eggs than the birds ever could to the young. The birds dive from perches or from a hover up to fifty feet (15.2 m) above the surface into shallow water (two feet [60 cm] deep, or less). With the prey held firmly in its bill, the kingfisher returns to a perch, where it pounds the fish until it submits to being swallowed, head first—an act that Audubon carefully recorded in his painting. The scientific name is strange: *ceryle* is Latin for kingfisher, *alcyon* is from the same in Greek; "the kingfisher of kingfisher" seems redundant. The Greek word *alkuom* is derived from *hals*, from the sea, and *kuo*, I conceive. In Ovid's *Metamorphoses*, Book IX, we learn that Alcyone threw herself into the sea after her husband, Ceyx, had been shipwrecked. The two were changed into kingfishers, birds that were said to nest in the sea during the winter solstice—at least in ancient Greece. At this season, through the influence of Aeolus, the wind-god and father of the fond wife, all gales were hushed and the sea was calmed. The birds' floating nest could then ride high and unimpaired over the waves during the tranquil "halcyon days." Medieval European myths held that the dried body of a kingfisher would avert thunderbolts. In 1678, Francis Willughby wrote: "It is a vulgar persuasion that this bird, being hung on an untwisted thread by the Bill in any room, will turn its Breast to that quarter of the heaven whence the wind blows. They that doubt of it may try it!" The trick, of course, was to catch one. Audubon caught three, painted them at different times, and pasted them together for the final composition.

Havell No. LXXVII

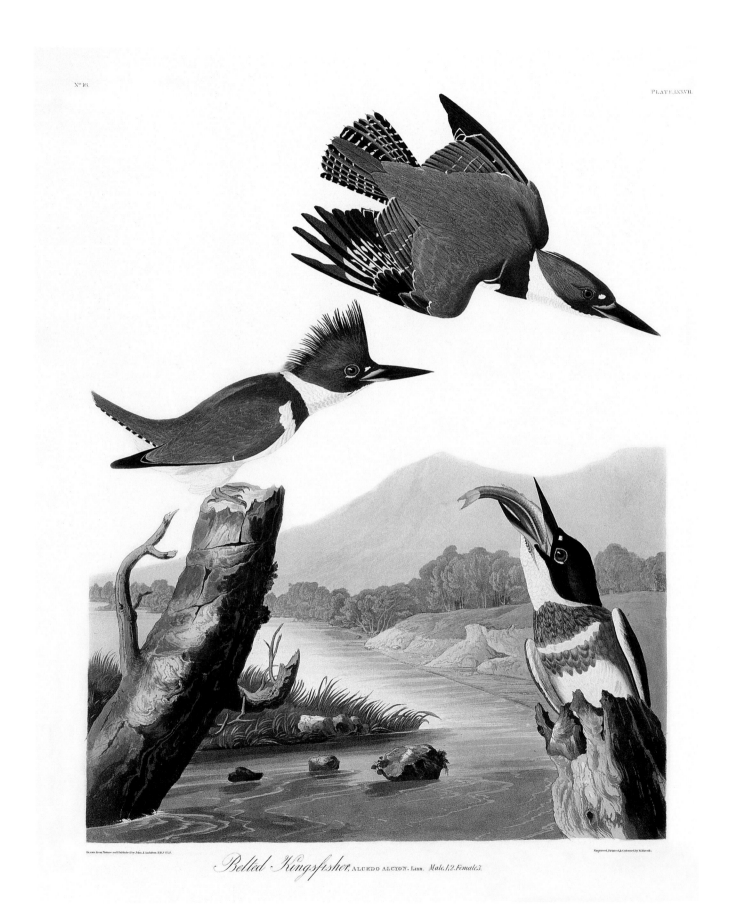

Belted Kingsfisher, ALCEDO ALCYON. Linn. Male.1,2.Female.3.

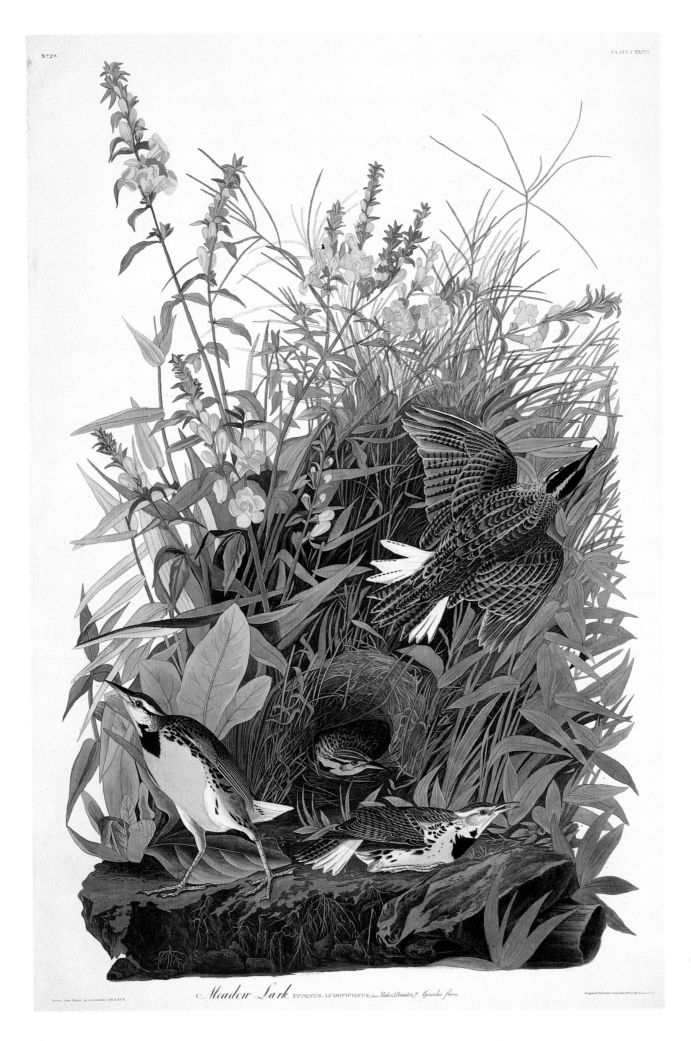

Meadow Lark. STURNUS LUDOVICIANUS. Male & Female. Gerardia flava.

EASTERN MEADOWLARK
Sturnella magna

In his text accompanying "The Meadow Lark," Audubon was rapturous: "The full beauties of an early spring are profusely spread around us; the glorious sun illumines the creation with a flood of golden light." As it was—and is—for so many farmers, the meadowlark was one of Audubon's favourite birds. In this painting from 1829, Audubon re-creates his field observation that the birds select a thick tuft of grass in which to build their domed nest. One of the first birds to return to the stubble fields in spring, the meadowlarks eat grain left over from the previous harvest, and consume great quantities of noxious insects. In 1833, Thomas Nuttall still inaccurately placed the bird among the starlings, whereas French-Canadian folk singers placed them between their thumb and forefinger, plucking in sequence each part of the "gentil Alouette." The detailed study of the downy false foxglove (*Aureolaria virginica*), one of the masterpieces of American botanical art, is perhaps the finest piece of work by Audubon's young assistant, George Lehman. It forms the ideal backdrop for the four birds. By having one of them flying, Audubon was able to show the diagnostic white outer tail feathers. The bird at the lower left is standing on its toes, a pose so typical of this species during courtship that even Mark Catesby chose it in the 1720s for his pioneering *Natural History of the Carolinas*. Feathers, of course, can be accurately copied from a museum specimen; painting what a bird does, rather than just its feather patterns, requires first-hand knowledge. In "The Meadow Lark," just as in Albrecht Dürer's 1503 "A Large Clump of Turf" (to which Lehman's effort has been compared), the boundary between art and science disappears.

Havell No. CXXXVI

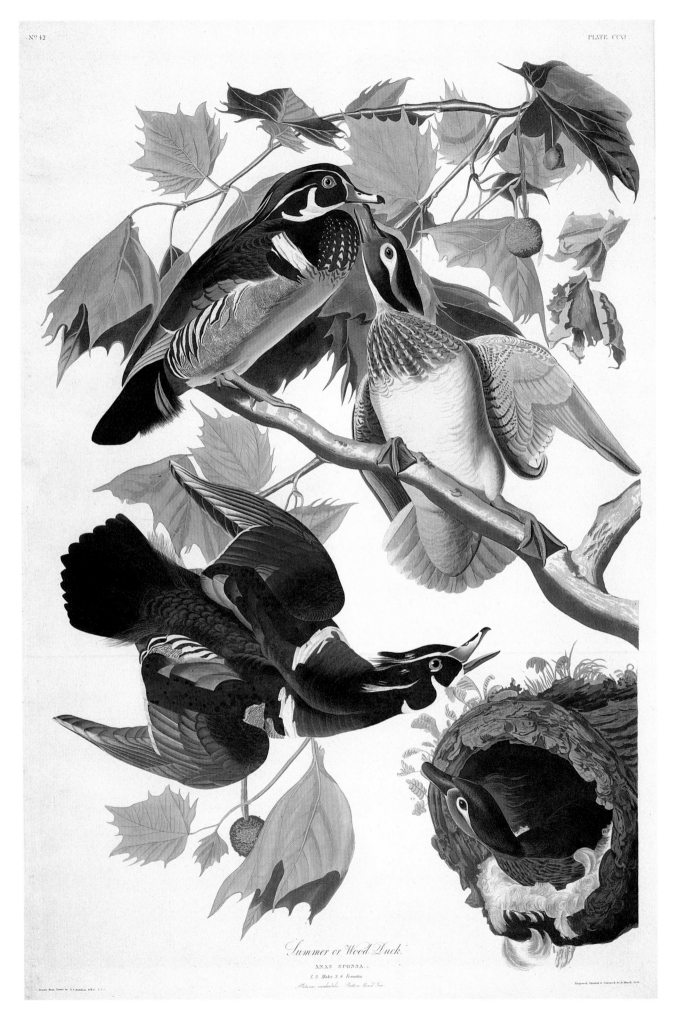

Summer or Wood Duck.

ANAS SPONSA.

1, 2. Males 3, 4. Females

WOOD DUCK
Aix sponsa

Rainbow duck, regal duck, bride duck—any of these popular names seems more evocative than summer duck (it does nest in summer, but so do all our nesting birds) or wood duck (it does nest in cavities in trees, but so do many other species). Today, we use wood duck as the name for perhaps the most beautiful duck in the world. The only serious rival is its very close relative from China, the mandarin duck. The spectacular plumage of the males of both species is almost impossible to describe, but the females are virtually indistinguishable in their drab brownness. Audubon wrote: "Few birds are more interesting to observe during the love season." Audubon and his wife, Lucy, kept pet wood ducks at their home in Henderson, Kentucky, and so he was well acquainted with their habits. He showed a newly formed couple gently touching bills, while another pair has already set up house high in a sycamore tree. The love aspect is important. *Sponsa* is Latin for a betrothed woman, and so it is not surprising that in Italian the wood duck is call *Sponsina*. In the Mayan of ancient Mexico, it was called *Iztactzonyayauhai*, although the intervening centuries have obscured the translation. The bride and groom analogy actually comes from the mandarin duck, pairs of which were traditionally given in China as wedding presents, being considered symbols of fidelity and chastity. Perhaps these two characteristics were thought to ensure fecundity: both the mandarin and the wood duck have clutches of a dozen or more eggs. The babies, who can walk as soon as they are born, soon step from their nest into space, only to parachute to the ground, cushioned by their thick down even from extreme heights. Even in Audubon's time, wood ducks were considered relatively rare, as drainage and cutting of hollow trees severely impacted their habitat. As late as 1920, they were extremely uncommon in eastern Canada and totally absent from Saskatchewan and Alberta through to western British Columbia. With the reflooding of wetlands, and the installation of thousands of man-made nesting boxes, the wood ducks have rebounded. Nevertheless, it is always a surprise that something so beautiful can be so common.

Havell No. CCVI

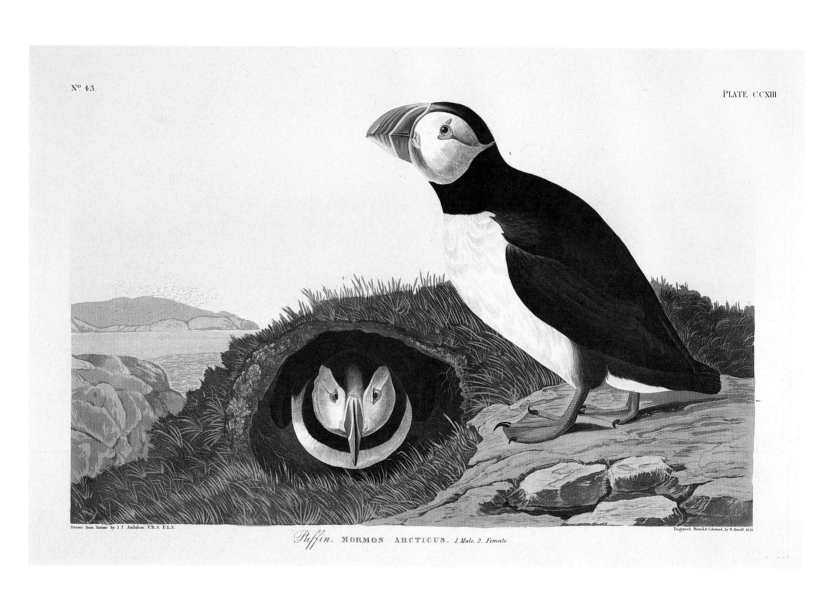

ATLANTIC PUFFIN
Fratercula arctica

On August 10, 1833, Audubon wrote in his *Labrador Journal*: "The air was filled with these birds, and the water around absolutely covered with them." With uncomfortable conceit, he added: "I shot twenty-seven times and killed twenty-seven birds... The air was so thick [with them] that no one could miss if he tried." In the text accompanying the plate, his claims became even more boastful. "I had two double-barrelled guns... I shot for one hour... How many Puffins I killed in that time I take the liberty of leaving you to guess." It is hard to reconcile this guiltless slaughter with the moral outrage he expressed in his *Episode* on the Eggers. In it, he rightly warned of the inevitable disappearance of entire colonies—even species—of seabirds. He was equally disgusted with the drunken habits of the thoughtless plunderers who trampled eggs and nests full of chicks under their hobnailed boots. In reality, there were so many puffins that even Audubon could not conceive of their disappearance, though he described fishermen "skinning the birds like rabbits" and using their flesh to bait their cod-hooks. To a large degree he was right: today, the puffin is considered the most numerous bird in the North Atlantic, with as many as 10 to 16 million nesting in Iceland alone. Locally, the range has shrunk, often due to the introduction of brown rats, which feast on the defenceless eggs and chicks. The successful reintroduction of nesting pairs to islands in the Bay of Fundy has brought the birds back to Maine, New Brunswick and Nova Scotia. In the background of Audubon's plate is a small rocky island, completely covered with birds. Finding cavities between the rocks, the puffins honeycomb their islands with nesting burrows, one of which Audubon showed sheltering an emerging female.

Havell No. CCXIII

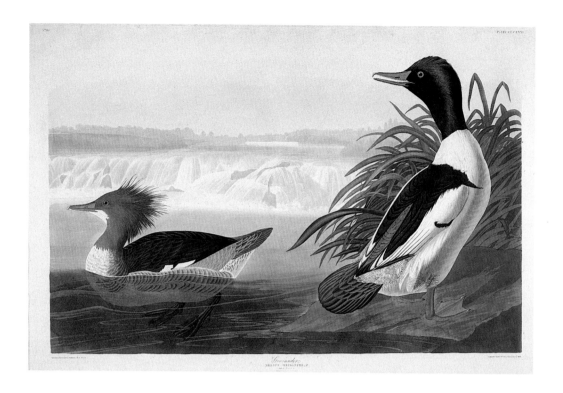

COMMON MERGANSER
Mergus merganser

Audubon kept some captive mergansers, to which he fed "two dozen fish 4 inches in length four times a day, and yet they always seemed desirous of more." Mathematically, it could be argued that one merganser could consume 35,000 fish a year. This kind of news is dear to the hearts of many fly-fishermen, who for generations have justified their misguided war against the merganser on the questionable grounds that the birds eat vast quantities of parr in salmon and trout streams. Nervousness among fishermen increased in late fall, when rafts of hundreds of mergansers could be seen cruising prime water. Mergansers do consume millions of fish, including juvenile salmon and trout, but their diet consists mostly of coarse fish, many of which are themselves predators. The net impact on game fish is, therefore, neutral. The bill of the merganser is well suited to catching small fish. The serrated teeth give rise to the common name in English, "sawbill" (in French, *becscie*). From the early seventeenth century, the female was called the dun-diver, and was considered a separate species, although with a certain lack of conviction. As late as 1804, however, Thomas Bewick in his *History of British Birds* felt obliged to list five reasons why the dun-diver was *not* the same as a merganser. The first reason he gave was that the dun-diver was far more numerous—not a surprising conclusion, considering that after the summer moult in August and September the males assume female plumage complete with a small crest. Bewick also asserted, rather more surprisingly, that all the dun-divers were males, which, of course, was totally inaccurate. *Mergus* and *anser* combine to give us "a diving goose." It does dive, but also flies swiftly after finally getting off the water by running downstream with the current to get airborne. Once aloft they would have no problem in flying over the Falls of Cohoes on the Hudson River just north of Troy, New York, where Audubon painted this portrait.

Havell No. CCI

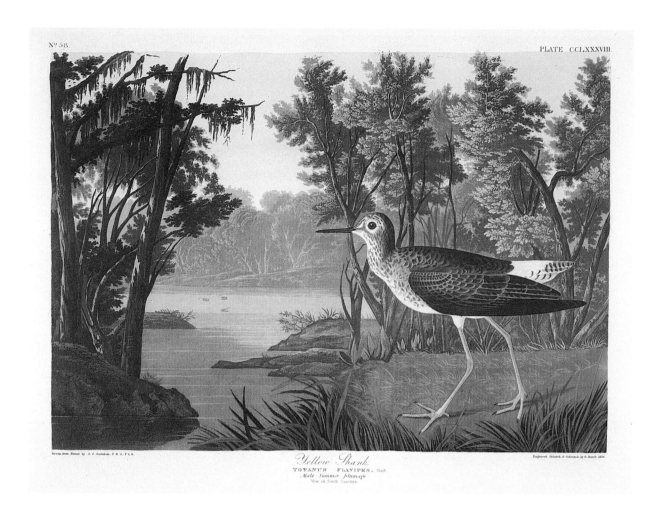

No 58.

PLATE CCLXXXVIII

Yellow Shank.
TOTANUS FLAVIPES. Vieill.
Male Summer Plumage
View in South Carolina.

LESSER YELLOWLEGS
Tonatus flavipes

"I have represented one of these birds on the fore ground of a little piece of water a few miles distant from Charleston in South Carolina." This plate, painted in 1832, is one of the loveliest examples of those with full environmental settings, but the swamp was almost certainly not painted by Audubon. The background, and perhaps even the bird itself, was the work of George Lehman, a landscape painter of Swiss-German descent from Lancaster, Pennsylvania, whom Audubon hired as his assistant in 1829 to paint habitats specifically for birds that had been collected in New Jersey. Again in autumn 1831, and into winter and spring 1832, Lehman rejoined Audubon to paint the environmental settings for birds from further south. Ultimately he would supply the backgrounds for at least twenty of the finished paintings. But like an Italian Renaissance master who employed apprentices, Audubon retained complete control over the design and layout. By placing the bird in the foreground, Audubon and Lehman were able to emphasize how the bird got its name. Audubon encountered the species in Labrador but failed to find their nests. He reported that, "according to my friend Thomas MacCulloch [the birds] breed in considerable numbers about Pictou." The map of Canada was still so vague that Audubon could write that the yellowlegs "breeds in the Fur Countries, up to the highest northern latitudes."

Havell No. CCLXXXVIII

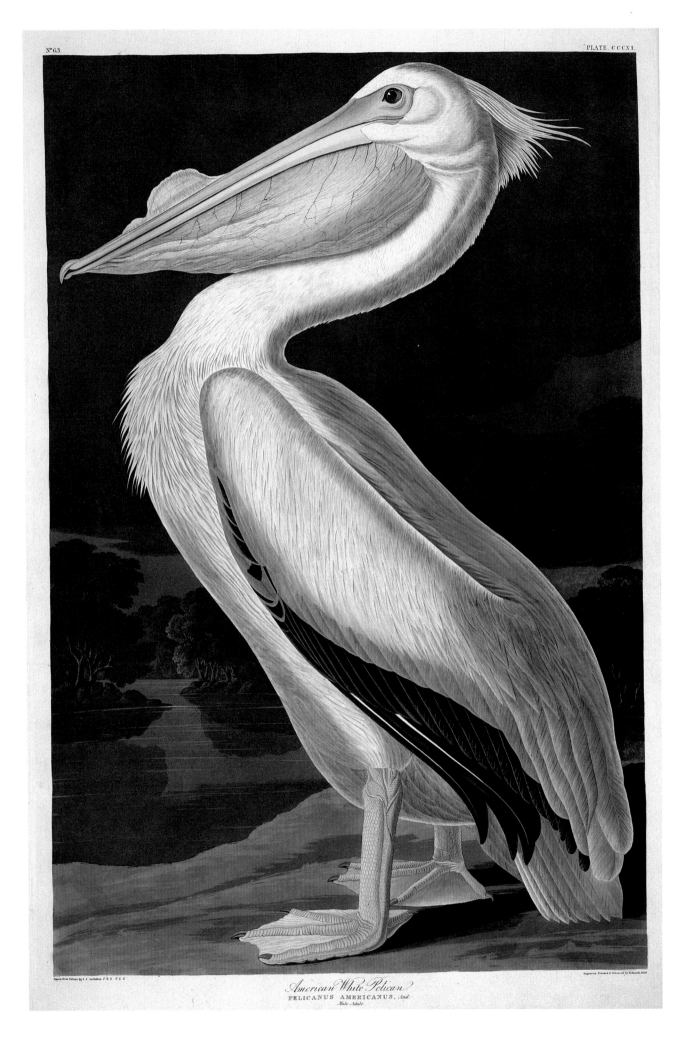

American White Pelican
PELICANUS AMERICANUS, Aud.
Male Adult

AMERICAN WHITE PELICAN
Pelecanus erythrorhynchos

In this great portrait from 1831, Audubon has shown an adult white pelican in profile against a dark sky, one of the very few times the artist used this convention. The veined pouch and the inward-turned webbed toes are excellent examples of the attention Audubon paid to accurate scientific detail. The fibrous knob on the bill and the silky crest feathers show the bird in its breeding season. He called the bird *Pelecanus americanus*. Audubon wrote that "I have honoured it with the name of my beloved country," because "This beautiful species—for, reader, it is truly beautiful . . .," deserved such an accolade. He continued, "The brightness of its eyes seemed to me to rival the purest diamond." Since Audubon's day, others have concurred. Arthur Bent in his *Life Histories of American Birds* wrote: "The White Pelican is really a glorious bird . . . [with the] spotless purity of its snow-white plumage offset by its glossy black wing feathers and enriched by its deep orange bill and feet." Paul Taverner in his *Birds of Canada* (1937) called them "one of the spectacular features of prairie wildlife." Indeed, with their nine-foot (2.7 m) wingspan, and the almost military precision with which they flap their huge wings in unison, evenly spaced pelicans flying in long undulating lines or V formations are one of the most magnificent sights in the Canadian wilderness. This total mastery of the air is of great antiquity. Fossils identical to the skeletons of modern birds dating from the Tertiary, 30 to 60 million years ago, prove (as Frank Chapman said so succinctly in 1908) that "Pelicans were pelicans long before man was man." When Audubon was alive, the numbers were incredible; he often killed several at one shot. Even well into the twentieth century, nesting colonies of more than three thousand birds could still be seen on the great Prairie lakes from southern Manitoba, across most of Saskatchewan and into northern Alberta. Strangely, nests are often more than a hundred miles away from the feeding grounds. Almost twice as large as the brown pelican, the white pelican never dives for its food, relying instead on communal fishing as a phalanx drives small surface fish into ever-decreasing areas, where the giant pouches extend for the capture. "When a school of fish is spotted from the air," wrote one of Audubon's contemporaries, "the Pelicans descend like meteors, leaving a trail of thunder like a warning of an approaching storm." This picturesque language pales in comparison with Audubon's own graphic description, when he likened the call of this normally silent bird to the sound "produced by blowing through a bunghole in a cask."

Havell No. CCCXI

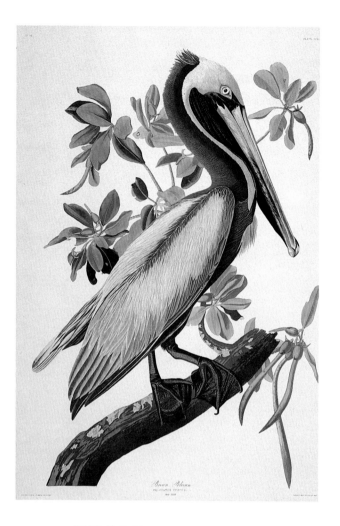

BROWN PELICAN
Pelecanus occidentalis

Casual sightings in Nova Scotia, Cape Breton and southern British Columbia help justify the inclusion of one of Audubon's most famous portraits, of what is essentially a southern bird, among the birds of Canada. Low to the water, individuals fly in long lines, their huge wings flapping sedately in perfect unison, as if taking their cue from the leader. All elegance in the air disappears when they plunge into the water to feed. At the last second, they fold their wings to three-quarters, thereby increasing entry speed by shifting the centre of gravity forward of the wing-carrying capacity. The huge pouch expands to entrap the surface fish, but also stops the plunge with a wrenching jolt that snaps the neck sideways. An extensive network of subcutaneous air sacs acts as a shock absorber, and also adds buoyancy. The beak is lowered to drain excess water, then raised to guide the trapped fish into the throat—their own Alcatraz, the Spanish name for the brown pelican. Audubon showed the brown pelican perched in a mangrove painted by George Lehman, his young assistant. Once they were incredibly numerous along the Gulf Coast, but in the twentieth century the population was severely reduced, largely from the effects of pesticide poisoning. Even in Louisiana, where it is the official state emblem, they were exterminated, and fresh birds had to be imported from Florida. The expandable membrane under the beak, Audubon wrote, "is dried out and used for keeping snuff, gunpowder and shot." Audubon would know from personal experience, because taking snuff and hunting were his two major addictions.

Havell No. CCLI

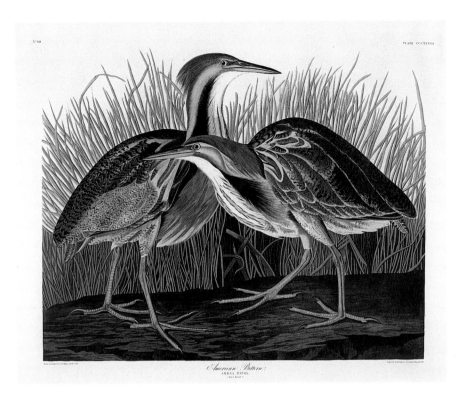

AMERICAN BITTERN
Botaurus lentiginosus

According to Audubon's text, this wonderful painting was the work of his youngest son, John Woodhouse Audubon, in 1832. Capturing the intricacy and subtlety of the original watercolour in the final copper engraving was a remarkable feat for Havell and his technicians. For such a large bird, the American bittern is remarkably difficult to spot. The cryptic colouring allows it to blend perfectly into its environment; and the bird can freeze in a reed-like pose, with its long bill pointing skyward and its long legs mimicking the stems of the cattails and bulrushes. Carrying the disguise further, the bittern will gently sway in the wind in unison with its surroundings. It can even rotate so that its best camouflage is always exposed to the intruder. When the bill is upturned, the strange placement of the eyes becomes apparent: they are located so far out on and under the skull that they can look straight ahead or down. The pose chosen by Audubon shows two herons in their typical hunting stance, bills held parallel to the ground before a lightning stab. It also allowed Audubon to show the triangular black patch of throat feathers, a unique pattern among night herons. Villagers called it the "night raven," whose vocalizations always foretold a death. If no peasant obliged, then the death of a cow or pig was accepted as proof conclusive of the bittern's morbid prophetic powers. The voice has been described as sounding like a large mallet driving a wooden stake into a bog of soft mud, the percussion followed by a squishy after-sound. The bittern breeds as far north as Great Slave Lake, at about 61 degrees north, right across Canada from northern British Columbia to Churchill, Manitoba, and to Quebec and New Brunswick. Ironically, the first specimen described was a vagrant that was found in England. Perhaps the fact that bitterns were the favourite food of Henry VIII explains their rarity. Audubon reported that the poorer classes in the South had royal tastes, because they made gumbo soup from the bittern.

Havell No. CCCXXXVII

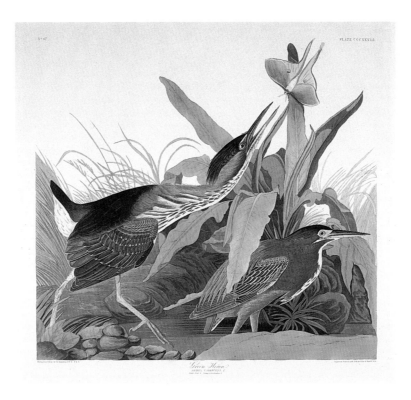

GREEN HERON
Butorides virescens

The green-backed heron is particularly interesting to ornithologists, for it is the North American representative of a world-wide group that includes at least thirty subspecies, classic examples of adaptive coloration. From the pale green and multicoloured North American race to the virtually all-black lava heron of the Galapagos Islands, the green-backed is an avian master of regional camouflage. Not surprisingly in an era of less scientific knowledge, many of the more marked varieties from the Sahara, Tahiti, New Guinea, Madagascar, Japan and Sri Lanka were formerly considered separate species. Our green-backed heron breeds from Nova Scotia to Southern Ontario, wherever small fish and insects can be found, along both fresh and salt water shores. Audubon reported that he watched a pair on the grounds of the Hon. Joel Robert Poinsett, the urbane South Carolinian politician who would someday be the secretary of war under President Martin van Buren. Perhaps more important, Poinsett was the first ambassador of the United States to Mexico, and in 1826 brought back the Christmas plant that bears his name, the poinsettia. In *The Birds of America*, twenty-five plates include paintings of about thirty-five various species of insects, virtually all of which can be identified. None is more charming than the luna moth about to be snapped up by the green-backed heron. Sherman Denton, in his *Moths and Butterflies of the United States East of the Rocky Mountains* (1900), wrote that the "surpassingly beautiful *Actias luna*, with its translucent pea-green wings bordered with purple, is justly esteemed by collectors as one of the most lovely creatures the insect world affords." Denton transferred the wing scales of butterflies and moths directly into his book, which, luckily for certain species, was limited to five hundred copies. He did the fifty thousand insect transfers himself, because, as he noted peevishly in the introduction, "of not being able to find anyone to help."

Havell No. CCCXXXIII

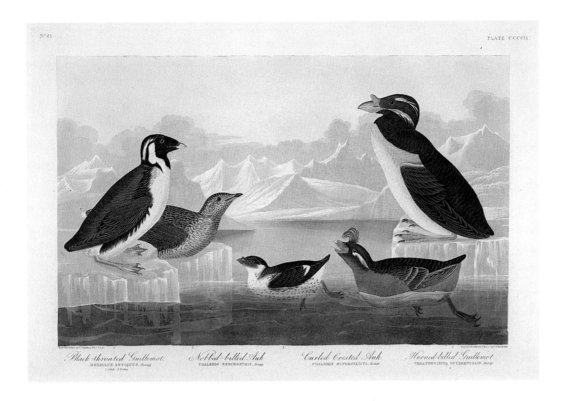

FIVE ALCIDS

a) Crested Auklet, *Aethia cristatella*; b) Ancient Murrelet, *Synthliboramphus antiquum;* c) Least Auklet, *Aethia pusilla*; d) Rhinoceros Auklet, *Cerorhinca monocerata;* e) Marbled Murrelet, *Brachyramphus marmoratus*

Behind the obvious aesthetics of a given plate there is frequently an interesting story. Such is the case of this painting, "Four Alcids," which today we know represents five alcids, all birds of the Pacific Northwest. Audubon had no first-hand experience with any of these birds. They were drawn from specimens he obtained in London in 1837, and he therefore could contribute nothing original to their natural history. He believed that he had represented both an adult and an immature black-throated guillemot, not knowing that the brown bird was actually an immature marbled murrelet. This small seabird hid its secret life from naturalists for 185 years. In 1970, the editors of *Audubon Field Notes* offered $100 for proof of a nest. Four years later, a nest was discovered 150 feet (45.7 m) up a Douglas fir, miles from the ocean in the Santa Cruz Mountains of California. Because of the Cold War, American scientists had discounted a report from 1961 that Russian ornithologists had discovered a nest high in a Siberian larch. That a seabird would nest in the forest far inland came as a total surprise. The plate itself contains another surprise. The original watercolour had the birds on a blank sheet, with a different placement. In their *Fine Bird Books 1700–1900*, the art experts Sitwell, Buchanan and Fisher asked: "Did another hand paint the ice floes for him? No lover of Audubon will be willing to believe this." Unfortunately for the experts, in addition to the final placement of the birds, the background was the work of Audubon's engraver, Robert Havell, who created from his imagination a scene supposed to represent the Northwest Coast of America, a place that neither he nor Audubon ever visited.

Havell No. CCCCII

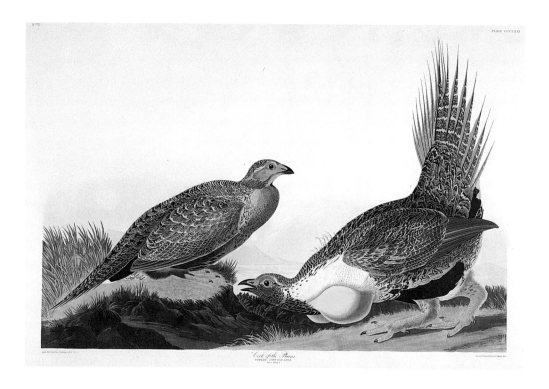

SAGE GROUSE
Centrocercus urophasianus

The sage grouse just qualifies as a Canadian bird, with its range extending north from the American border to the sagebrush and plains of Alberta and Saskatchewan. The Nez-Percé Indians called it "mak-esh-too-yoo," and it was "pi-imsh" to the Wallah Wallah tribe. To Audubon, our largest native grouse was the "Cock-of-the-Plains." At twenty-eight inches (71 cm) in length, the sage grouse is exceeded in size among its tribe only by the capercaillie of the wooded mountains of Scotland, Switzerland and Scandinavia. Having not yet visited the Far West when he painted this portrait, Audubon never saw the bird alive. He received skins from Thomas Nuttall and Kirk Townsend's western expedition, and could only quote them at length in describing the bird and its habitat. The mottled browns of their feathers provide such concealing coloration that the birds, despite their size, are incredibly difficult to spot when they are hunkered down among the grasses on the open prairie. During courtship, however, caution is thrown to the wind. Males congregate at a so-called "lek," a bare knoll where they perform their courtship dance for the benefit of apparently bored but truly interested females. Two enormous bright yellow sacs on either side of the neck are inflated and deflated in rapid succession, giving rise to the fanciful nickname, the "fried-egg bird." It is this dance that Audubon has so graphically painted. In reality, the males usually inflate while standing vertical. Extremely quick steps while standing in the same spot create a drumming sound that is heard for considerable distances across the grasslands, announcing the performance. Daniel Giraud Elliot knew the birds intimately. In his *Gallinaceous Game Birds of North America* (1897), he wrote: "It is a splendid bird, which any country may be proud to claim as native to its boundaries, and may it long be preserved to enliven the desolate regions among which it lives!" Audubon would have echoed these sentiments.

Havell No. CCCLXXI

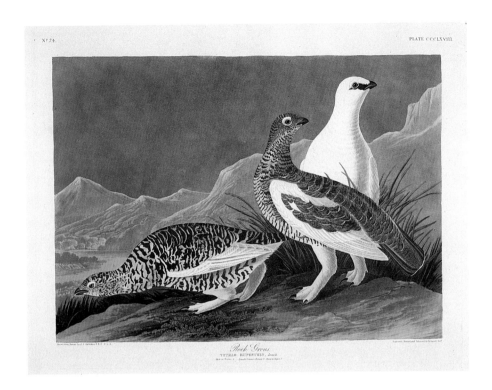

ROCK PTARMIGAN
Lagopus mutus

"Done from Nature by John James Audubon." That is the claim written at the lower left of "The Rock Grouse." Not quite true. The birds themselves eluded Audubon, and so he used as models three specimens that had been sent to him in London in 1836 by Captain James Clarke Ross of the British Navy. To spread the credit even further, the background was painted in oil by Audubon's son Victor. As Audubon personally knew nothing about the birds, he resorted to lengthy quotes from Richardson's *Fauna boreali americana,* which had recently appeared in print. Audubon properly placed his birds in a high mountain setting, above the tree line. Birds found in this habitat are almost certainly rock ptarmigans as opposed to the very similar willow ptarmigan, which Audubon saw in the low-lying tundra of Labrador. The birds seem to be in a perpetual state of moult, and therefore their summer plumage is virtually impossible to describe. In all seasons they retain their white wings. In winter, the birds change—hence their Latin name, *mutus*—to a pure white plumage, except for their red eyebrows and the black line from the beak to the eye. Audubon depicted the bird in the back of the composition in its winter dress. In Canada and Scandinavia in Audubon's time, vast numbers were killed annually, especially in the winter, when they could be shipped frozen over long distances to market towns where they would be salted for summer use. There were reports of three hundred or more being taken in a single day, three or four birds killed at a single shot. Being very tame, the remaining birds would fly reluctantly only a few yards before settling again. Butchery was easy. In winter, feathers grow all over the feet, providing the birds with portable snowshoes similar to those used by rabbits. This annual growth is reflected in the Latin name *Lagopus*, which means "hare-footed."

Havell No. CCCLXVIII

"I picture to myself the dense and lofty summits of the forests, that everywhere spread along the hulls and overhung the margins of the streams, unmolested by the axe of the settler."

JOHN JAMES AUDUBON, *EPISODE*, "LOUISVILLE"

THE WILDERNESS FOREST

In the 1800s European immigrants came to a land that was virtually covered in trees. Up and down the East Coast were giant hardwoods that rivalled the towering softwoods of California, the Pacific Northwest and British Columbia. This was the forest about which John L. Rowan, half a century after Audubon's birds were painted, wrote in his 1876 *The Emigrant and Sportsman in Canada*. Another English traveller wrote: "The Americans seem to hate trees and cannot wait to cut them down." At worst, the forest was seen as the enemy of progress; at best, it was seen as an inexhaustible source of raw materials. In Audubon's day, there were an estimated 26 million inhabitants along the Eastern Seaboard—and lumber was the principal material used for houses, sidewalks, charcoal, paving, household goods, heating and light, and as fuel for steamboats and railroads. One railroad in Massachusetts in 1865 burned 53,710 cords of wood. There were thousands of covered bridges, each with its own massive beams, and all clad in wood. In the early 1800s, an estimated twenty thousand wooden flatboats and rafts floated the one-way trip from Pittsburgh to New Orleans. It took a complete acre of first-growth forest to provide the wood to fence in ten acres of land. In 1875 there were an estimated 127 million board feet of lumber in the plank roads of New York alone, and by 1883, long after barbed wire had become common, there were still 20 million *miles* of wood used in fences. Audubon sensed that despite the murderous toll taken by hunters, the greatest destroyer of life was man's interference with the environment. Although specifically referring to the passenger pigeon, he could have been describing the relationship of all wildlife with its surroundings when he wrote: "I have satisfied myself by long observation, that even in the face of such dreadful havoc, nothing but the diminution of our forests can accomplish their decrease."

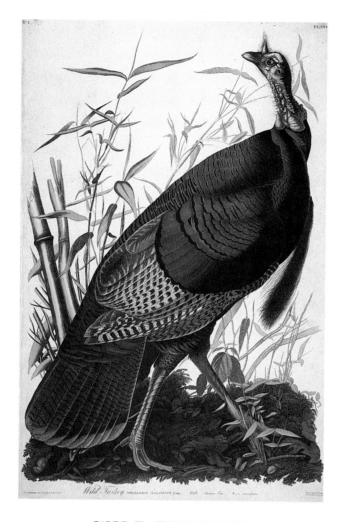

WILD TURKEY
Cock (above), Hen (facing)
Meleagris gallopavo

If Benjamin Franklin and just under half of Congress had had their way, the wild turkey, rather than the bald eagle, would be the national bird of the United States. "In English they are called Turkeys because they are thought to have been first brought to us out of Turkey." So stated Francis Willughby in his *Ornithology* of 1678. In the fifteenth and sixteenth centuries, Turkey was the general name for all Muslim countries, including those in Africa. Willughby traced neither the etymological nor geographical roots properly. Seven species of ancestral turkeys have been identified, but only from American fossil deposits dating back 40 million years to the Oligocene. The turkey is, therefore, unquestionably of American origin. The Spanish conquistadors met the turkey in the late fifteenth century in Mexico, where it had been domesticated by the Aztecs and the Mayans. Back in Spain, the huge birds were seen by Hebrew merchants who mistakenly applied the Old Testament word "tukki," which meant "peacock." Meanwhile, farther north, John Cabot's lieutenant William Strickland brought back birds from the forested regions of the St. Lawrence to England in 1497 or 1498. Soon, with the impending marriage of Catherine of Aragon to Henry VIII, resident Spaniards identified the birds as the *tukkis* they had seen from the New World or, as it was then called, the Indies.

The first published notice of the bird was in 1525 in Oviedo's *History of the*

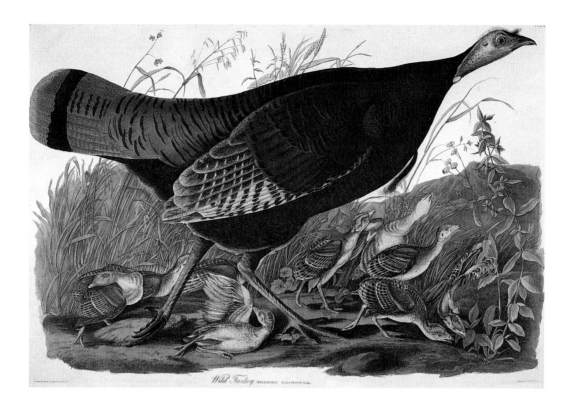

Wild Turkey MELEAGRIS GALLOPAVO, Linn.

Indies; the French promptly and properly named it "the bird of the Indies," *l'oiseau d'Inde*, today's *dinde*. By 1566, turkeys were still so rare in France that a gift of twelve was thought to be a present fit for a king, in this case Charles IX, who in 1570 served some up at his wedding feast. In England, the introduction was more rapid and more democratic. By 1555, birds fetched four shillings each, and by 1573 they were considered fare for farmers and a pest to farms: "ill neighbours to peasons and to hops." In New England, turkeys were so plentiful up to the time of Washington that they sold for a cent or two per pound. In the 1820s, Audubon wrote of wild flocks of a hundred. It was not insignificant that he chose the turkey for the first plate of his monumental *Birds of America*. A century earlier, in 1731, Eleazar Albin included a turkey plate in the first bird book ever published with hand-coloured copper engravings. Audubon confirmed birds of up to thirty pounds (13.6 kg); Charles Lucien Bonaparte claimed birds up to forty pounds (18 kg); and by 1890, in his *Illustrated Book of Poultry*, Lewis Wright wrote breathlessly, "the wild bird is far larger than any known in England...They have been shot weighing nearly 60 pounds, and carrying the head four feet above the ground." Wild birds were extirpated long ago in Southern Canada, but migrations from a 1949 Pennsylvania stock transplant into Ontario, plus migrations from healthy populations in New England, have brought the largest of our forest birds back in remarkable numbers. Although the turkey has been domesticated for centuries, selective breeding is relatively new. Today the overwhelming majority are white birds, with emphasis on fat legs and freakish amounts of breast, whose feathers are more easily plucked than those of the wild bronze variety. By comparison, the wild birds appear skinny and elongated, making the sixty-pounder somewhat suspect. Incidentally, in Turkey the turkey is called "the American bird." Ben Franklin and John James Audubon would have approved.

Havell Nos. I and VI

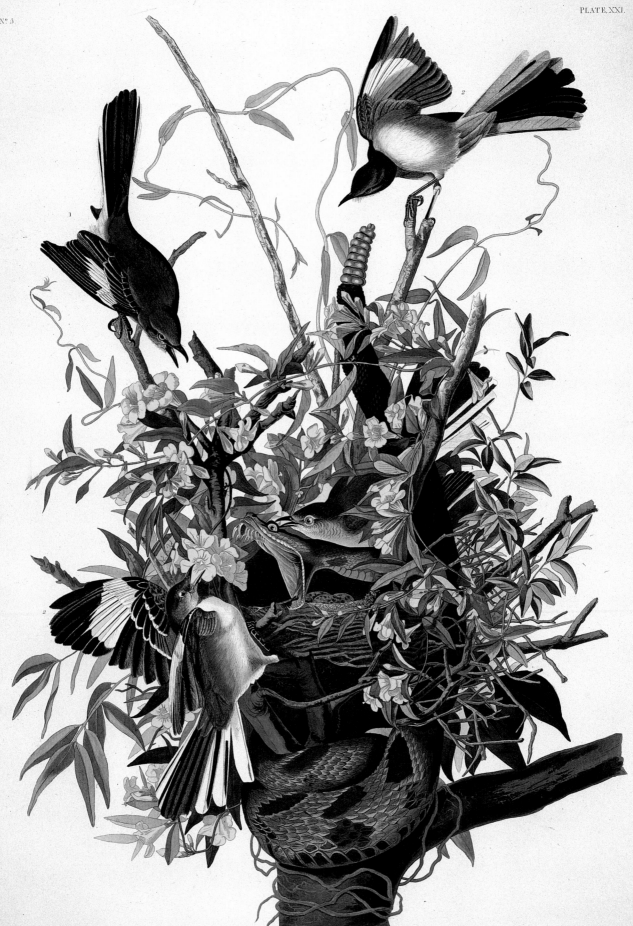

 PLATE. XXI.

Mocking Bird. TURDUS POLYGLOTTUS. Linn. *Males,* 1. *Females,* 2. *Florida Jessamine Gelseminum nitidum.*

Drawn from Nature and Published by John J. Audubon, F.R.S.E.L.S.

Engraved, Printed and Coloured by R. Havell.

NORTHERN MOCKINGBIRD
Mimus polyglotus

The Indians in the Carolinas of the seventeenth century called it *cencontlatolly*, or "four hundred tongues." Audubon wrote: "There is probably no bird in the world that possesses all the musical qualifications of this king of song." Individual mockers have been known to master as many as thirty different imitations of species ranging from hummingbirds to eagles, frogs to crickets, and even squeaking wheelbarrows. Sonographs confirm that the copy is perfect even in frequencies above the range of human hearing. Despite the northward spread across southern Canada, this bird was so associated with the South that five states—Arkansas, Florida, Mississippi, Texas and Tennessee—have chosen the mockingbird as their official avian symbol. Today its range has spread into Maine and southern Quebec. Audubon's plate is a masterpiece. The eastern diamondback rattlesnake depicted by the egg-filled nest is a terrifying creature. The eight rattles and the original "button" on the tip of the tail indicate a five- or six-year-old snake that, if the proportions compared with the birds are accurate, would easily challenge the ninety-six-inch (244 cm) length of the largest rattler ever recorded. Here the snake adds more dramatic than artistic interest. Four birds, several in what appear to be contorted poses, fight to defend the nest, set high in a tree surrounded by garlands of yellow-orange Florida jessamine flowers. The vast gaping mouth, the deadly battery of decurved fangs, and the violent attack signalled by the prominent upturned rattle all contribute to a sense of drama as the four birds fight, perhaps to the death, to defend their progeny against a relentless foe. European critics, egged on by Audubon's detractors back in the United States, tried to discredit the artist because of this painting. The fangs of a rattler were not decurved, they said, nor could such a huge serpent climb a tree. Audubon was right in both cases. In this particular case, the "tree" was a bush, so that the nest was at most only a few feet above the ground. As for the fangs, Audubon in his diary entry of October 25, 1821, at Oakley Plantation in West Feliciana, Louisiana, wrote: "Finished drawing a very fine Specimen of a Rattle Snake that measured 5 feet 7/12 inches [1.7 m], weighed 6 1/4 lbs. [2.8 kg], and had ten rattles." He studied the snake in minute detail. On February 24, 1827, he was asked to give a paper at the Wernerian Society in London in connection with his mockingbird plate. He was universally acclaimed, and elected on the spot to the prestigious society. His enemies, however, lay coiled. Charles Waterton ridiculed him with a rage that perhaps could be explained by his financial interest in a new edition of Alexander Wilson's *American Ornithology*. Ironically, Waterton's own credibility would ultimately be destroyed because of two tall snake tales from South America.

Havell No. XXI

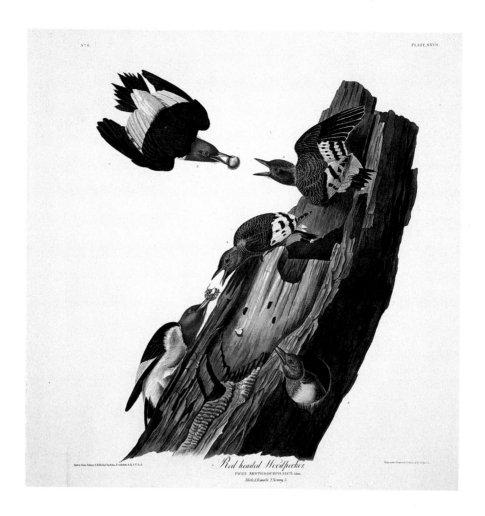

RED-HEADED WOODPECKER
Melanerpes erythrocephalus

The red-headed woodpecker was one of Audubon's favourites. How else could he have written, "With the exception of the mocking-bird, I know of no species so gay and frolicsome. Indeed, their whole life is one of pleasure." And yet Audubon's mistaken description of their eating habits, in words and in art, caused untold damage to the species. "They not only feed on all kinds [of fruit] as they ripen, but destroy an immense quantity besides. No sooner are the cherries seen to ripen, than these birds attack them…Trees of this kind are stripped clean by them…" In the plate, the upper bird flying in from the left has a cherry in its beak. Their bad name as a fruit thief is strangely at odds with an actual examination of the contents of 101 woodpecker stomachs, only two of which were found to contain traces of cherries. On the other hand, red-headed woodpeckers can eat up to six hundred insects an hour. Appropriately, the adult climbing the decayed trunk is offering a caterpillar. Audubon remarked on another curious aspect of this species: the perfectly round hole is as smooth as any filed-down man-made opening. The holes can become a problem in telephone or electrical poles. The situation in the 1920s got so bad that the *Kansas City Star* reported in an editorial: "The little red-headed woodpecker has become such a nuisance on the electric lines of the metropolitan street railway system, that it has become necessary to appoint an official woodpecker exterminator."

Havell No. XXVII

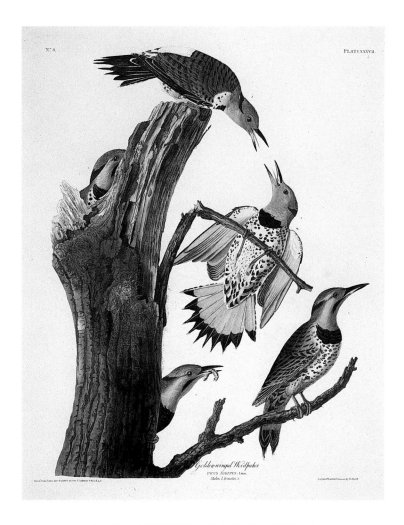

NORTHERN FLICKER
Colaptes auratus

"What adds to the elegance of this Bird is that the beams of all the wing feathers are of a bright gold colour." Thus did Mark Catesby in 1731 first describe the "Gold-wing'd Wood-Pecker." With its rhythmically bounding flight, the flicker is as welcome to us as it was to Thoreau, who wrote in 1853: "Ah, there is the note of the first flicker... But how that single sound peoples and enriches all the woods and fields... It seems to put life into the withered grass and leaves." Few of our birds are more beautiful, except maybe the red-shafted flicker that was included in former bird lists. Here the shafts of gold are replaced by crimson, the yellow under-coat by pale red. Where the colour morphs overlap, the shafts and tones are orange. Unfortunately for life-listers, all three former species are now considered one. Thousands were once shot, but now that hunting is prohibited, starlings have replaced man as the flicker's main enemy, competing for food and nesting sites. Fortunately, the flicker is a prolific egg-layer. In 1893, one Staten Island nest contained nineteen healthy young, and another bird laid seventy-one eggs in seventy-three days. Flickers spend much of their time on the ground eating ants, whose formic acid is effectively counteracted by the strongly alkaline sticky substance on the woodpecker's tongue. But perhaps not effectively enough. Audubon wrote: "I look upon the flesh as very disagreeable, it having a strong flavour of ants." How many ants did Audubon have to eat before he could make that statement?

Havell No. XXXVII

CEDAR WAXWING
Bombycilla cedrorum

Known as the cedar bird in Colonial times, they were inexplicably called "chatterers" by Europeans, a singularly inappropriate name for perhaps our most silent bird, having only a feeble lisping sound uttered when they rise or alight. In summer they become insectivores, sallying forth to snap up flying bugs before returning to their original perch. They relish tent caterpillars and canker worms; a flock of thirty can eat an estimated ninety thousand worms a month. Audubon chose to portray them amid the lacy branches of the tree from which they derive their English name. The powdery blue berries of the cedar are perhaps their favourite food, but, especially in winter, the flocks descend on mountain ash and strip the trees of their clustered orange berries. The waxwings' insatiable predilection for berries is partly explained by an unusually short alimentary canal, which requires only twenty to forty minutes to digest the food. The birds are compelled to feed constantly. The berries also make the waxwings delicious. Audubon described berry-filled birds as "tender and juicy." The birds were so stuffed that they could no longer fly, and were easily taken by hand. Actually, cedar waxwings often gorge themselves on fermented berries and become, literally, falling-down drunk. Before eating songbirds was frowned on in North America, it was customary to give a basketful of these beautiful birds as Christmas presents. "Waxwing" is a relatively new name, derived from the flat red appendages extending from the tips of the secondary flight feathers; both in colour and texture, they look like sealing wax. No use for these droplets has been found. The Latin name is interesting: *Bombycilla* is from *bombyx*, the silkworm, an allusion to the lustrous velvety or silky plumage. The German *Seidenschwanz*, "silk-tail," is delightfully descriptive. The common name in French Canada reflects history rather than science. In the summer of 1615, the Récollet fathers landed in Tadoussac, coming at the request of Samuel de Champlain to oversee the religious life of New France. The *habitants* called the birds *récollets* from the colour of the crest, which resembled the hood of the holy fathers. How did contemporaries perceive Audubon's plate? In Thomas Nuttall's *Manual of Ornithology of the United States and Canada*, published in 1832, we find the answer. In most natural history books it is standard practice to open a chapter by listing all previous references. Nuttall followed the tradition by citing the scientists who had described the "Cedar Bird or Cherry Bird," but in the list he added an editorial comment: "Audubon pl.43 [extremely fine and natural]."

Havell No. XLIII

PLATE XLIII.

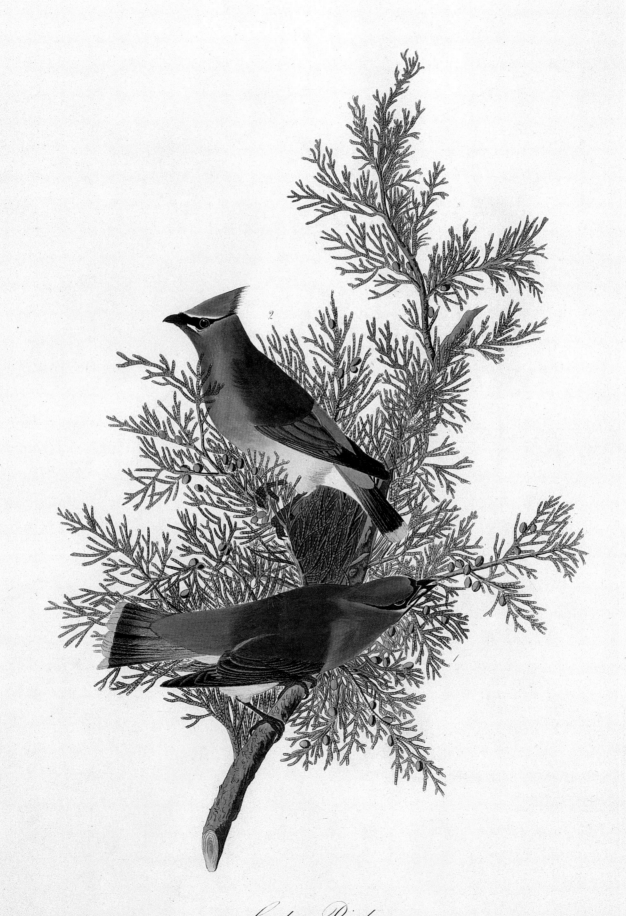

Cedar Bird.

BOMBYCILLA CAROLINENSIS, Brifs,

Male, 1, Female, 2.

Red Cedar. Juniperus virginiana.

Drawn from Nature and Published by John J. Audubon, F. R. S. F. L. S.

Engraved, Printed, & Coloured, by R. Havell.

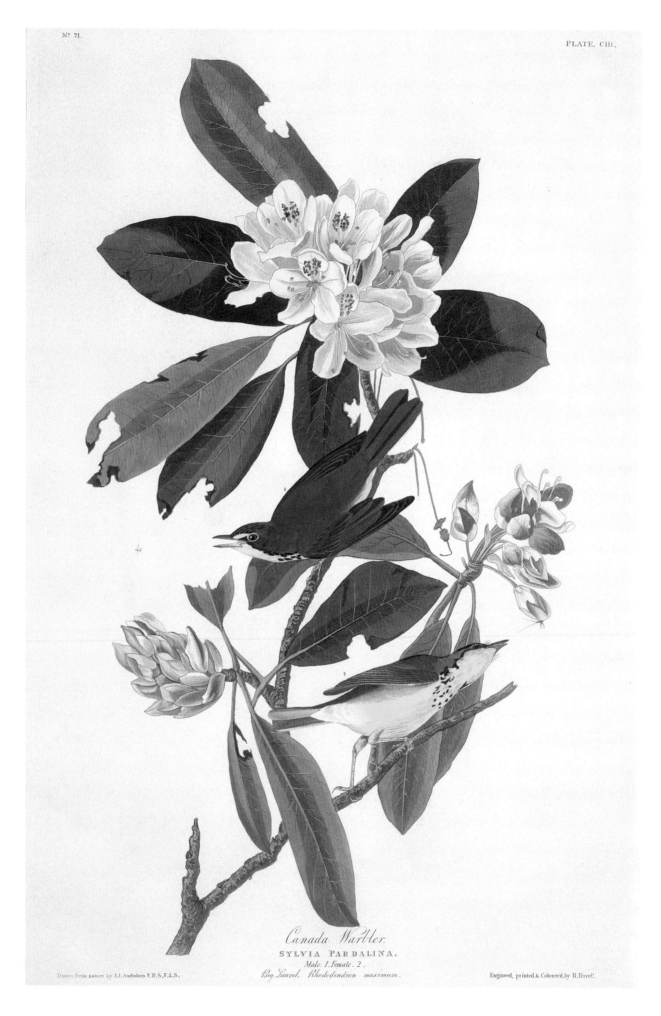

Canada Warbler.
SYLVIA PARDALINA.
Male. 1. Female. 2.
Big Laurel. Rhododendron maximum.

CANADA WARBLER
Wilsonia canadensis

When the subscribers of Audubon's *Birds of America* received a blue folder with their first five plates, they found that Bonaparte's flycatcher was included. It was a small, attractive, grey-and-yellow bird perched on the dramatic, bright red seed pod of a Southern magnolia. Audubon named it after his friend and patron, Charles Lucien Bonaparte. At first he had called it the "Cypress Swamp Fly Catcher," when he painted the picture in Louisiana on October 5, 1821. Although convinced it was a new species, Audubon admitted, "I have not seen another individual since." Eight years later, in 1829, while staying in a woodsman's cabin in the Great Pine Forest of western Pennsylvania, Audubon painted two Canada flycatchers in a giant laurel, the *Rhododendron maximum*. As it turned out, they were the same bird, the Canada warbler. The earlier bird was shown in strict scientific profile; the seed pod was painted by Audubon's assistant Joseph Mason. The two birds in Plate 103 are far more lifelike, excellent examples of how much Audubon's style had matured. And it was Audubon himself who painted the rhododendron, a blunt botanical portrait complete with all the insect and caterpillar cuts in the leaves. The tree was so impressive that Audubon included a separate description of it in his text. The early assumption that this beautiful bird was a flycatcher is understandable, for unlike most of its warbler relatives the Canada does actively hunt flying insects. In addition, it sings melodiously in a most unwarblerlike manner. Confusion caused by changing plumage in the fall was as common in Audubon's time as it is today. Lacking the field records that birders and scientists take for granted, Audubon and other naturalists "discovered" pine swamp warblers, hemlock warblers and even an elusive autumnal warbler. These all proved to be females of other species. The new name denotes what was assumed to be its breeding range. Audubon reported following it up through New Brunswick, Nova Scotia, Newfoundland and Labrador. In fact, the Canada warbler has been reported in every continental state and province, excepting Washington, Idaho, the Yukon and the Northwest Territories. This painting was from one of the most productive and brilliant weeks of Audubon's career. In the cabin overlooking a stream flowing to the Lehigh River, he painted the raven, pileated woodpeckers, the goshawk and the two beautiful magnolia warblers in their purple-flowering raspberry bush.

Havell No. CIII

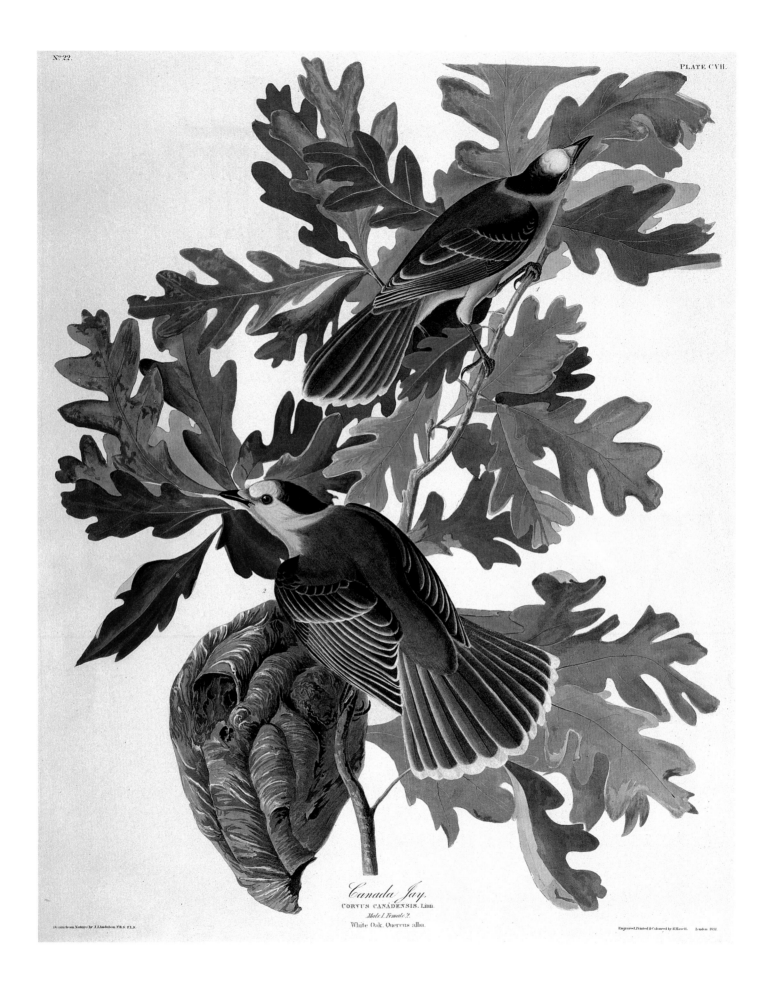

Canada Jay.
CORVUS CANADENSIS. Linn.
Male 1. Female 2.
White Oak. Quercus alba.

GREY JAY
Perisoreus canadensis

A column of pale blue smoke rises from a campfire, an axe rings in the north woods, and out of nowhere the first grey jays float down silently on set wings from the dark pines to steal food from the woodsmen. The pilferage is a small price to pay for the company of a bird that, according to Audubon's evocative text, "trusting the generosity of man, fearlessly approaches him." Audubon found the bird "elegant," "joyous and lively." In the folio plate, Audubon placed two adult grey jays, collected in the state of Maine in September 1829, against a back-drop of white oak leaves in their autumn dress. He added a nest of the paper wasp, re-creating a scene he had witnessed personally. There are three distinct sub-species of the former Canada jay, with varying amounts of grey. This originally led Audubon to include the grey jay as a separate species when a dark specimen was sent to him from the Columbia River. Earlier, Alexander Wilson used the jay for a thinly disguised attack on the nascent evolutionary theories of the Comte de Buffon in France, who, Wilson said sarcastically, would probably dismiss the Canada jay, as it was called, as a cross between a blue jay and a catbird, or worse, a degenerate form of the European jay, sunk to lower status because of the cold climate to which it had migrated. There had been disquiet among naturalists, a full fifty years before Darwin, concerning the possible mutability of species. Normally, the grey jays are seen in pairs or alone, although, because of their remote northern forest habitat, they are not a common sight. Yet they are sur-prisingly abundant. In 1887, a hunter from the Quebec–Labrador coast killed ninety from one flock "and could easily have trebled that number." The birds line their rough nests with the finest of materials, usually incorporating down feath-ers from other species. The insulation is so effective that the chicks hatch while the snow is still deep, and are fully fledged when other birds are just beginning to nest. Eggs and nestlings of other species appear just in time to be springtime fare. During the winter the adults feed on berries, bugs and supplies of food scav-enged from lumber camps and stuffed into hollows and under bark during the preceding summer and fall. To add to their winter larder, the jays—and their Eurasian counterpart, the Siberian jay—seem to use sticky saliva to glue insects and seeds to the undersides of branches, above the snow that will pile up below. The grey jay, known as the Canada jay until very recently, was also called the moose-bird and the camp-robber. In Audubon's day woodsmen called it the whisky-jack, a name phonetically derived from the Cree, *whiss-ka-chon*; Whisky John became Whisky Jack.

Havell No. CVII

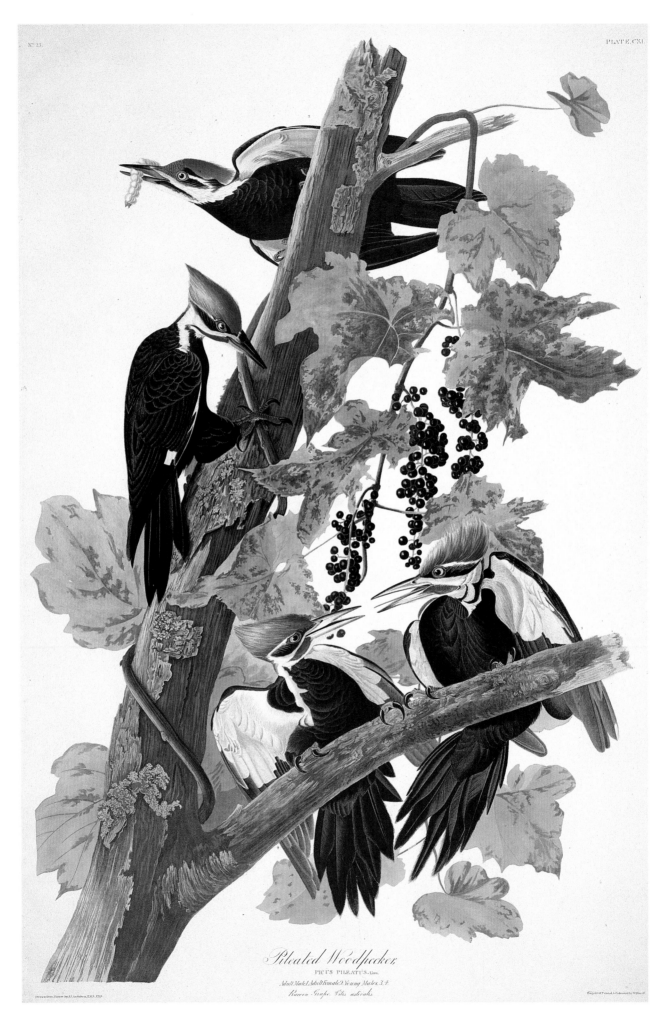

Pileated Woodpecker
PICUS PILEATUS, *Linn.*
Adult Male 1. Adult Female 2. Young Males 3, 4.
Raccoon Grape. Vitis æstivalis.

PILEATED WOODPECKER
Dryocopus pileatus

The pileated is our second-largest woodpecker, exceeded in size only by the extinct ivory-billed. Known in Colonial times as the woodcock or logcock, it is still called the "cock-of-the-woods" in many rural areas across its wide North American range. The hysterical call reverberates throughout the woods, but the birds are difficult to spot because of their uncanny sense of safe distance. Their calling card, however, is hard to miss: an alarmingly large conical hole drilled near the base of a tree right through to the heart, a messy pile of over-sized chips littering the ground. Audubon claimed that the birds attacked young corn—a charge that Nuttall and other later naturalists questioned—and that the farmers, therefore, used that as the excuse for slaughtering them. Audubon reported that the birds were particularly fond of wild grapes, and he chose to portray this family of four in a composition of raccoon grapes and leaves. Audubon painted both the birds and the botanical elements in this, one of the most artistically successful of all his plates. In England, Audubon launched an abortive scheme to have copies of all his plates painted in oil. He engaged the services of a young Edinburgh landscape artist, Joseph B. Kidd, who completed one hundred paintings. In several he added certain elements that were not in the Audubon originals or the engraved plates for the elephant folio. The excellent copy of the pileated woodpecker composition, which was finished in 1831, was one of his paintings. Audubon also did some oils, but Kidd's copies were of such quality that attribution to the master and the journeyman is often impossible to determine other than through letters and other written material relating to the actual painting. Audubon was obviously very partial to the pileateds, but at the same time he could write, "Its flesh is tough, of a bluish tint, and smells so strongly of the worms and insects on which it generally feeds, as to be extremely unpalatable." As a scientist rather than an epicure, Audubon claimed that the length of the bill of the juvenile was longer than that of the adult, and painted his young birds accordingly. The bill of older birds is, indeed, hardened and worn down through use.

Havell No. CXI

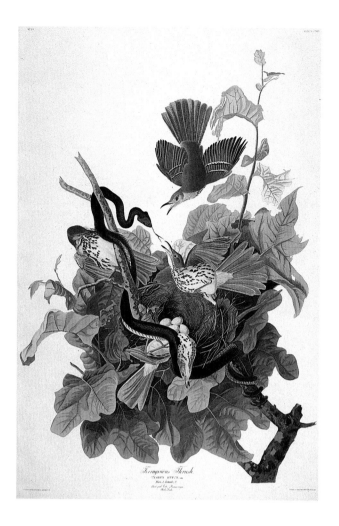

BROWN THRASHER
Toxostoma rufum

Audubon made use of snakes in four of his elephant folio plates of birds. A giant rattler attacks a nest of mockingbirds. A large garter snake writhes in its death throes in the talons of a swallow-tailed kite. A coral snake insinuates itself along a narrow branch under the watchful eyes of two chuck-will's-widows. Although the coral snake, like its Old World relatives the cobras and the mambas, is highly poisonous, its tiny mouth and short fangs significantly limit the parts of the human anatomy that are vulnerable to its bite. Audubon's coral snake, therefore, looks benign, except perhaps to the birds, which seem very much on edge. The fourth snake plate shows a black snake attacking the egg-filled nest of a brown thrasher. The female swooned, and in real life Audubon actually helped to revive her. Audubon's choice of poses emphasizes not only the extreme aggressiveness of the thrashers but also their cooperative method of defence. This was not by accident: Audubon used this picture to impart the same moral message that would be expected from paintings of a human drama in which mutual support can help victims overcome potential tragedy. Audubon witnessed this scene and reported that the snake was driven away. The detailed rendering of the thrashers' plumage is among Audubon's best, but nowhere is his understanding of muscle structure better exemplified than in the sinuous curves of the snake.

Havell No. CXVI

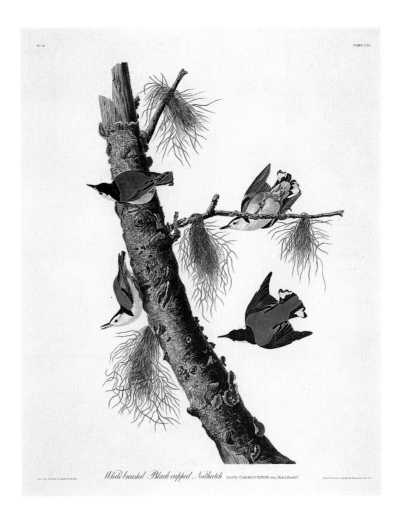

WHITE-BREASTED NUTHATCH
Sitta carolensis

When searching for food on trees, the white-breasted nuthatch is invariably upside down; it is the only species to feed this way. This delightful portrait clearly shows the degree to which Audubon captured details that previous bird painters missed entirely. First of all, the beaks and the orientation of the birds at the right and the structure of the dead tree all lead the eye to focus on the bird at the left, which is shown in its diagnostic pose heading down the trunk. A space has been left between the tail and the bark, clearly showing that, unlike a woodpecker, the nuthatch does not use its tail for leverage. Its specialized style of movement is made possible by exaggeratedly curved toes and an unusually long hind nail, which locks onto the surface. Careful examination of the birds shows that Audubon correctly differentiated the lengths, but in case anyone missed it he also placed the extended hind toe of the upper right-hand bird in silhouette. The modern use of the word "hatch" conjures up silly visions of the bird sitting on a nut. It is a corruption of "hack," a word that well describes the bird's habit of cramming a nut or seed into a cleft of two branches and then chipping or hacking away (hatchetlike) at the outer shell to get at the tender kernel inside. The Danish name, *naeddehakker*, echoes the Scandinavian roots of so many of the common words that entered English on the lips of the dragon-boat warriors of the Viking invasions. Despite the name, their preferred food is insects, larvae and spiders' eggs.

Havell No. CLII

AMERICAN CROW
Corvus brachyrhynchos

The crow is without doubt a highly intelligent bird, capable of almost human deviousness. Perhaps this helps explain why it engenders such widespread dislike. Damned by most, loved by few, the crow has been despised even by naturalists. In 1833 Thomas Nuttall described him as "troublesomely abundant." Henry Dresser in his *Birds of Europe* (1871–1890) was blunt: "Of all the birds that are held by the farmer and the game-preserver in bad repute, none, perhaps, deserves its bad name more than the crow. A bold and unsparing robber, and cunning and wary, as he is impudent and voracious, he is everywhere looked on with disfavour." The medieval collective hunting noun says it all: "a murder of crows." The loathing is as widespread as the geographic range of the crow and its endless subspecies throughout the entire Palaeoarctic region across to China and Japan, Europe and even North Africa. And yet Audubon saw man, not the crow, as the villain. It is worth quoting Audubon at length: "Scarcely one of his race would be left in the land, did he not employ all his ingenuity . . . in counteracting the evil machinations of his enemies. But, alas, he chances unwittingly to pass over a sportsman, whose dexterity is greater: the mischievous prowler aims his piece, fires:—down towards the earth, broken-winged, falls the luckless bird in an instant. 'It is nothing but a crow,' quoth the sportsman." Audubon decried bounties being offered on their heads, and was revolted by the slaughter of forty thousand birds in one season in one state. Even worse was the "base artifice of laying poisoned grain along the fields to tempt these poor birds." We see in this text, and in his scathing condemnation of the "eggers" of Labrador, the emergence of a conservation ethic. Audubon's credo was decades before its time: "I admire all [Nature's] wonderful works, and respect her wise intentions, even when her laws are far beyond our limited comprehension."

Havell No. CLVI

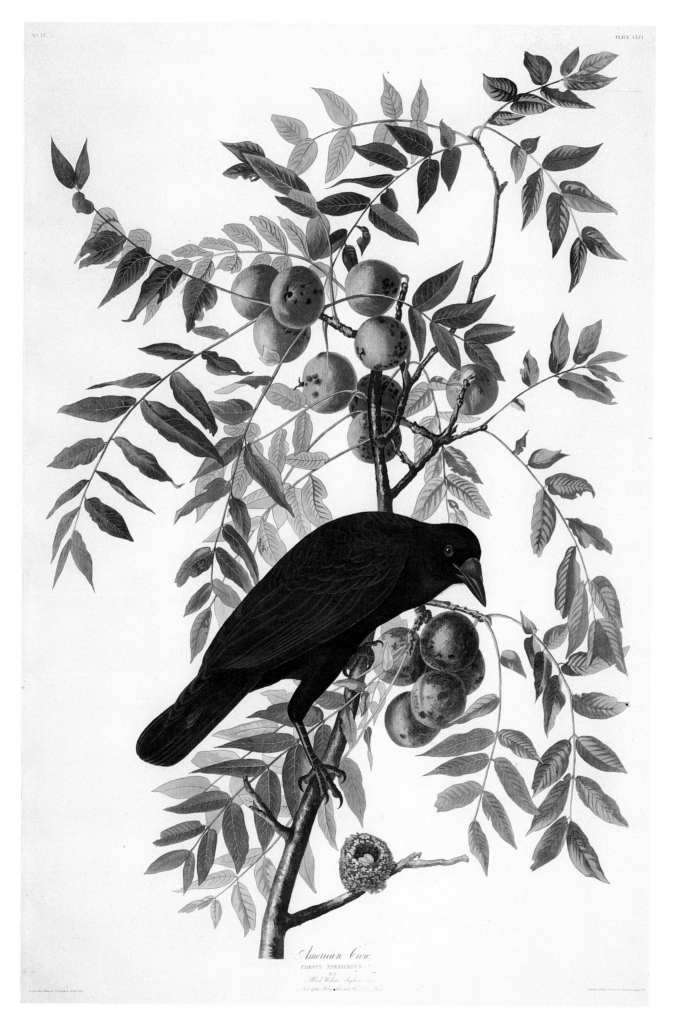

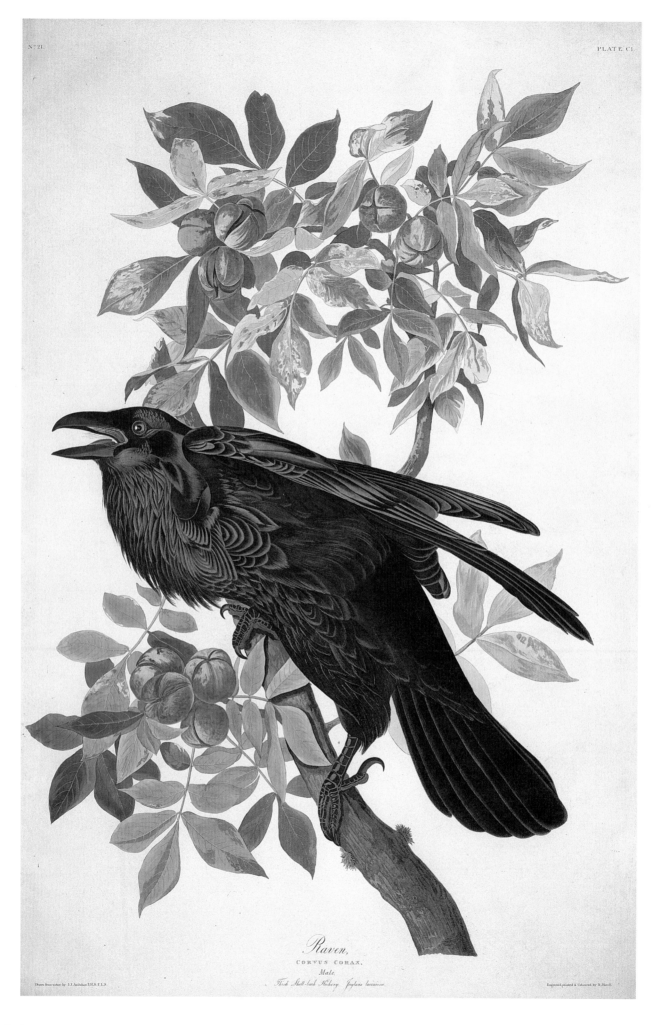

Raven,
CORVUS CORAX,
Male.
Thick Shell-bark Hickory, Juglans laciniosa.

COMMON RAVEN
Corvus corax

Over two feet (60 cm) long and with a four-foot (122 cm) wingspan, the raven is the largest-bodied member not only of the crow family but of all passerine birds. We tend to associate them with the Arctic and sub-Arctic, but they are found throughout the temperate zones of the northern hemisphere. Audubon opens his text on the raven by describing in rapturous terms the physical and natural beauties of America, whose wildness the raven exemplifies. He imputes to them powers of communication that border on actual language. In July 1833, off Little Macatina Harbour in the Gulf of St. Lawrence, a captured young raven, exhorted by its mother, walked to the end of the bowsprit of Audubon's schooner, failed to fly and, falling into the water, drowned. He also extols their family virtues: "At length the young burst out of the shell, when the careful parents, after congratulating each other on the happy event, disgorge some half-macerated food, which they deposit in their tender mouths." This parental solicitude is strangely at odds with the biblical and medieval traditions that ravens are so disgusted at the sight of their downy young that they immediately abandon them until they assume a darker plumage. How the young survived without food raised more than one ecclesiastical eyebrow. From earliest recorded and oral history, the raven has been the emblem of doom and deluge. Considered blessed, or cursed, with prophetic powers, the birds were consulted before decisions were taken on important matters, especially military. Of course, ravens were attracted to the battlefield because of the likelihood of a gruesome meal. Their association with death predates written history: at Lascaux in France, there is a twenty-thousand-year-old picture of a raven next to a fallen hunter, one of only a handful of bird paintings in the Neolithic caves of Europe. The *locus classicus* of the raven's association with rain is the biblical narrative of Noah's flood, but this is only one of several very similar and even more ancient Near Eastern myths. The raven played the same role in the Babylonian Epic of Gilgamesh. More recently, early Viking sagas tell of the legendary discoverer of Iceland sending out ravens to lead him to a new land. Henceforth he would be known as Raven–Floki. Odin, the supreme Nordic god, had two ravens, Huginn and Muninn, who flew around the world gathering knowledge to bring back to their master. Closer to home, ravens appear in the tribal myths of the Mandan Indians of the Great Plains and the Kwakiutl and Haida on the West Coast; and the fact that ravens also figure in the mythology of the native peoples of eastern Siberia helps ethnologists trace human migrations across the Alaska–Asia land bridge.

Havell No. CI

WILDERNESS IN BALANCE

The interaction between prey and predator is not fully understood even today; this, despite the fact that since Audubon's day vast amounts of information have been accumulated on aspects of wildlife that were not even dreamed of in the nineteenth century. With the publication of Charles Darwin's *On the Origin of Species* in 1859, scientific and social investigation focused on the survival of the fittest, a concept that simplified success or failure through interspecies relations. Largely ignored was the role of the environment. For Audubon and his contemporaries, success or failure for an individual animal was basically determined by a simple formula: "Kill or be killed." Population declines caused by hunting or habitat destruction were written off as natural cycles or, more likely, a change in migratory patterns. The birds would always come back. Birds of prey were considered successful because they killed. Few people questioned why there were so few birds of prey compared to the populations on which they feasted. As species, which class was the more successful—the prey or the predator? Besides, there was little reason to question. The abundance of wildlife was on a scale that made resources seem inexhaustible. In his texts, even when he decried the apparent cruelty of raptors, Audubon described rather than explained their relationship with their food sources and their environments. His paintings often included the types of insects that formed the diets of individual species. For an io or cecropia moth, a nighthawk was a predator. The birds of prey did not hold the balance of power; they were part of the balance itself. In his paintings, Audubon celebrated their power, their fierce mien; in short, he assumed he painted portraits of success. In reality, he painted a wilderness in balance.

BALD EAGLE (IMMATURE)
Haliaeetus leucocephalus

Audubon persisted in championing his discovery of the "Bird of Washington," which in fact was an immature bald eagle, and yet he enthused: "Not even Herschel, when he discovered the planet...could have experienced more rapturous feelings." The text from the *Ornithological Biography* of 1831 explained why Audubon felt George Washington should be honoured by having this eagle named after him: "He was brave, so is the eagle; like it, too, he was the terror of his foes; and his fame, extending from pole to pole, resembles the majestic soarings of the mightiest of the feathered tribe." Audubon first spotted this "new" species along the Upper Mississippi in February 1814, "with my *patroon*, a Canadian...a man of much intelligence." He considered it to be "indisputably the noblest bird of its genus." A fellow passenger protested that the bird had come from the nest of the "brown eagle," that is, the bald eagle, but Audubon ridiculed the idea. He had already dismissed the bald eagle as cowardly and vile. The non-existent species appeared in the octavo edition in a lithographed plate that gained nothing by being reduced. It is arguably one of the least successful of Audubon's major birds. The pose bears a striking resemblance to the wood engraving of the sea eagle in the 1797 and later editions of Thomas Bewick's *History of British Birds*. Audubon knew Bewick's work and admired him so much that he named a wren after the English engraver, seven years before he actually met him, in Newcastle-upon-Tyne in 1828. The "patroon," or captain, of Audubon's keelboat was named Larimier, and he was taking his passengers to the French-Canadian settlement of Ste-Geneviève. Audubon and his business partner, Rozier, were transporting three hundred barrels of whisky to sell to the fur-traders, who would in turn use and abuse it in their dealings with the Indians; commerce on the frontier was amoral. It is interesting that Audubon chose Herschel's detection of Uranus as an analogy. What marked Herschel's achievement as one of the great astronomical events was that it represented the first discovery of a planet since the time of the ancients. Herschel, in March 1782, did discover a new planet; Audubon, in February 1814, did not discover a new eagle.

Havell No. XI

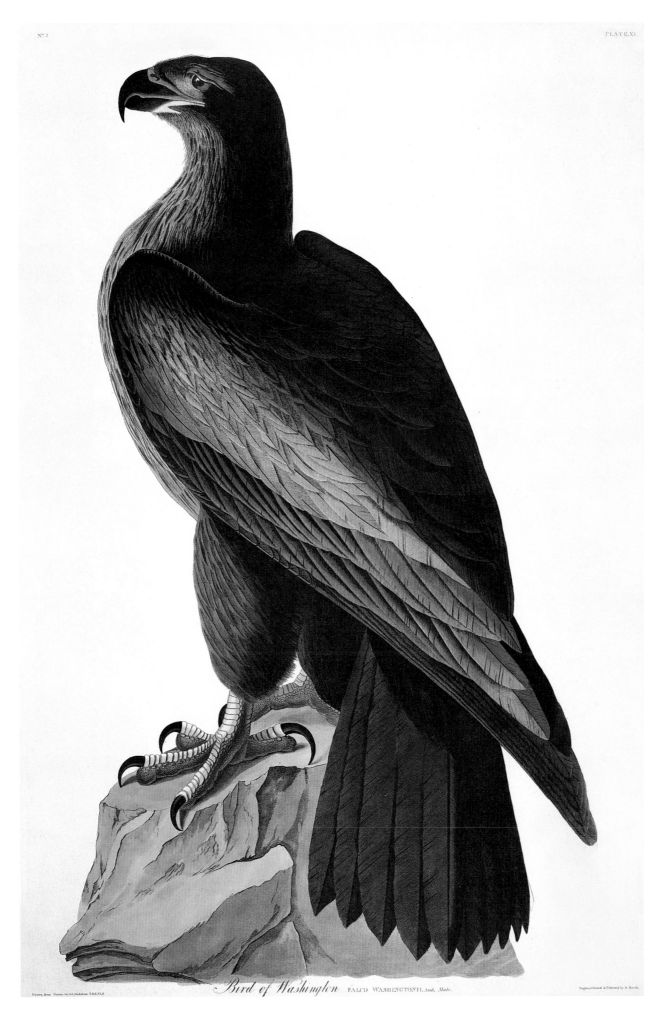

Bird of Washington FALCO WASHINGTONII, Aud, *Male.*

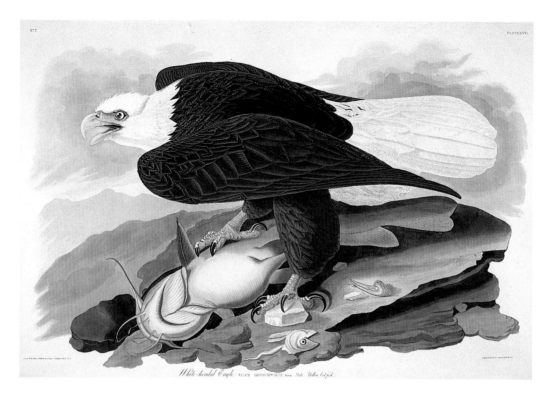

BALD EAGLE
Haliaeetus leucocephalus

Of all the birds that offer possibilities for dramatic poses, the bald eagle ranks among the highest. Why, then, did Audubon choose this one? The first answer is that it was not his first choice. In his *Journal* from London in 1828 he wrote: "This morning I took one of my drawings from my portfolio and began to copy it, and intend to finish it in a better style. It is the White-headed Eagle which I drew on the Mississippi some years ago, feeding on a Wild Goose; now I shall make it breakfast on a Catfish, the drawing of which is also with me, with the marks of the talons of another Eagle, which I disturbed on the banks of the same river, driving him from his prey." The original painting with the goose, complete with feathers plucked from a bloodied chest, still exists. The more truthful answer almost certainly lies in the constant comparisons of his work with that of Alexander Wilson, whose financial backers had effectively kept Audubon out of the influential scientific and cultural circle of Philadelphia. Audubon in effect duplicated his competitor's pose, complete with the dead fish. Wilson's fish was just plain dead; Audubon's catfish is bloated with gas, and under the sharp talons is likely to explode. The badly stuffed eagle from Peale's Museum that Wilson slavishly copied is still extant. Audubon, by painting his eagle so powerfully, challenged his rival to a duel of eagles, and won. Despite his obvious admiration for the bird, Audubon ended his very long description by agreeing with Benjamin Franklin that the wild turkey would have made a far better choice for the national symbol of the United States. The wild turkey lost by a very close vote in the U.S. Congress. Hunted and poisoned almost to extinction in the lower forty-eight states, the bald eagle has recently made a strong comeback, but only in British Columbia and Alaska can one find a treeful of bald eagles, one of the most cherished sights for a birdwatcher.

Havell No. XXXI

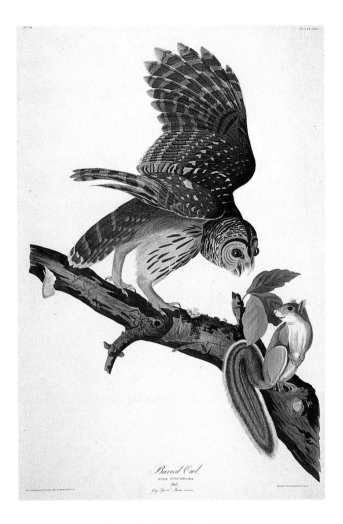

BARRED OWL
Strix varia

The barred is one of our larger and most numerous owls. In this portrait Audubon combined two biological factors, one from first-hand knowledge and the other inadvertently. He knew that the flight feathers are very rounded and the trailing edges of the primaries minutely fringed. This combination, so accurately shown in this plate, imparts an eerie noiselessness to the owl's flight. Audubon observed, but could not have explained scientifically, that the grey squirrel seems strangely unperturbed, while the owl appears confused. In bright light, the make-up of the owl's eyes causes it to miss much of the detail it is capable of discerning in low light. In effect, in the full daylight of Audubon's painting, the barred owl could not see the squirrel as well as it could at dusk. Sound is as important as sight for successful hunting. The ear openings of the barred owl are different in shape and are not placed symmetrically on the skull. Minute variations in the time it takes for a sound to register in each ear helps the owl pinpoint its prey. Audubon claimed that the "Barred Owl is a great destroyer of poultry, particularly of chickens when half grown." And yet, when the stomachs of 109 owls were examined, only four contained the remains of poultry! Actually, the chances were far higher that they would contain the remains of smaller owls, especially screech owls, for the barred is the most cannibalistic of its tribe. Of course, its main diet consists of mice and other small rodents found in the deep woods.

Havell No. XLVI

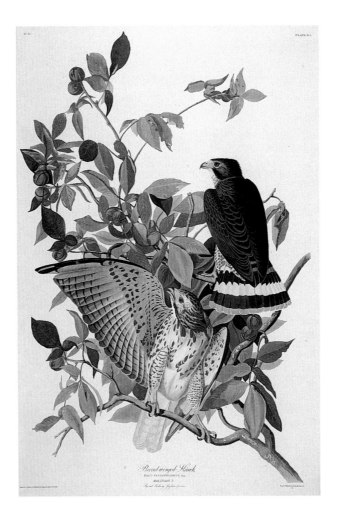

BROAD-WINGED HAWK
Buteo platypteris

Audubon told a story of capturing a broad-winged hawk on its nest and carry-ing it into his room, where "I measured the length of his bill with a compass, began my outlines, continued measuring part after part as I went on, and finished the drawing, without the bird ever moving once." Little wonder, therefore, that he dismissed the broad-wing as "spiritless, inactive and deficient in courage, sel-dom chasing other birds of prey, but itself frequently annoyed by the little Sparrow Hawk [Kestrel], Kingbird and the Martin." The incident had taken place in 1812 when Audubon was working on an early painting. In 1874 someone took Audubon at his word, and to his surprise the hawk "assailed the nest intruder with great fury and tore the cap from his head." To avoid serious injury from this so-called docile hawk, the intruder rewarded the bold defence by shooting the bird. Of all the plates dealing with birds of prey, "The Broad-winged Hawk," com-pleted in 1829, is artistically one of Audubon's most successful. The preening of the underwing allows Audubon not only to show the feather patterns, but also to depict the bird in the act of doing something that is part of its regular routine. The pig-nut tree in which the broad-wings perch was painted by George Lehman. This plate provides an interesting contrast to the stark drama of Plate 103, "The Rough-legged Hawk," which shows its subjects perching on a dead tree whose spike-like branches echo their fearsome nature; birds' exposed talons and cruel, open beaks reflect Audubon's prejudice in their favour.

Havell No. XCI

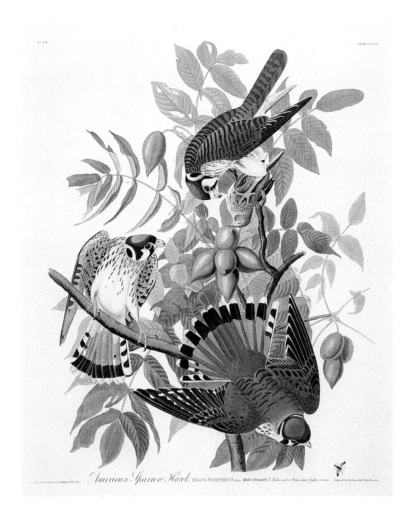

AMERICAN KESTREL
Falco sparverius

Audubon felt that this was one of the prettiest hawks, a sentiment echoed by almost every naturalist and birdwatcher since. Despite an obvious similarity to the European kestrel, until recently this diminutive falcon was known as the sparrow hawk, a misnomer that lives on in the Latin name and in Audubon's plate, which shows the top bird about to feed on what appears to be a savannah sparrow. In reality, kestrels feed mainly on small rodents, amphibians and, as the lower right bird shows, insects. In England this falcon is known by its most evocative name, the "windhover." With precise adjustments counteracting the force of the wind, the kestrel truly hovers as if suspended, while scanning the meadow grasses for telltale signs of movement. Then with lightning speed it streaks down for its prey. The eyes must be able not only to focus from a great distance but also to retain focus during the rapidly shrinking distance during the dive. Not uncommonly for hawks, the kestrel's eyes are approximately eight times as powerful as those of humans. During the sixth century BC, to gain favour with the patron gods, the embalming of the animals that were thought to be their earthly manifestations reached unbelievable proportions in ancient Egypt. In catacombs near Saqqara, passages from floor to ceiling are lined with pottery jars containing an estimated eight hundred thousand falcons and four million ibises. The Egyptians called the falcon "Horus." The Cree Indians called him "Peepeekeeshees." Audubon called his pet kestrel "Nero," until it was killed by his pet chicken.

Havell No. CXLII

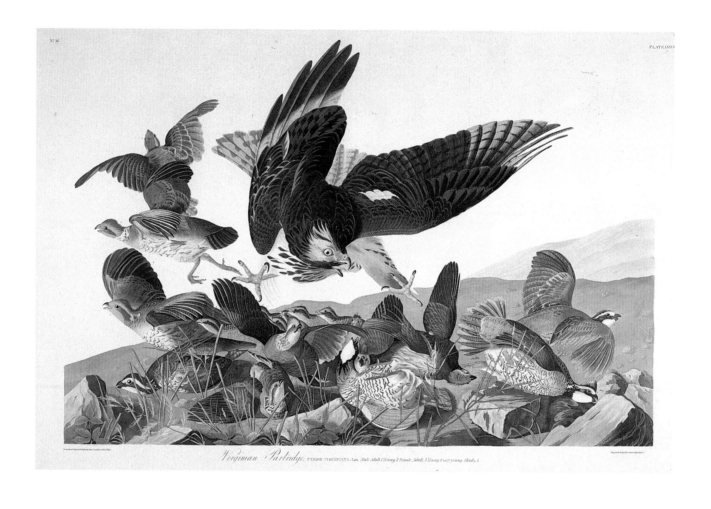

A. NORTHERN BOBWHITE
Colinus virginianus

B. RED-SHOULDERED HAWK
Buteo lineatus

Audubon described how Virginia partridge would form a protective circle by backing into each other until their tails touched. Audubon wrote: "Their very sociability often affords means for their destruction; for while crowded together in a ring, a dozen or more have been killed at a shot." The numbers were astonishing. In 1820, Audubon reported that they were found in large quantities "both dead and alive." They sold for 12 cents a dozen. Hunting and habitat destruction began to take their toll, and within twenty years Thomas Nuttall reported that the price had gone up to 10 to 15 cents a pair in the markets of New York and Boston. When threatened, the covey of quail would explode in all directions to confuse and confound a predator. Audubon described his own plate: "I have represented a group of Partridges attacked by a Hawk. The different attitudes exhibited by the former cannot fail to give you a lively idea of the terror and confusion which prevail on such occasions." The immature red-shouldered hawk has burst upon the sixteen quail, who do indeed fly off in all directions. This scene not only accurately reflects nature, but from an artistic point of view it gives Audubon full range for the interaction of species, of prey and predator. This is the only plate in the *Birds of America* in which the principal species is shown being preyed *upon*. The scattering of the birds also allows Audubon to depict five different plumages, male, female and young, as well as the feather patterns above and below the body and wings. No single painting of Audubon shows more clearly his total departure from the traditional, diagrammatic bird portraits of his predecessors. The glaring eye of the hawk, the threatening sharpness of the extended talons, the almost theatrical hysteria of the fleeing quail—nothing could be further removed from the placid renderings of Catesby or Wilson. Clearly, new artistic ground was being broken, and yet in the octavo edition of the *Birds*, Audubon unaccountably replaced the dramatic scene with a simple placement of two adults quietly guarding six babies. In the reduced lithograph, there is not a hawk in sight, and not a shred of what made Audubon so far ahead of his time. Virginian partridge is the name Audubon used, but in his text he described the call, familiar to all outdoorsmen as "Ah, Bob White," the term that would ultimately prevail for the bird now known as the bobwhite.

Havell No. LXXVI

EASTERN SCREECH OWL
Otus asio

The scientific name, *Otus asio*, is made up of two Latin words that both mean "horned owl." The redundancy is perhaps more appropriate than might appear, because the two colour phases—reddish and grey—of the screech owl may have been the reason that this diminutive common owl was divided into two species. Audubon and his contemporaries called it the mottled owl, for the effect of the white feathers on the pattern; we call it the screech owl because of its distinctly unmusical call. It is one of the most endearing birds in North America, and one of Audubon's personal favourites: "I carried one of the young birds represented in the plate in my coat pocket from Philadelphia to New York," he wrote. The image of the owl was also a favourite of plagiarists. The upper owl appeared, in reverse, as a woodcut—without acknowledgment—in Nuttall's *Manual of Ornithology*, which was published a mere three years after Audubon completed his plate. Nuttall's description of this most urban owl is worthy of quoting: "In the day they are always drowsy, or, as if dozing, closing, or scarcely half opening their heavy eyes; presenting the very picture of sloth and nightly dissipation." If anthropomorphism is allowed, the owls do look hung-over. Frogs, worms, small birds and, in summer, vast quantities of flying insects are included in their diet. In one recorded instance, screech owls flew thirty-six miles (58 km) round trip to capture small fish (horned pouts) through a hole cut in the ice by some boys. But mice form the major component of the diet. The screech owl eats the mouse whole, and regurgitates the fur and bones in a compact pellet, which he expels out of the nesting cavity onto the ground. Mounds of pellets at the base of a tree are a sure sign that owls are in residence. Audubon's painting includes an artistically and botanically excellent branch of the scrub pine (*Pinus virginiana*), but it is the extended wing that catches the eye. This was a convention that Audubon used frequently; plate 91, "The Broad-winged Hawk," is a good example. This pose led to the identification, in Scotland, of a lost painting of ring pigeons by Audubon. It appeared in modified form on the title page of the volume on pigeons in *The Naturalist's Library*, in Edinburgh in 1835. The association is interesting: William Lizars, the engraver, also made the first ten plates of the elephant folio *Birds*; John Prideaux Selby, the author and Lizars' brother-in-law, received art lessons from Audubon for his own bird book; and Sir William Jardine, the publisher and editor, introduced Audubon to Lizars. In the England of Audubon's day, the world of natural history was a very tightly knit community.

Havell No. XCVII

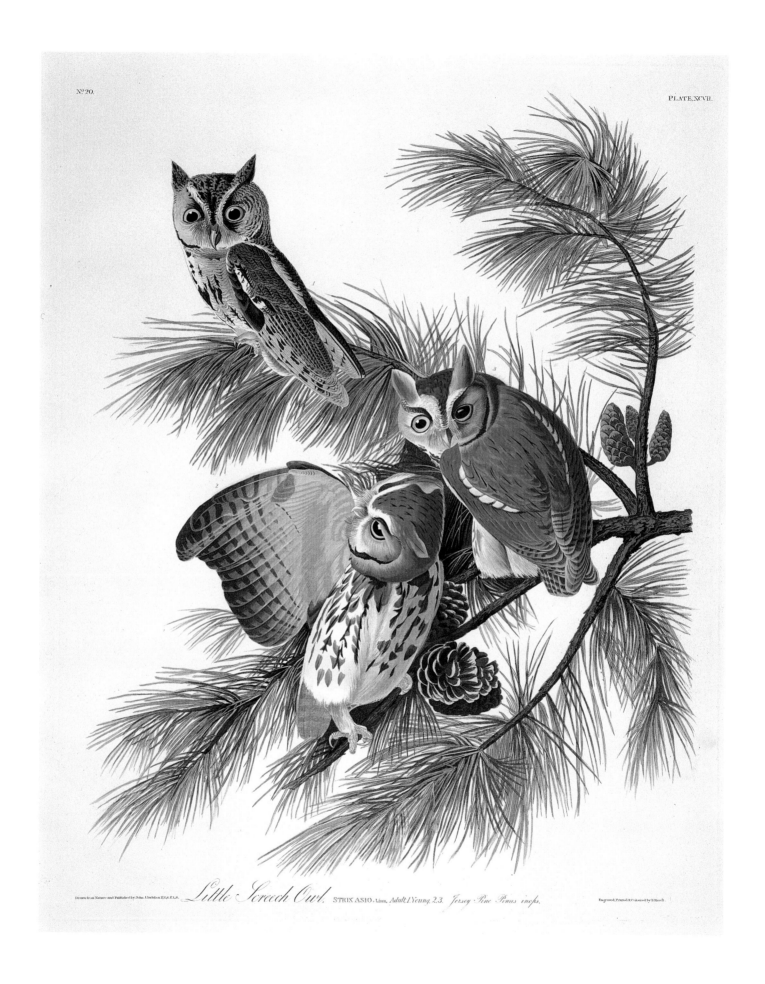

Nº 20.

PLATE XCVII.

Little Screech Owl. STRIX ASIO, Linn, *Adult 1 Young, 2,3. Jersey Pine Pinus inops.*

Drawn from Nature and Published by John J.Audubon, F.R.S.F.L.S.

Engraved, Printed & Coloured by R.Havell.

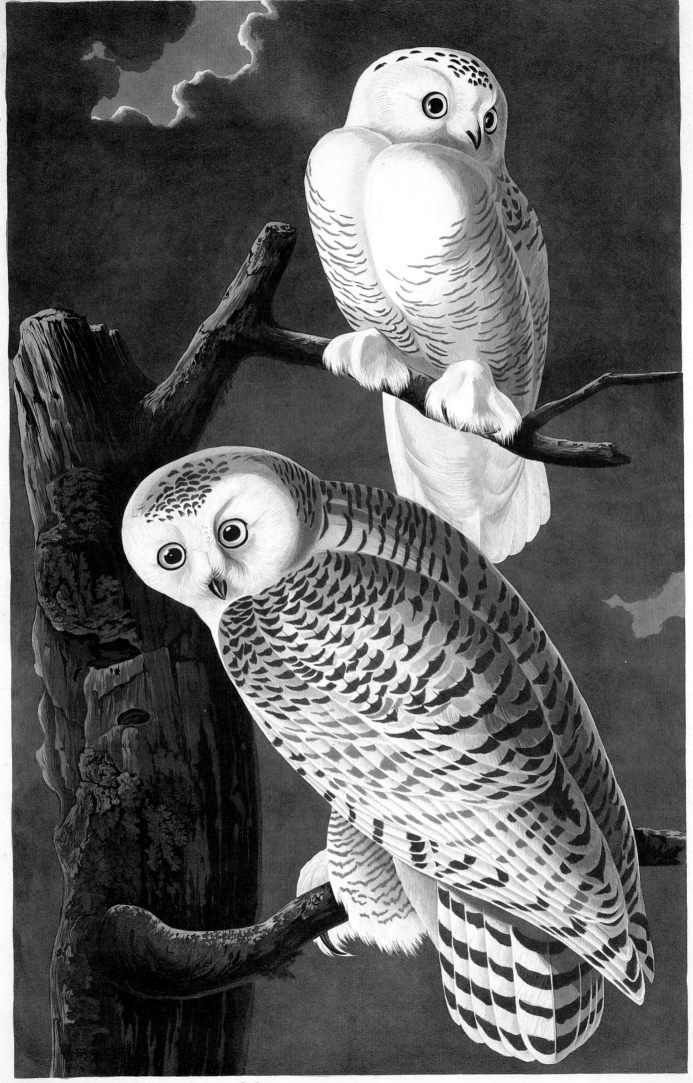

Snowy Owl, STRIX NYCTEA. *Linn. Male,1. Female,2.*

Drawn from Nature by J.J.Audubon. F.R.S. F.L.S.
Engraved, Printed, & Coloured by R.Havell, London.

SNOWY OWL
Nyctea scandiaca

Audubon dramatically contrasted these two snowy owls against a brooding sky. The break in the clouds rimmed in a halo of light shows a pale blue sky, contradicting the frequent assertion that this is Audubon's only night scene. The use of the dead tree as a perch adds another powerful and almost sinister image. He knew that "this beautiful bird" was only a winter visitor to the United States, and that it was truly a northern bird—even though it had been seen as far south as Georgia. He searched unsuccessfully for it in Labrador and Newfoundland, and admitted that "of its place and mode of breeding, I know nothing." Consequently, for much of the description in his text in the *Ornithological Biography*, he relied on a lengthy quote from his friend and correspondent, Thomas MacCulloch, of Pictou, Nova Scotia, the future president of Dalhousie University. Although relatively common across its Arctic range, the snowy owl is not often encountered in southern Canada. In fact, most people only see it on the Canadian fifty-dollar bill, on boxes of inexpensive wine (both red and white) or on cigar tins. In fact, the White Owl Award is one of Canada's most prestigious conservation honours. In Audubon's day there were still large blanks in scientific knowledge. He did not know of the relationship between the drop in the northern lemming population and the owl's southern visits, nor that the brown speckling on the feathers indicated that the lower bird was a female. He did observe, however, that the flesh resembled a chicken and was "not disagreeable eating." His attention to detail was extraordinary for his time. His description of these owls fishing while lying on their sides was a first: "One might have supposed the bird sound asleep," when suddenly a foot was thrust out with lightning speed to grab the unsuspecting meal. Accurate though the scene may be, rodents, not fish, are the snowy owl's preferred food. In comparison with the original watercolour, the faulty engraving greatly emphasizes the cleavage of the breast of the upper bird. In fact, although this is one of our largest owls, its bulk is almost all feathers, with an astonishingly small body underneath. Point-blank shots pass "right through the bird" without any harm, only a few ruffled feathers.

Havell No. CXXI

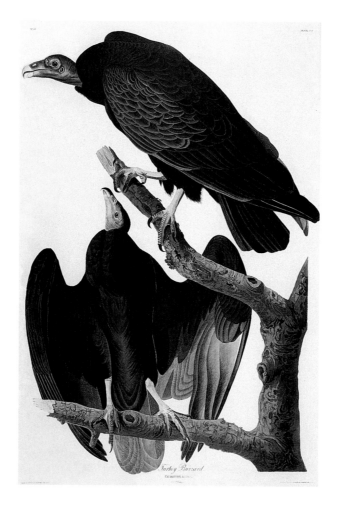

TURKEY VULTURE
Cathartes aura

In Audubon's day it was considered a southern bird, and as recently as the 1950s and 1960s sightings north of Delaware were rare. Today the turkey vulture, banking on upturned wings, wheels over Southern Canada's fields and highways, which supply much of its food through road kills. Its admirable habit of ridding the landscape of carrion cannot disguise the fact that it is not a beautiful bird, but what it lacks in physical beauty it more than makes up for in its effortless soaring, at one with the unseen winds and thermals. Because of its carrion-feeding habits, the turkey vulture was assumed to carry disease and attempts were made to eradicate it, as a health problem for humans. Their role in public hygiene is now better understood, and along with the closely related black vulture, it is encouraged throughout South and Central America, where sanitation facilities are primitive. The bare face and featherless legs are evolutionary adaptations. With little to cling to, the bacteria in rotting flesh do not adhere. Also, because of extremely powerful digestive agents, bacteria passing through the tract are killed. Even the feces when expelled on the legs and feet act as disinfectants. In 1820 Audubon painted perhaps his most amusing portrait of a baby bird, a bipedal ball of orange fluff, black pin-feathers just emerging as the bird appears from an equally black cave. Unfortunately, Audubon decided not to include the chick in the final plate, opting instead for two birds silhouetted against the sky on a dead tree, symbolic perhaps of the birds' association with death.

Havell No. CLI

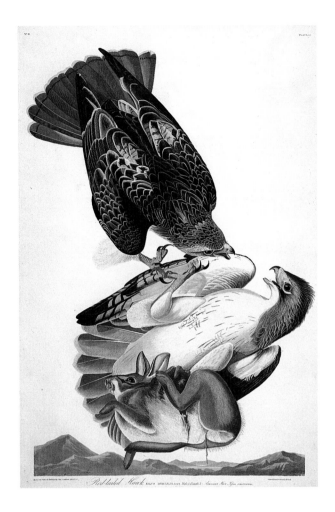

RED-TAILED HAWK
Buteo jamaicensis

In earlier days the unfortunate misnomer "hen hawk" was all the justification needed for ignorant and incessant warfare against our most common large hawk. Although it has been known opportunistically to pick up sick hens, the red-tail does not eat chickens regularly. The vast majority of its food consists of rodents and small mammals up to the size of muskrats and rabbits. The red-tail prefers open fields and perches along highways, where it waits patiently until it spots its prey, and then with folded wings it tips off into the void to plummet down on an unsuspecting meal. During courtship, males and females are seen somersault-ing out of the updraft of a thermal, clutching each other's talons and cartwheel-ing in a spectacular embrace towards the ground. At an unseen command they disentangle and, catching another thermal, soar on their huge wings back up thousands of feet. The same movements turn aggressive and occasionally deadly after their offspring have fledged. Audubon wrote: "It was after witnessing such an encounter between two of these powerful marauders, fighting hard for a young hare, that I made the drawing, in which you perceive the male to have greatly the advantage over the female, although she still holds the prey firmly in one of her talons, even as she is driven towards the earth." Close examination reveals that one of her talons has pierced the pad of her mate; disentanglement may be impossi-ble. By choosing the aerial battle pose, Audubon was able to include two life-size hawks, seen from above and below, in a single sheet.

Havell No. LI

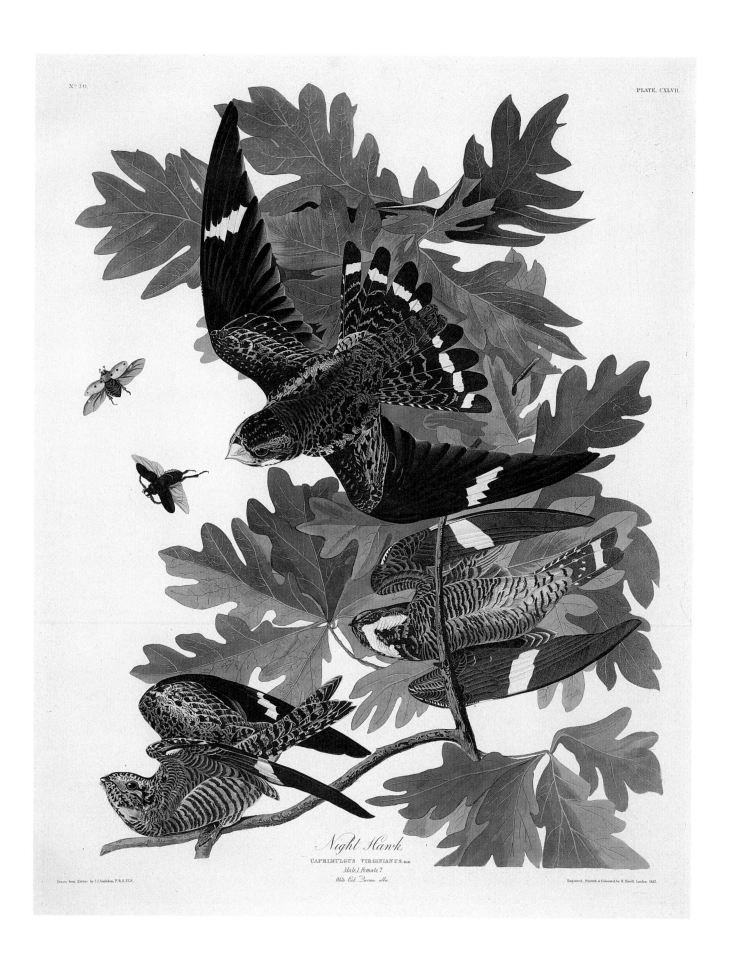

Night Hawk.
CAPRIMULGUS VIRGINIANUS.
Male 1 Female 2.
White Oak Quercus alba.

COMMON NIGHTHAWK
Chordeiles minor

Despite its huge size, *The Birds of America* anticipates the modern field guide by showing the various specific characteristics, colours and patterns that are diagnostic for each species. The modern field guide, primarily because of its small size, but also because of the convention of combining related species on a single plate with the birds shown in profile, cannot show many of the field marks. With the large format, and with each plate dedicated to a single species, Audubon was not bound by such strictures. In this plate he has shown the distinguishing marks of the nighthawk: the white bands on the wings and tail, the white throat chevron and the barred flanks. This could not have been accomplished if he had painted only one bird. Artistically, Audubon has emphasized the speed and erratic nature of the flight of the nighthawk by placing the birds against a background of overlapping oak leaves. The detail and accuracy of the leaves and insects shows another side of Audubon's art, one that is too often overlooked. For many city-dwelling Canadians, summer truly begins when the first nighthawks zigzag high above the gathering sunset. Then, in a lull in the traffic's roar, their squeaking *bizert* song glances down from the evening sky. As shown in Audubon's plate, the birds are hawking insects. After a migration from vaguely known wintering grounds in South America, this member of the superstitiously and absurdly misnamed order of "goatsuckers" (*caprimulgiformes*) takes up residence on our gravelled roofs, which have replaced rocky outcrops as its favourite nesting site. So confident are the birds of their camouflage against the stones that they can be approached within inches and even picked up without any reaction. No true nest is made, and eggs are deposited directly on the roof. The feet of the adult bird are so weak that they cannot perch as do other birds; rather, nighthawks must align themselves in rows along the branch for extra support—again a fact that Audubon has depicted. Formerly the object of gunners in the 1800s, thousands of "bull bats" were shot in the Southern States, where they were considered "quite as fat and better than the reed birds [bobolinks]." Audubon called them "fat and juicy." The Creoles called them the *crapaud volant*, the flying toad. They have also been called the mosquito hawk and, in England, the fern owl. They are not related to bats, owls or hawks. In 1852, Henry Thoreau captured their essence when he wrote: "Thus they went squeaking and booming... and I could imagine their dainty, limping flight, inclining over kindred rocks with a spot of white quartz in their wings."

Havell No. CXLVII

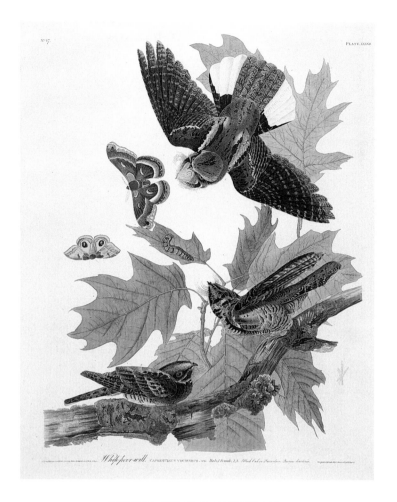

WHIPPOORWILL
Caprimulgus vociferus

That Audubon minutely observed his birds is clearly demonstrated by comparing this plate with that of the closely related nighthawk (Havell CXLVII), which is so closely related, in fact, that for years the two were considered the same species. The layout of the plates is basically identical. The identifying field marks of the two species are shown from above and below, with the bristles around the mouth of the whippoorwill and the white wing- and tail-bars of the nighthawk obviously contrasted. Of particular interest are the moths. In the whippoorwill plate, Audubon has included detailed portraits of a cecropia and an io. Both are found east of the Rockies. They emerge from their cocoons in late June, and by nightfall their wings are dry and strong enough to sustain flight. The inclusion of the moths was appropriate for a bird whose diet is mostly large flying insects. Audubon's keen eye further noted that even the largest moths were swallowed tail first. The caterpillar hugging the middle leaf sports false "eyes" and is probably the larva of a swallowtail butterfly. On the companion plate, of the nighthawk, Audubon accurately showed that the main food of that species is smaller flying insects. Audubon also noted that the feet are too weak to be of any real help in traditional perching; therefore, he has placed the bird at the lower left lengthwise along a branch for added support. The Latin name of the whippoorwill is delightful: *vocifer* loosely translates as "loudmouth." Anyone who has heard the bird repeat its call forty or fifty times in rapid succession will think the name suitable.

Havell No. LXXXII

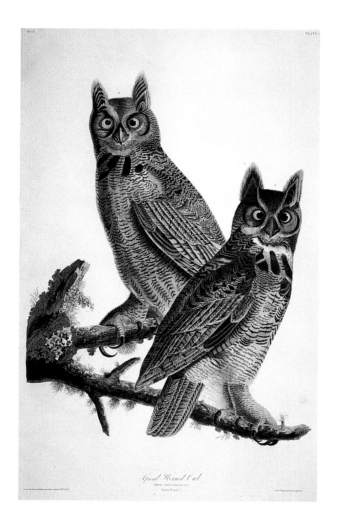

GREAT HORNED OWL
Bubo virginianus

One of the most spectacular owls in the world, with a wingspan of over fifty-five inches (1.4 m) the great horned owl also ranks among the largest. Found in virtually all habitats, from our own northern tree line to Tierra del Fuego, it is also one of the most adaptable. Contrary to popular belief, these owls have excellent day vision. Fixed in their front-facing sockets for binocular sight, the eyeballs are larger than our own. The structure of the rods and cones and the assemblage of the retina permit the eyes to pick out dead prey at six feet or more in light as low as 1 percent of the minimum intensity required by humans. The "ears" play no role in hunting; they are in reality only tufts of feathers. For so huge a bird, their absolutely silent flight is remarkable. Audubon described the flight in ominous tones: ". . . gliding, sailing, sweeping like a moving shadow, now distinctly seen, and again mingling with the sombre shades of the surrounding woods, fading into obscurity." Audubon tasted the flesh of the barred owl but remained silent about the gastronomic virtues of the great horned. Perhaps he took to heart the biblical interdiction found in Leviticus 11:13–17: "These are they which ye shall have in abomination among fowls; they shall not be eaten . . . the little owl, and the cormorant, and the great owl." Despite the possible wrath of God, the countryfolk of Yorkshire, even well into this century, knew that owl soup was a cure for whooping cough.

Havell No. LXI

GREAT GREY OWL
Strix nebulosa

Eye contact with the unblinking stare of the great grey owl is either thrilling or disconcerting, depending on one's feelings for birds of prey. It is an experience that few have had, for the great grey is a bird of the deep north woods, and is only rarely seen in populated areas of Canada and even more rarely in the United States. With its camouflaged feathers and its silent and slow flight that seems to defy gravity, the great grey appears to be an extension of the eternal hush of the northern forests. For this imposing species Audubon had to resort to using a captive female as his model. In his *Ornithological Biography* he wrote: "My drawing was taken from a remarkably fine specimen in the collection of the Zoological Society of London." Despite a wingspan of up to five feet (1.5 m) and a body length over thirty inches (76 cm), the owl, depending on its recent diet, weighs only between two and three pounds (.9 to 1.3 kg), the size of a small frying chicken and less than a quarter of the weight of a female eagle owl, the world's largest. The great grey weighs even less than the snowy owl or the great horned owl. Known throughout Northern Europe as the Lapp owl, the great grey inhabits the taiga regions from Scandinavia and Russia across our own tractless northern forests. Totally silent, it is known, with a mixture of awe and affection, as the great grey ghost. With a circumference of more than twenty inches (50 cm), the perfect facial disc is the largest among owls. Like parabolic dishes, the discs concentrate noise and direct sounds to the ear openings, which lie just beneath the level of the eyes along the sides of the skull. In a delightful misquotation from Richardson's *Fauna boreali americana*, a leading European ornithologist in 1863 claimed that the owl ate "marine" animals. The intended word was "murine," meaning mouselike voles and lemmings. Audubon rightly concluded that, because of the relatively small size of the talons, which he showed in the portrait, the birds did not generally prey on larger mammals. He also rightly assumed that the small eyes indicated that these birds usually hunted by daylight. Audubon's pose depicts another aspect of the great grey's structure: the small eyes are fixed in their sockets, so the bird must turn its entire head to follow whatever is in focus. The lack of eye movement is compensated for by a mechanism of vertebrae that permits a full 270-degree rotation of the head. This flexibility mitigates the impact of the owls' relatively narrow field of vision, approximately 110 degrees versus almost 180 degrees for humans. In an example almost unique in bird painting, Audubon has his owl looking at us over its shoulder, exactly as it would in nature if we approached it from the rear.

Havell No. CCCLI

PLATE CCCLI

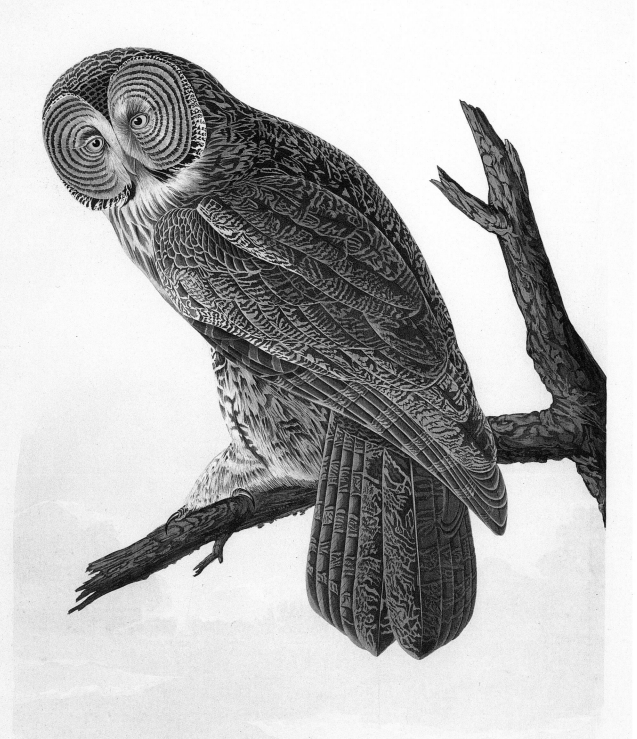

Great Cinereous Owl.
STRIX CINEREA, *Gmelin*

Female. Adult.

WILDERNESS WATERWAYS AND WETLANDS

If indiscriminate chopping down of forests, over-farming and fencing were three of the Horsemen of the Apocalypse as far as wildlife was concerned, there was a fourth: drainage. During the century in which Audubon lived, wetlands covering an area of 100 million acres, or 150,000 square miles, were drained. This area is greater than all of New England. The water level and water table dropped; this meant that more trees died of thirst, and with their roots no longer able to conserve precious moisture, erosion set in with a vengeance. Perhaps 60 per cent of America's topsoil was washed or blown away during the Draining of America. And with the disappearance of the swamps and marshes, with the needless damming and ill-advised regulating of our rivers, the habitat disappeared for countless millions of wildfowl and other forms of wildlife dependent on a watery world. In 1876, John Rowan wrote: "Where nature is so bountiful in her gifts man rarely appreciates them. As with the forest, so with the fish. It would really seem as if Nova Scotians hate the salmon, and have determined by every possible means to deny them access to their rivers. Over-fishing is bad enough, but to shut the fish out of the rivers altogether is little better than insanity. By-and-by, when the forests have been utterly destroyed and the rivers rendered barren, Canadians will spend large sums of money in, perhaps, fruitless efforts to bring back that which they could now so easily retain." The waterbirds that filled the markets and Audubon's paintings are today a hesitant echo of their former selves.

CANADA GOOSE
Branta canadensis

Audubon described the Canada goose with no less than twenty pages of text, one of the longest descriptions in the entire *Birds of America*. He waxed eloquent about their "courage," "affection," "rage," about their being "lovers," "loving and patient consorts," and their ability to feel "exultation." The numbers had been so significant in the late eighteenth century that Thomas Pennant could write in his *Arctic Zoology*: "The English of Hudson's Bay depend greatly on Geese, of these and other kinds, for their support; and in favourable years, kill three or four thousand, which they salt and barrel." Audubon himself wrote in his Labrador *Journal* of August 1833: "I saw a large pile of young Canada Geese that had been procured a few days before, and were already salted for winter use." The aboriginals around Hudson's Bay so impatiently awaited their arrival as a harbinger of spring that they called it "the Goose Month." Their long V formations have been part of Canada's skies from time immemorial, their loud honking sometimes penetrating houses through closed doors and windows. The Canada goose should be called the Canada geese. From the largest, the giant Canada (*Branta canadensis maxima*), also known as the honker, at eighteen pounds (8 kg), to the smallest, the cackling goose (*B.c. minima*) at three to four pounds (.9 to 1.3 kg), at least twelve distinct subspecies are recognized. The white throat patch on the black neck, the barred tan back and the white vent are common to all, but nesting habits and geography isolate most of the various populations. Originally found right across Canada, the bird has now become a world citizen through ill-conceived introductions in England, Europe and even New Zealand. Highly migratory in the wild, the geese have become all too well adapted to urban parks, golf courses and lawns. Urban geese have become a pest and even a health hazard. Recently, Toronto's vast resident flock gave up a group, which were reintroduced into New Brunswick. Their beauty is hard to resist. Aldo Leopold captured their essence in his *Sand County Almanac* (1949): "They weave low over the marshes and meadows, greeting each newly melted puddle and pond. Finally, after a few pro-forma circlings of our marsh, they set wing and glide silently to the pond, black landing-gear lowered and rumps white against the far hill. Once touching the water, our newly arrived guests set up a honking and splashing that shakes the last thought of winter out of the brittle cat-tails. Our geese are home again."

Havell No. CCI

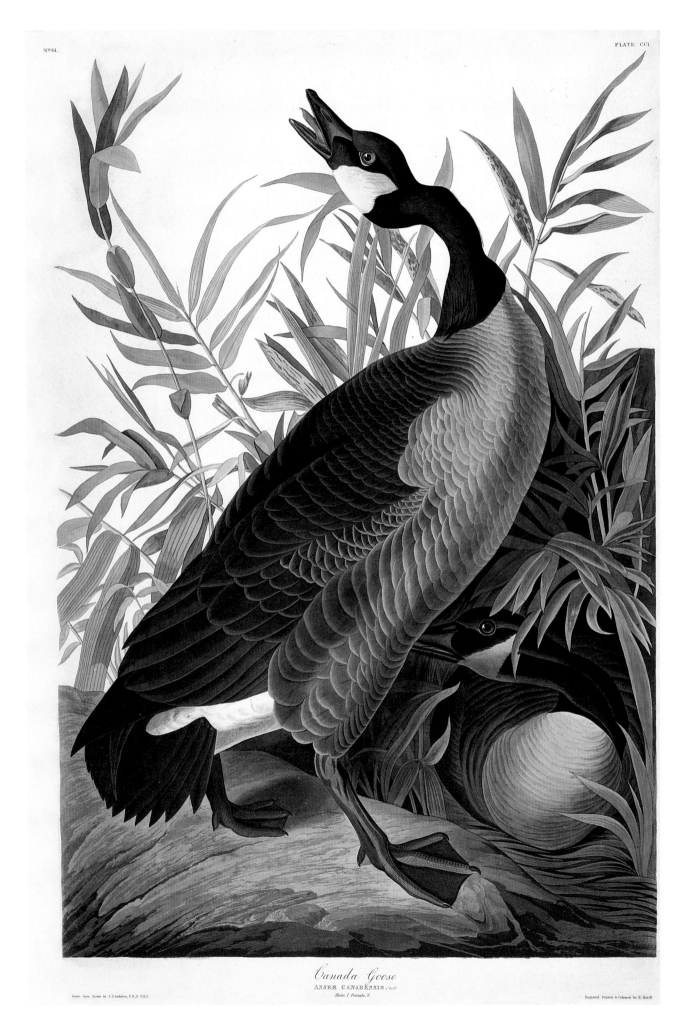

Nº44. PLATE CCI

Canada Goose
ANSER CANADENSIS, Vieill
Male, 1. Female, 2.

Drawn from Nature by J.J.Audubon, F.R.S. F.L.S. Engraved, Printed & Coloured by R. Havell

CANADA GOOSE (HUTCHINS')

Branta canadensis

Audubon had searched in vain during his Labrador trip for a specimen of the species that had been collected on Melville Island during Captain Parry's second Arctic voyage, on June 19, 1822. At the time, they were not recognized as a subspecies of the Canada goose, but rather were thought to be a colour morph of the brant (the smallest of the wild geese). The Cree Indians of Hudson's Bay knew they were not brants; they called them by a different name, *apistiskeesh*. One of the crew members on Parry's ship was James Clark Ross, the future Captain Sir James Ross, who would later command the *Erebus* and *Terror* to the Antarctic. Ross and his father were also with the Booth Expedition when the north magnetic pole was discovered. It was Captain Ross who sent Audubon the specimen of this small goose, which he painted in London in 1834 or 1835. Ross also supplied Audubon with the rock ptarmigan, the glaucous gull, the ivory gull, the long-tailed jaeger and the red phalarope. Interestingly, Ross's gull was named after Captain Ross, but Ross's goose honours Bernard Rogers Ross, chief factor of the Hudson's Bay Company, who lived from 1827 to 1874. Richardson, in his 1832 *Fauna boreali americana*, says he chose to honour Hutchins because he had supplied most of the information on Hudson's Bay birds for Thomas Pennant's 1784 *Arctic Zoology* and John Latham's 1780 *General Synopsis of Birds*, even though Pennant, at least, never acknowledged the debt. Today, ironically, we recognize the Hutchins' goose as one of the twelve subspecies of the Canada goose, and have renamed it the Richardson's goose. The Hutchins' is the second-smallest subspecies of Canada goose, only marginally larger than the cackling. All share the black neck and white throat patch, but as was confirmed by the discovery of the Hutchins' nest in 1926, their breeding habits are very diverse. This goose, which is strictly a coastal species, lays its eggs on a mound, whereas most of the others lay theirs in depressions. Robert Havell, the engraver, added the tundralike background.

Havell No. CCLXXVII

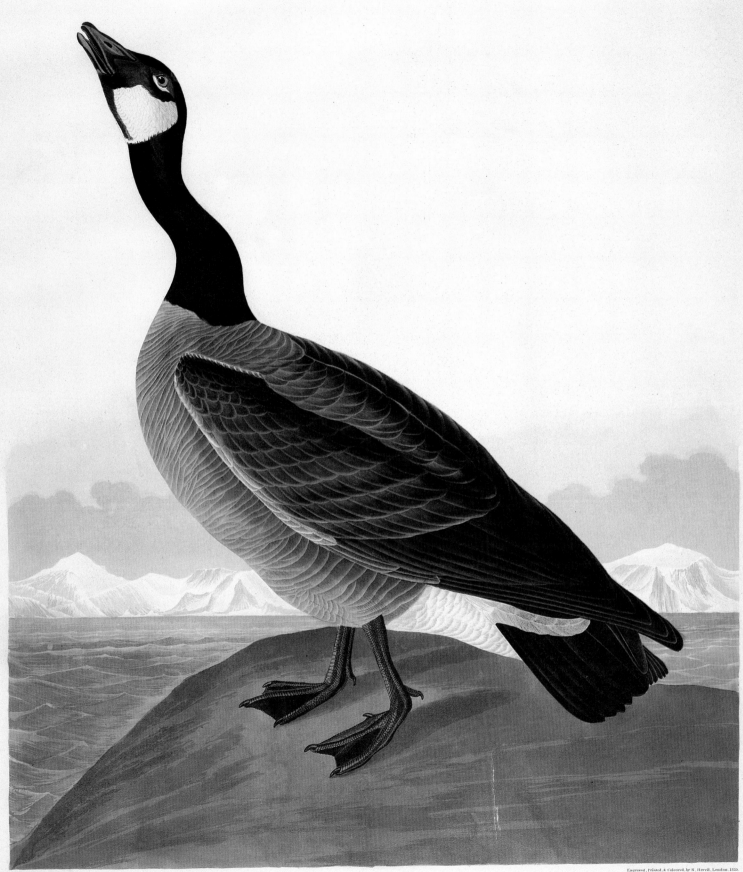

Drawn from Nature by J.J.Audubon, F.R.S. F.L.S. Engraved, Printed & Coloured, by R. Havell, London, 1835.

Hutchins's Barnacle Goose.
ANSER HUTCHINSII, Richᵈ & Swain.

GREAT BLACK-BACKED GULL
Larus marinus

The great black-backed gull, majestic with its sixty-six-inch (168 cm) wingspan, is the largest and strongest of its tribe. Wheeling or soaring high overhead, it seems more like an eagle than a gull. It towers over its smaller cousins, who keep a respectful distance when they share a rock or shore during the non-breeding season. Audubon, with obvious gothic glee, wrote of the great gull's predilection for putrid whale meat, other seabirds, and any fish it could pirate from its neighbours. It would have been equally accurate, if less dramatic, simply to note that the birds are omnivorous. Their range is restricted to the rocky coasts on both sides of the North Atlantic. Because the black-back is higher up the food ladder than the smaller gulls, its numbers are correspondingly less. There are an estimated twenty-five thousand nesting pairs in Great Britain, compared with three hundred thousand pairs of herring gulls. In North America, they breed north to Labrador, but in recent years they have extended their range to Lake Huron. Living up to thirty years, the mature great black-back has a yellow beak with a carmine spot near the tip. Instinctively, the nestlings peck at this dot of colour, causing the adults to regurgitate partially digested food. The smell of a nesting colony is not easily forgotten on a hot summer's day. Maturity also brings yellow feet and black claws. Audubon painted his bird to show all the field marks, and included a detailed study of a foot. The bird is pictured wounded, crying out in pain, and stretching its good wing in its death throes in a vain attempt to escape. By silhouetting the wing against a blank sky, Audubon was able to emphasize the most obvious field mark, the black back for which the species is named. In this dramatic composition Audubon has combined art and science with a touch of theatre, while brilliantly fitting the huge gull into the confines of the printed page. There are a dozen or so plates in which Audubon has included dead birds, but usually they have fallen victim to some natural predator. This plate, along with those of the Eskimo curlew and the pair of goldeneyes, is one of only three that show the principal birds either dead or close to death.

Havell No. CCXLI

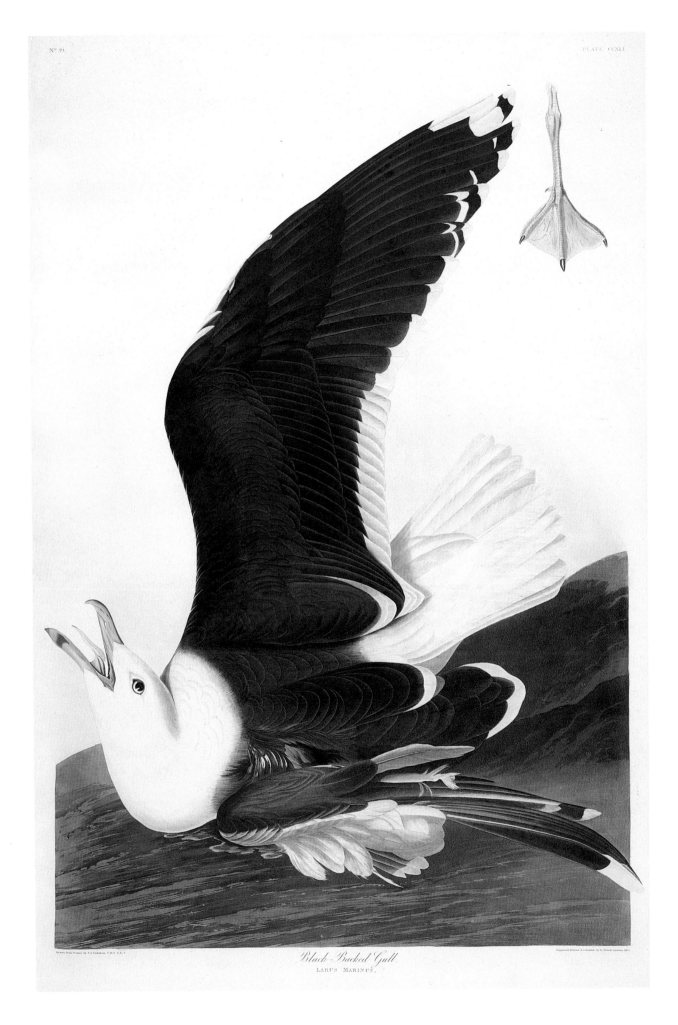

Black-Backed Gull.
LARUS MARINUS.

GREAT BLUE HERON
Ardea herodias

Audubon had vowed to paint all North American birds *life size*. Fitting the four-and-a-half-foot (1.3 m) great blue heron into the available space was a challenge both artistically and scientifically. In his text, he devoted a significant amount of space to a detailed description of the mating dance and display that appears in this plate. Only in the breeding dress do we find the soft plumes that cover the lower neck and back that Audubon has figured in such detail. The great blue is a member of the Ciconiiformes, which as an order date back 100 million years. Within the group, the largest birds form the eleven species in the *Ardea* genus, including the great blue of North and Central America and the Caribbean. Until 1973, an all-white group was considered a separate species, but it has now been established that it is merely a colour variant of the great blue. Audubon painted them in a separate plate, "The Great White Heron," and in his text described the majestic birds "perched like so many newly finished statues of the purest alabaster." That the great white is found exclusively along the south Florida coasts, whereas the great blue is common on inland lakes, and that the white is larger and has a greater wingspan than the blue further compounded the confusion. The great blues nest in heronries of huge, messy nests concentrated in a few trees. It always comes as a surprise that such tall birds, with such large feet, can perch steadily on what appear to be branches far too slight to support their weight. The noise of a heronry is astonishing; it has been likened to the battle cries of axe-murderers on a rampage. The medieval hunting term for a group of herons was "a siege," not inappropriate considering the mayhem. In stark contrast is the beauty and elegance of the heron in flight: the wings beat slowly—two to three beats per second—but the unusually large wing surface carries the bird at surprising speeds. Standing patiently along waterways and coasts, the great blue can dart out his rapier-like bill with blinding suddenness to spear a hapless fish or frog. Audubon has emphasized the movement by counterbalancing the forward thrust of the bird with clumps of grasses curved in the opposite direction in both the foreground and the background. Old age does not appear to slow them down. More than 70 per cent of the chicks die during their first year, but if they survive beyond six months, they can expect to live twenty years and more in the wild. Once they were not so lucky. Demand for nuptial plumes for the millinery trade almost caused their extinction. Natural disasters continued where the mad hatters left off: a hurricane in 1935 reduced the number of white birds to 150. The blues were more fortunate, and are found commonly throughout their vast North American range.

Havell No. CCXI

Nᵒ 43.

PLATE. CCXI.

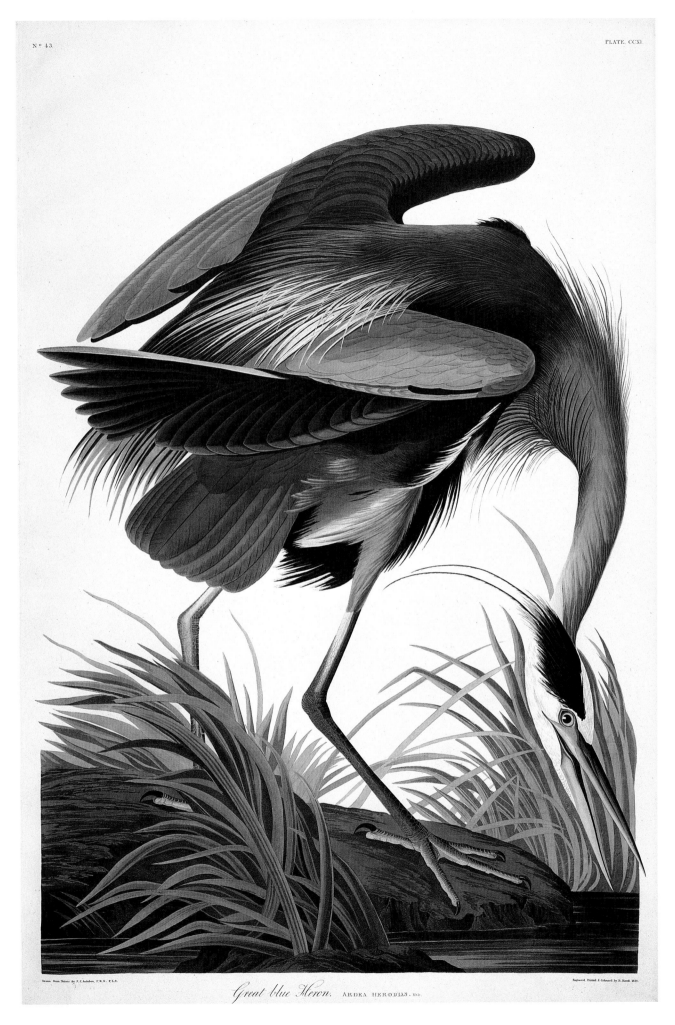

Drawn from Nature by J. J. Audubon, F.R.S., F.L.S.

Engraved, Printed & Coloured by R. Havell, 1834.

Great blue Heron. ARDEA HERODIAS. Male.

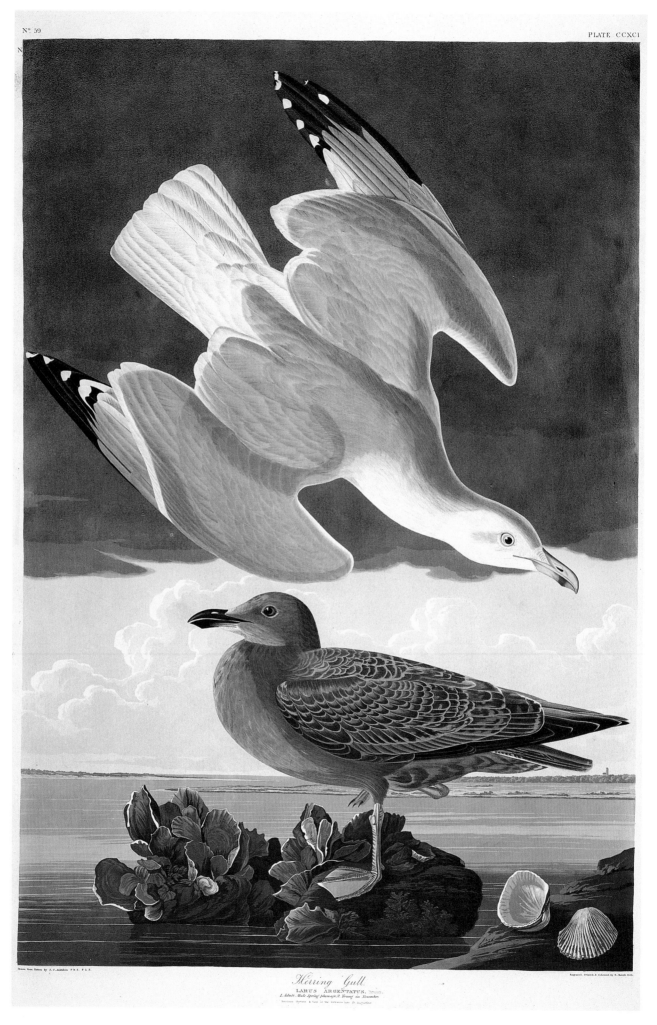

HERRING GULL
Larus argentatus

Two groups of five subspecies, each covering Europe, Asia and North America, make the herring gull one of the most common and familiar gulls in the northern hemisphere. This was not always the case, as the herring gull is one of the few birds whose numbers have increased dramatically since Audubon's day. In 1900 there were an estimated four to eight thousand nesting pairs in New England; today, there are an estimated 120,000 nesting pairs. Similar increases have been noted in northern Europe. The causes, however, are not happy ones: garbage and wasteful fishing methods. Being an opportunistic feeder, the herring gull scavenges both inland and along the coasts, eating everything from turnips to fish entrails, but mostly the refuse from the population explosion of humanity. Another reason for the herring gull's success is a discomfiting level of intelligence. In 1833, on White Head Island at the mouth of the Bay of Fundy, Audubon learned that when their mossy nests were robbed on the ground, the birds began nesting in trees and even on buildings, much to the concern of municipal health officials. Herring gulls are frequently seen doing a "rain dance." They stand in one spot on a lawn, patting the surface with their webbed feet. The vibrations make worms think it is raining. When they surface, the gulls grab them. Audubon was fascinated to see thousands near Cape Sable, the southernmost point of Nova Scotia. He noted: "They also take up shells in the air, and drop them on the rocks to break them." One bird, Audubon noted with admiration, took three tries, each from a higher elevation, to break open a particularly tough mussel. With talents such as these, herring gulls can live long lives. The oldest herring gull on record was tagged as a chick in Denmark in 1925 and was recovered in 1953, twenty-eight years later. The plate shows an adult with the plumage that it acquires after the third year, and an immature ". . . which I have placed on a bunch of Raccoon oysters where it was standing when shot." J.C. Squire, in his poem *The Birds*, conjured up the right vision: "A dizzying tangle of gulls were floating and flying / Wheeling and crossing and darting, crying and crying." Soaring effortlessly on their four-foot (1.2 m) wings, and with their dapper grey-and-white plumage, the herring gulls are beautiful birds individually, but in a flock they are a joy to behold.

Havell No. CCXCI

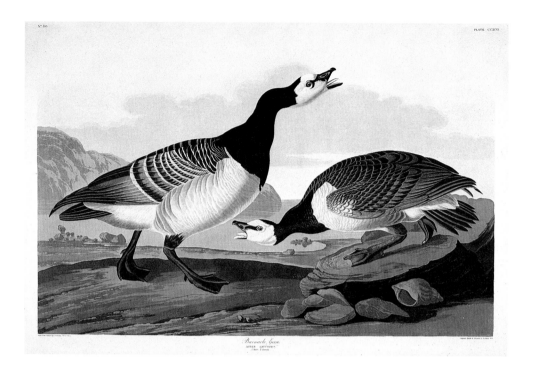

BARNACLE GOOSE
Branta leucopsis

"I acknowledge that I have never met with one of them...I must further confess my ignorance of the habits of the Barnacle." Audubon never did see the barnacle goose in North America, but he included the portrait, he explained, in the fond hope that the bird would soon be seen. In fact, the barnacle is a European species, which only occasionally visits the Atlantic seaboard. Although the bird was known to winter in Europe, its nesting habits in the high Arctic remained a mystery until 1921, when birds were discovered breeding in Greenland and Spitsbergen. This ignorance gave rise to the most ridiculous fable ever propounded by serious natural historians. The clue is in the name, barnacle. In his 1597 *Herball*, Gerard wrote: "But what our eyes have seen, and hands have touched, we shall declare." And what he saw was a seashell now called *Concha anatiferae* (the shell that makes geese). This is a type of barnacle that attaches itself to rotting timbers and shipwrecks, and extends a tentacle resembling the barbs of a feather; this, along with its fleshy foot, or pedicle, was enough to cause serious people to believe that the barnacle contained an embryonic bird. After an appropriate gestation period, a full-grown barnacle goose emerged. Gerard even included a woodcut showing this happening! The first quoted source for this miracle was Gyraldus in 1175. By the sixteenth century the names of authorities who subscribed to this silliness, some even claiming personal experience of it, become too numerous to list, but they included such churchmen as Bishop Olaus Magnus of Norway, and Torquemada, whose grasp of similar truths qualified him to be the "Angel of the Spanish Inquisition." Because the barnacle goose was born of a seashell, it was—despite all rational proof to the contrary—considered by the Renaissance Catholic Church to be a fish, and therefore was permitted to be consumed on meatless Fridays.

Havell No. CCXCVI

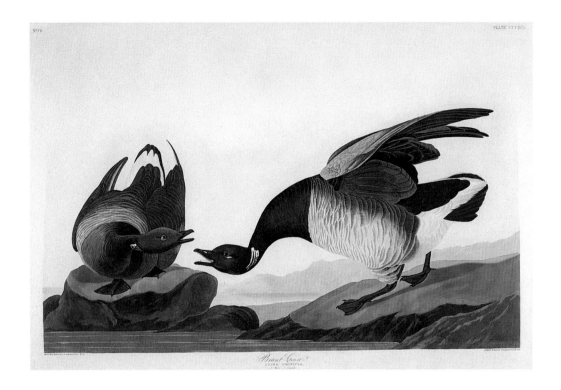

BRANT
Branta bernicla

Arthur Bent, in his *Life Histories of American Birds* from the 1920s, wrote: "From the standpoint of the epicure, the Brant is one of our finest game birds, in my opinion the finest, not even excepting the far-famed Canvas-back. I cannot think of any more delicious bird than a fat, young Brant, roasted just right and served hot, with a good bottle of Burgundy." Audubon would have agreed. He wrote that they were as beloved by the epicures of Boston as the canvas-back was by those of Baltimore. He personally found the Brant "tender, juicy and fat." In Audubon's day the brant were by our standards incredibly numerous, but starting in 1931, with the unprecedented and nearly complete destruction of the eel-grass *Zostera marina*, their main source of food south of Labrador all down the Atlantic coast, the numbers plummeted. Hunters would wait in vain for the long, undulating lines of geese, flying silently (as Audubon claimed) or sounding (as Alexander Wilson claimed) "like a pack of hounds in full cry." The East Coast brant is replaced on the West Coast by the black brant, a bird that is very similar, but on whose belly the black markings are much more extensive. In both cases, the birds appear black from a distance. This explains the derivation of their name from an old Anglo-Saxon word for "brand" or "burnt." Strangely, the black brant is a very uncommon visitor to the East Coast, and therefore it is a surprise that the first specimen was described scientifically by George H. Lawrence in 1846 from a bird taken at Egg Harbour, New Jersey. In Audubon's plate, the background habitat may well have been painted by his eldest son, Victor, a fine landscape painter in his own right, who would supply several settings for Audubon's *Quadrupeds*. It was also Victor who oversaw most of the publishing details for the miniature octavo edition of the *Birds*.

Havell No. CCCXCI

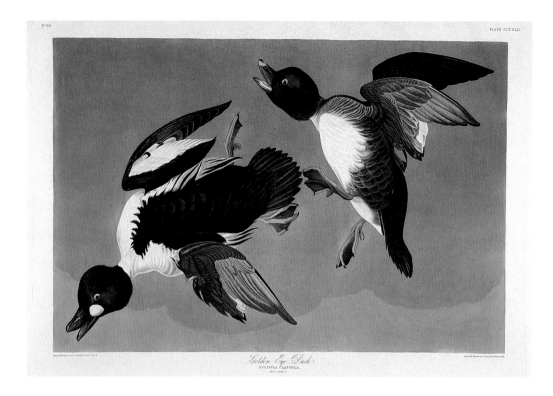

COMMON GOLDENEYE
Bucephala clangula

Audubon wrote: "You rise on whistling wings and, faster than Jer Falcon, speed away." "Whistler" is one of the common names of the goldeneye. Males and females beat their wings at slightly different rates, and so, mathematically, they achieve unison only for a brief moment before resuming an ever-changing syncopation. The head of the male is a beautiful metallic green, contrasted with pure white underparts and a white patch on both cheeks. The eyes are, as the name would suggest, golden. Criticism is levelled at Audubon for poses that are considered distorted. His plate of the two goldeneyes is frequently cited. A closer examination of the left-hand bird bears out the explanatory text. There is a drop of blood at the wrist of the lower wing. The birds have been shot and can no longer fly, but rather are hurtling through space towards their death. The poses, therefore, are not distorted at all, but rather capture the movements of birds, travelling at high speed, which have absorbed the impact of a gunshot. One artist who understood what Audubon was portraying was Winslow Homer. His 1909 painting "Right and Left" shows two goldeneyes being shot out of the air by the discharge of a gun whose still-smoking barrels partially obscure the hunter in the small boat in the distance. The positioning of Homer's birds and their poses are obviously based on Audubon's original. It was painted less than two years before Homer's death, and although not his last painting, it is considered his last great painting even by those critics who dismissed Audubon's efforts as "contrived." One wonders what the criticism would have been if he had chosen accurately to portray the nonsensical-appearing poses in the courtship dance. No one seems to have ridiculed the representation of exactly those antics of the closely related European goldeneye by John Guile Millais in the late 1890s. Of course, Millais only claimed to be portraying "natural history," and so posed no threat to the established art community.

Havell No. CCCXLII

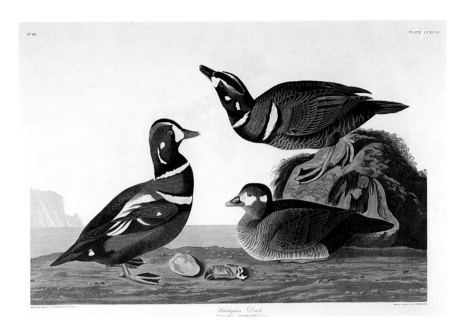

HARLEQUIN DUCK
Histrionicus histrionicus

After the incomparable wood duck, the harlequin is considered by many to be the most beautiful of its family in North America. Their elegant attire has given them common names like lords and ladies, by which they are known to Maritime fishermen, or, more broadly, the painted duck. The double Latin name, *Histrionicus*, comes from *histrio*, meaning a stage player. The bold colours and even bolder pattern look like a costumed actor, specifically Harlequin, the lovable buffoon character in medieval Italian theatre who was the suitor of Columbine, the coy heroine. Her name is given to the beautiful wildflower whose drooping bells with five upturned curved spurs is so closely associated with Newfoundland. Its Latin name, *Aquilegia canadensis*, links our country with the very place where Audubon found the harlequin nesting in abundance. On May 31, 1833, he reported, "I found them breeding on White Head Island, and other much smaller places of a similar nature, in the same part of the Bay of Fundy." There seems to be another reason to love these ducks. The larvae and pupae of blackflies require the high levels of oxygen found primarily in eddies around rocks or under small waterfalls. These are also the preferred habitats of the harlequin, as the future blackflies form a major portion of their diet. As Thomas Nuttall explained in 1833, "They seek out the most rocky and agitated torrents." Harlequins can enter boiling foam and emerge *upstream* without any apparent difficulty. Along the ocean beaches they earn their Icelandic name, *brindufa*, the breaker dove, courting what would appear to be certain death in the crashing waves. Both eastern and western harlequins have an unusual habit of never leaving a watercourse; even when an oxbow almost doubles back on itself, they insist in keeping over the actual river. The harlequins can disappear in a flash from sight but, once seen, never from memory.

Havell No. CCXCVII

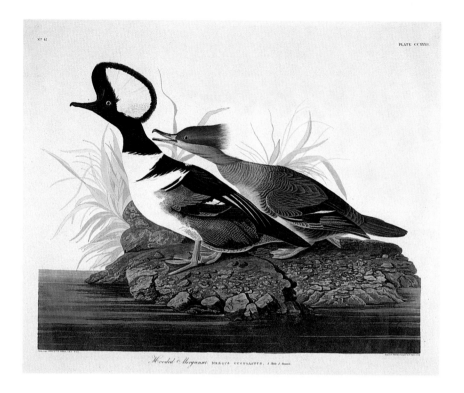

HOODED MERGANSER
Lophodytes cucullatus

Appearing wherever there are forest-lined ponds and streams or flooded bot-tomlands, from the Maritimes to Florida across the entire continent to Alaska and California, the hooded merganser is one of our most widely distributed species. Audubon was struck by their beauty and elegance, and by the affection towards the young evinced by the female (the males abandon their spouses as soon as incubation starts). But mostly Audubon was fascinated by their flight, which had, he wrote, "an almost incredible velocity." Other naturalists compared it to "the speed of a bullet." Flying at up to ninety miles per hour (150 kmph), the hooded merganser is indeed one of the fastest birds, wings beating so quickly that the out-line of the body can be seen through the blur of the pinions. The Cree Indians of Saskatchewan reportedly called it the beaver duck, supposing, almost surely inaccurately, that they entered abandoned beaver and muskrat lodges through the underwater passages to build their nests. In reality, like the wood duck, this mer-ganser is a tree nester, finding small cavities up to fifty feet (15 m) above the ground in a variety of tree species. They must be adjacent to or at least near water. There is considerable competition from wood ducks, which are attracted to the same nesting sites, but often the two species share a nest. There are so many eggs—hooded mergansers have been credited with as many as eighteen—that they are laid in layers. At their appointed time, the nestlings leap into space and float down to water or soft ground. As northern ponds begin to freeze, the birds move south ahead of the frost line, sometimes lingering on streams where rapids or waterfalls keep the water open. Their speed, abrupt changes in flight direction, small size and very ordinary-tasting meat have all helped the hooded merganser avoid persecution from hunters. Audubon portrayed this couple in their court-ing mode, with the male stretching out his neck and erecting his beautiful crest.

Havell No. CCXXXII

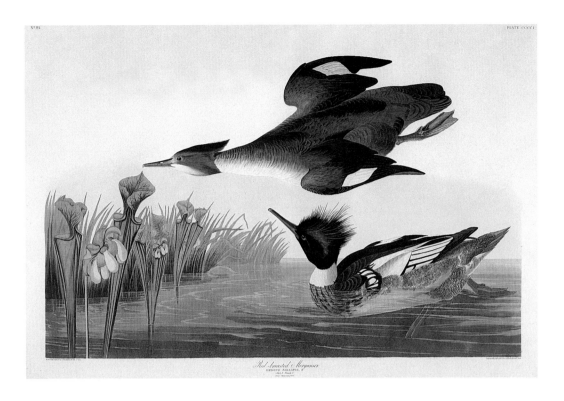

RED-BREASTED MERGANSER
Mergus serrator

Audubon was fascinated by the fish-eating merganser family. Because the red-breasted is, he said, "gluttonous in the extreme, it frequently gorges itself so as to be unable to fly." When it disgorged excess fish it could "move with astonishing rapidity, whether on the surface, where they ran with almost the speed of a grey-hound, or in the water itself, in which they show themselves as much at home as if they were seals or otters." He accurately described its range as covering most of the continent, but inaccurately claimed that it preferred fresh water to such an extent that it was seldom seen, except in cases of duress, in salt or brackish water. Despite this, he reported, "it is common in this season [spring] in the British provinces of New Brunswick and Nova Scotia, and is still more plentiful on the islands of the Gulf of St. Lawrence, as well as on the streams of Newfoundland and Labrador." Like their close relative the American merganser, the males of the red-breasted, during their late summer eclipse moult, assume the brown that is typical of the female's plumage. Huge numbers of what appear to be all females gather in the fall, the numbers swelling as the growing flocks migrate south along the Pacific and Southeast coasts. The layout of Audubon's final plate is an interesting example of how some of his original watercolours were modified by Robert Havell, the engraver. The changes were usually, but not always, for the better. Havell added the water and the interesting aquatic plants at the left, to give more balance and a sense of horizon to the composition. More significantly, he shifted the flying bird in Audubon's painting from the extreme left and placed it directly over the male, lowering it and reorienting the flight path. Originally, Audubon had aligned it with the upturned bill of the swimming male. Had Audubon's plan been followed, the intimate contact between the two birds would have been lost, and the imminent disappearance of the upper bird would have destroyed the unity of the composition.

Havell No. CCCCI

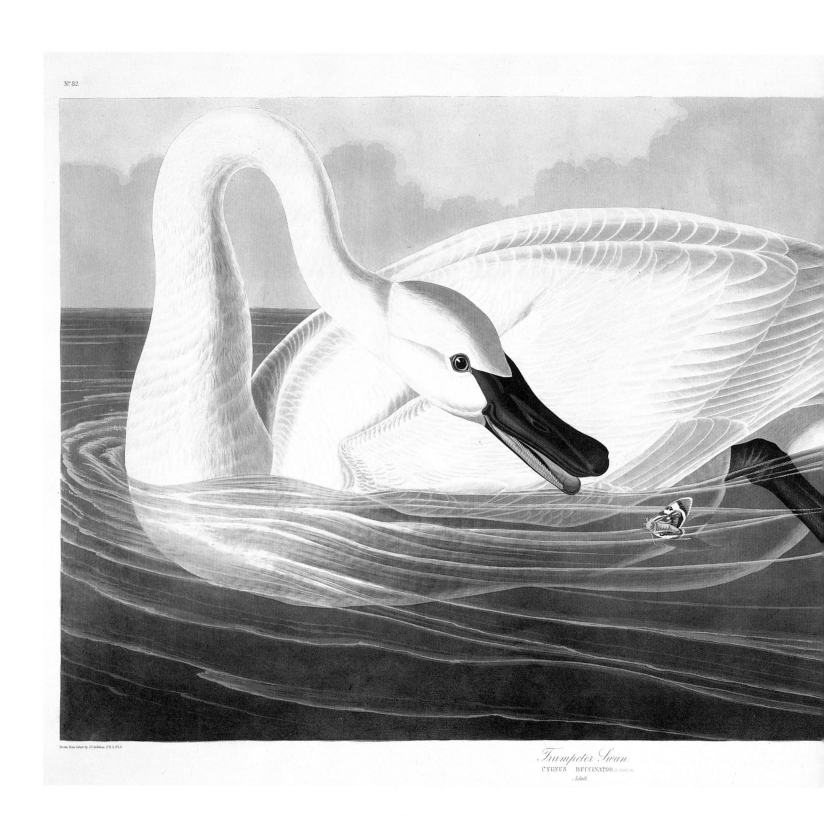

Nº 82.

Drawn from Nature by J.J.Audubon, F.R.S. F.L.S.

Trumpeter Swan.
CYGNUS BUCCINATOR Richardson
Adult.

PLATE CCCCVI

Engraved, Printed & Coloured by R.Havell 1836

TRUMPETER SWAN
Cygnus buccinator

Soon after Audubon arrived in England, and before he was well known, he was befriended by a prominent Liverpool family, the Rathbones. At their request, he contributed to *A Winter's Wreath* for 1829, his first public description of the American wilderness. The episode, which in slightly modified form was later included in his *Ornithological Biography*, recounted a swan hunt that he had undertaken with some Cree Indians near the Mississippi River on Christmas Day 1810. The swans in question were trumpeters. Measuring five feet (1.5 m) in length, with a wingspan up to ten feet (3 m) and weighing up to thirty pounds (13.6 kg), the trumpeter swan is the largest of its kind in the world. At the height of the fashion craze for feathers in the mid-nineteenth century, swan feathers were used to trim hats and dresses, as fans, and as powder puffs that were the epitome of softness, a feature not lost on a modern tissue manufacturer. The exclusive source of the birds was Canada. The Hudson's Bay Company had traded in trumpeter swans as far back as 1769, exporting 396 skins in 1806 and 800 in 1818. In 1828, 5,072 skins were sold in London, and 4,263 the next year. These were from the birds whose arrival Audubon described: "Flock after flock would be seen wing[ing] from afar in various directions." The birds that had survived the millinery trade continued to be an irresistible target for hunters. The huge flocks of Audubon's day were so reduced that by 1892, at the height of the collecting craze, a trumpeter's egg fetched $4, whereas those of the whooping crane and the heath hen (now extinct) could be bought for $3 each. By 1932 there was only a pitiful rump of sixty-nine birds in the United States, and an estimated three to four hundred in Canada. Protection through the Migratory Bird Act of 1918 brought the trumpeters back from the brink of certain extinction. In the 1960s, thousands were found nesting in Alaska, and today they are, in their season, a common sight on the remaining wetlands over virtually all their former range. In this plate Audubon depicts the swan eyeing a *Catocala cara*, a beautiful moth with a three-inch (7.6 cm) wingspan, that has fallen into the water. Crippled, it floats with the colourful underwing exposed, rather than the drab upper surface. Forest-lined watercourses are its preferred habitat, so its presence is totally appropriate. This is yet another example of the profound attention to detail that Audubon incorporated into his plates. But Audubon had another reason for his admiration of trumpeters: "Their quills, which I used in drawing the feet and claws of many small birds, were so hard, and yet so elastic, that the best steel-pen of the present day, might have blushed, if it could, to be compared with them."

Havell No. CCCCVI

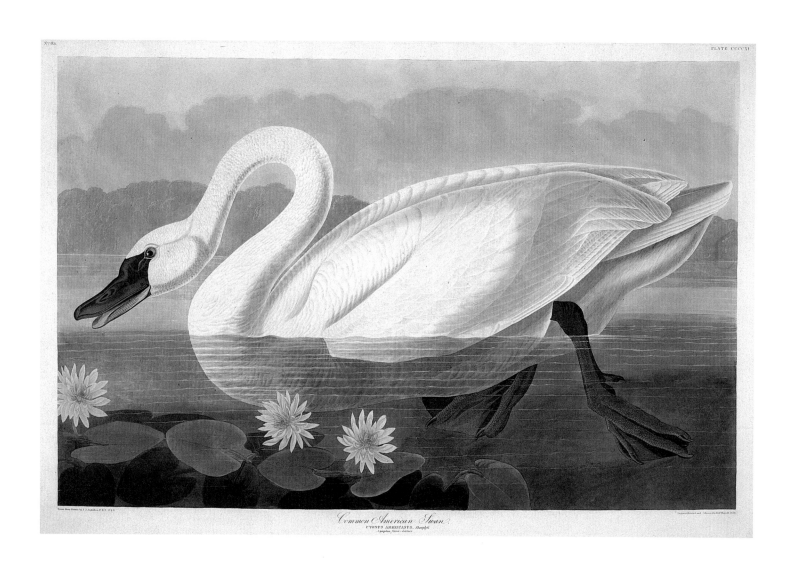

Common American Swan.
CYGNUS AMERICANUS, Sharpless.
Nymphaea Flava - Leitner.

TUNDRA SWAN
Cygnus columbianus

Until the powers that be decided that similar swans from Eurasia and America would henceforth be called the tundra swan, *Cygnus columbianus* was known as the whistling swan, a name that will endure for at least another generation, despite the scientists. From a distance, it is almost impossible to tell the whistler from the trumpeter. Only up close does the weight disparity become obvious: the whistling swan weighs up to eighteen pounds (8 kg), the trumpeter up to thirty pounds (13.6 kg). And if you are a fanatical birdwatcher, you will be interested to learn that the whistler has twenty tail feathers versus twenty-four for the trumpeter, a field mark of little use when these wonderful birds are flying thousands of feet above the ground during their remarkable migrations. Very much birds of the North, the whistlers of the Western Arctic, the Yukon and Alaska fly diagonally down across the chain of the great northern lakes to their wintering grounds in Chesapeake Bay, a voyage of from 2,500 to 3,000 miles (4022 to 4826 km). A handful of smarter birds winter off the coast of California. The trip is fraught with danger. Hunters spread an estimated six thousand tons (5442 t) of shot over the waterways and fields, resulting in death by lead poisoning. One swan in British Columbia was found to contain 451 pellets in its stomach. And exhausted birds occasionally pick poor locations to rest. Unable to fight the current, more than a hundred at a time have been swept to their deaths over Niagara Falls. Collectors stole their eggs, a crime in medieval England punishable by imprisonment for a year and a day and payment of fines to the king, for swans were by proclamation royal birds. In fact, as early as 1482, Edward IV decreed that "No person, except the King's son, should have any swan-mark or game of swans of his own." The swan-marks were similar to the brands applied to cattle to identify ownership. Despite the king's edict, the Honourable Company of Vintners received their mark from the Crown in 1472, and, along with the Company of Dyers, continue to own swans on the Thames today. The whistlers, requiring a smaller territory, have always been far more numerous than the much larger trumpeters, and their nesting areas are correspondingly greater. Audubon showed his swan swimming placidly past three water lilies. That the placement of the flowers for their artistic effect was not haphazard can be seen by conducting a simple experiment: if any one of them is covered, the balance is broken, and the impact is reduced.

Havell No. CCCCXI

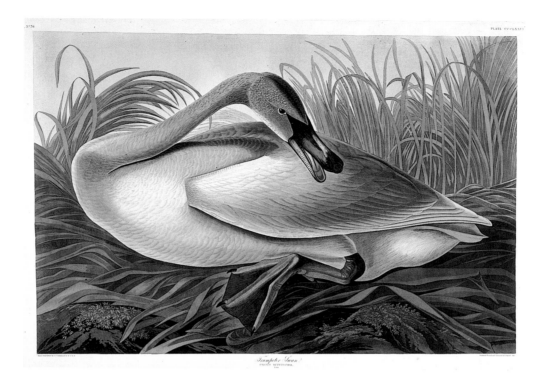

TRUMPETER SWAN (IMMATURE)
Cygnus buccinator

The trumpeter is strictly a North American bird. The first to arrive in the High Arctic, the adults build their nests on top of muskrat houses, around which the swimming mammals have kept some open water. In the short season, the young must develop sufficiently to accompany their parents thousands of miles on their first migration south. Audubon painted this immature bird in December 1821 in New Orleans. The time and place indicate just how far the bird must have flown since freeze-up of the northern lakes where it was hatched. Audubon reported that these young birds were commonly found in the Louisiana markets. Those who have seen trumpeters in the wild know how their almost stiff necks stretch vertically, as if the birds were standing at attention. Audubon described this stance, but chose to depict both the juvenile and the adult bird (in Plate 406) as their necks "move in graceful curves, now bent forward, now inclined backwards over their body." The ability to bend the neck with such suppleness lies in the fact that the trumpeter has sixty vertebrae, twenty-five of them in its neck—the most in the animal kingdom, even more than the giraffe. The scientific name *buccinator* comes from the Latin, *buccinare*, which means "to blow a trumpet." Their trumpet call, which can be heard for miles, comes from the very large windpipe coiled within their breast. Even though the lack of vocal cords would indicate otherwise, as far back as the *Dialogues of Plato* (written by Socrates, who was born in 469 BC) swans were thought to sing beautifully only at the moment of death, when they are "rejoicing in the thought that they are about to go away to the god whose minister they are." Through overhunting and egg-collecting, and finally through the tragic by-product of duck hunting, lead shot and lead poisoning, the trumpeter almost sang its "swan song" in 1932, when only sixty-nine birds were left in the United States.

Havell No. CCCLXXVI

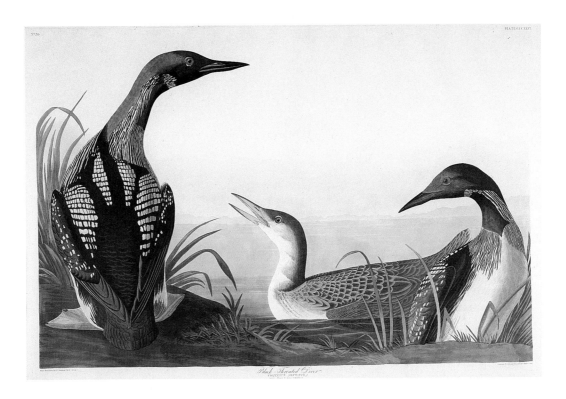

PACIFIC LOON
Gavia pacifica

Audubon saw several pairs of Arctic loons in Labrador during the 1833 voyage, and he claimed to have encountered them frequently throughout the United States. This is highly unlikely, as this particular species of loon spends its winters in the Far West, straying only accidentally into the East. The Canadian Arctic populations winter in the open water well off the Pacific Coast, somewhere between Southern Alaska and Baja California, even if the journey south starts in Ungava or Baffin Island. There is no hard evidence that any of the birds take a short-cut diagonally across the continent, so their migratory flight hugs the Arctic coast across the Northwest Territories, the Yukon and around Alaska. This journey is all the more remarkable for a bird whose bones are solid, rather than riddled with the air sacs that make virtually all other avian skeletons much lighter. In fact, loons' wings have a lower surface-to-weight ratio than those of any other flying bird. They are also the only birds whose legs, down to the ankle bones, are encased within the body. The flat tarsi and webbed feet extend out the back and provide powerful thrust for both swimming and diving. Loons have been captured 240 feet below the surface. The placement of the feet, however, renders loons almost helpless on land. Although the chicks can swim as soon as their down dries after hatching, they often hitch a ride on their parents' backs. Within ten weeks they can fly well enough to accompany the adults on their first migration. Red-throated loons are also found in Northern Europe and the British Isles. Not surprisingly, this painting, from 1834, was probably done from specimens Audubon found in London. When it is placed side by side with "The Common Loon" (Havell 306), the two plates seem to become parts of one composition, sharing virtually the same horizon, both with rocky shores beyond the sea, and both making use of curved blades of grass for the environmental setting.

Havell No. CCCXLVI

"*Although it was late September, the mowers were still engaged in cutting the grass, and the gardens of the farmers showed patches of green peas. The apples were still green.*"

JOHN JAMES AUDUBON,
JOURNEY IN NEW BRUNSWICK AND MAINE

GARDENS AND GRASSLANDS, FARMS AND FIELDS

N. P. Willis and his artist, William Bartlett, combined their talents to create *American Scenery*, one of the most popular travel books of the mid-nineteenth century. Despite the fact that neither of them ever saw the untouched frontier, Willis could still write, in his Introduction: "It strikes the European traveller, at the first burst of the scenery of America on his eye, that the New World of Columbus is also the new world from the hand of the Creator." They only visited those portions of North America that had already undergone substantial change at the hands of the more than 26 million people who had carved their niche out of the primeval forest. Cities, squatters' clearings, railroads, canals, steamships, roads—all had a profound impact on the altered landscape. Audubon just a few years earlier was already musing about where he would be able to go to see Nature unspoiled. Things were changing so fast. Where there had been endless towering forests, there were now homesteads with gardens; where once there had been the "inexhaustible" grasslands there were now fields. Most species suffered catastrophic declines, but others benefited as human tampering created suitable environments. Perfect examples are two of today's commonest birds—the European starling and the house sparrow—which have proliferated in almost biblical numbers in our cities and towns, gardens and fields. Neither was painted by Audubon. The explanation is simple: both were introduced into North America *after* Audubon had died.

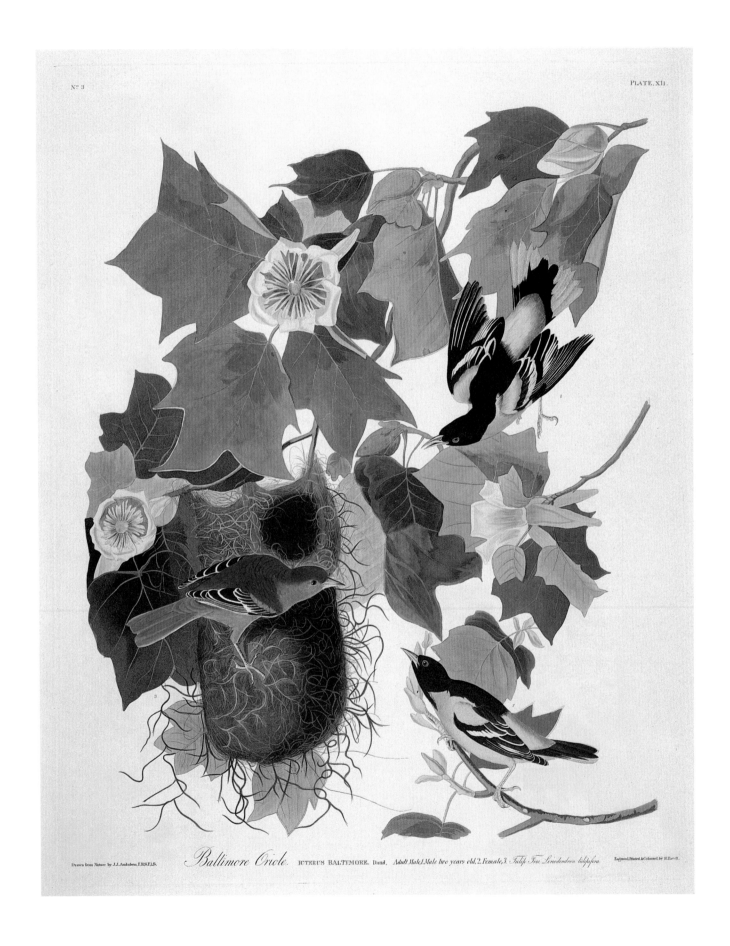

Baltimore Oriole. ICTERUS BALTIMORE. Daud. Adult Male,1.Male two years old, 2.Female,3. Tulip Tree Lyriodendron tulipifera.

BALTIMORE ORIOLE
Icterus galbula

Mark Catesby informs us that "it is said to have its name from Lord Baltimore's coat of arms which are paly of six, topaz and diamond, a bend, counterchang'd: his Lordship being a proprietor in those countries." It might have been more helpful if Catesby had merely said that Lord Baltimore's colours were orange and black. The first specimen was sent back to Europe from Maryland in the eighteenth century, and so the choice of name is at least understandable. When the lilacs and the fresh green of the new maples are at their most beautiful, a singing oriole is an unforgettable sight and sound. Audubon included a detailed rendering of the nest. They can be suspended precariously from the end of a small branch, thirty feet (9.1 m) above the ground. For some unknown reason, the female alone builds the nest, weaving strong plant fibres—and a selection of string found around human dwellings—with a thrust-and-draw shuttle movement of the bill. Construction takes between four and five days. The typical nest is attached to a single branch at half a dozen or more points; if supports were attached to more than one branch, the stresses caused by even a gentle breeze would rip the nest asunder. It has been estimated that a nest contains at least ten thousand "stitches," thousands of knots and loops. So strong is the construction that the same nest can be used for several years with only minor repairs being needed. In their wisdom, the powers that be have decided that the Baltimore oriole and the Bullock's oriole should now both be considered the northern oriole, despite the differences in colour and in the construction of their nests. Sometimes scientists have no sense of history. There is an interesting aristocratic anecdote connected with Audubon's portrait of the Baltimore oriole. When he was in Paris in September 1828, the incomparable flower painter Pierre-Joseph Redouté introduced Audubon to the Duke of Orleans, who would later rule France until 1848 as King Louis Philippe. When the future monarch saw the plate of the Baltimore oriole he is reported to have said, "This surpasses all I have seen, and I am not astonished now at the eulogiums of M. Redouté." The Duke became a subscriber, as did King Charles X. Despite royal patronage, Audubon considered his search for subscribers in France to have been unsuccessful.

Havell No. XII

MOURNING DOVE
Zenaida macroura

The common name of the mourning dove has nothing to do with the time of day, but rather with the mournful sound of its soft call. In medieval times, the English gave many species their own term of venery. We are familiar with a *pod* of whales and a *pride* of lions, but a *dule* of doves is not self-explanatory. *Dule* comes from the Norman French *deuil*—mourning—which was used to describe the sad song of the European equivalent, the turtle dove. (The word "turtle" is another Norman import: the bird's French name is *tourterelle* from the Latin *turtur*, an imitation of the bird's call.) In New France, the colonists applied a variant of the name—*la tourte*—to the now extinct passenger pigeon, the birds that supplied the major ingredient for pigeon pie. Made of *la tourte*, it became the familiar *tourtière*. It must be admitted, however, that this romantic derivation might be a case of convergent etymology. There is a Latin root, *torta panis*, for a round pie that gave rise to *tart*, *torte* and *tortilla* in various romance languages, and meat pies coexisted with pigeon pies in Europe before the colonization of New France. There are an estimated 500 million mourning doves in North America, making this our most common dove. They are incredibly fecund, producing two and even three broods a year. They are preyed upon by hawks, jays, crows, squirrels and even swarms of ants in the nest, but their numbers seem to grow annually as the range extends far to the north of the Carolinas, which gave it the name "Carolina pigeon" in Audubon's day. The Latin name *Zenaida* was bestowed by Prince Lucien Bonaparte, the influential naturalist who commissioned Audubon's first published bird portraits for the posthumous continuation of Alexander Wilson's *American Ornithology*. Princess Zenaida Charlotte Julie Bonaparte was his wife *and* cousin. He used her name for the species perhaps in the hope that it would become a self-fulfilling prophecy—that the conjugal fidelity associated with these "love birds," as they were called, would rub off on her. Frequently unable to resist the temptation of anthropomorphism, Audubon used the life of the mourning dove as an inspirational message for family life, in which devotion is rewarded with adoration. Even his choice of flowers went beyond the needs of art: "I have placed them on a branch of *Stuartia* which you see ornamented with a profusion of white blossoms, emblematic of purity and chastity."

Havell No. XVII

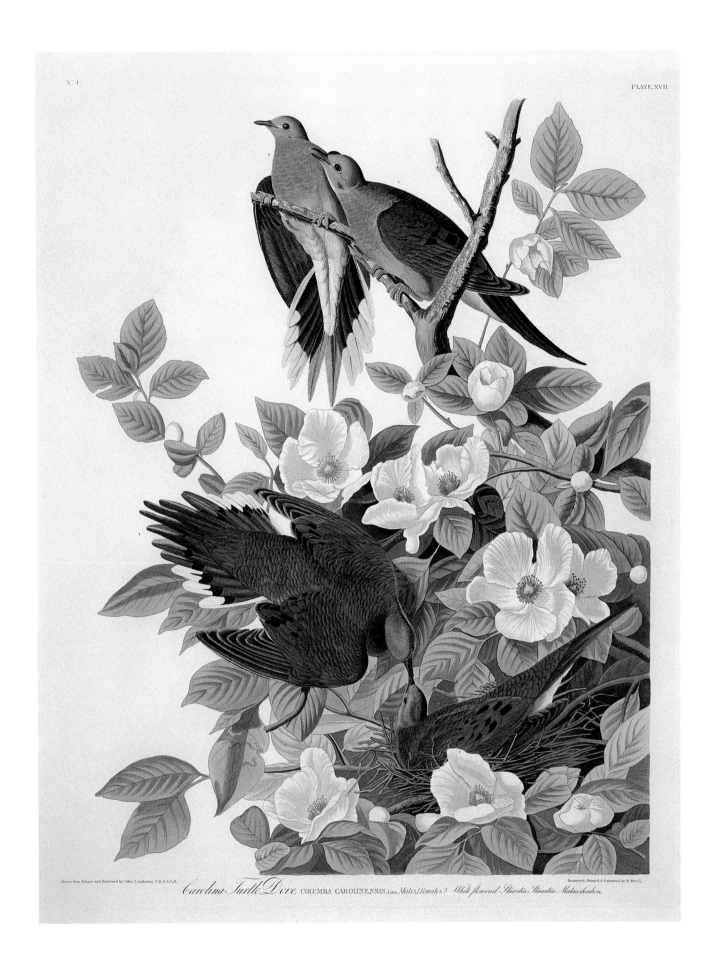

Carolina Turtle Dove, COLUMBA CAROLINENSIS, Linn. Males, Females? White flowered Stuartia, Stuartia Malacodendron.

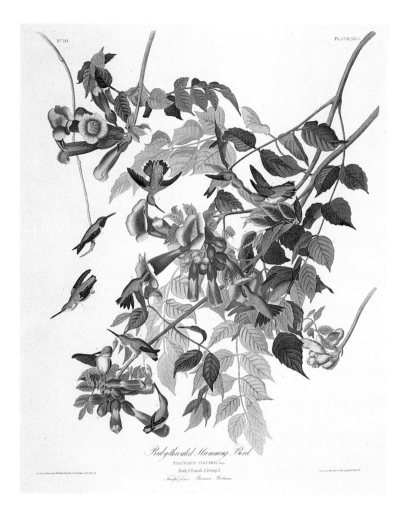

RUBY-THROATED HUMMINGBIRD
Archilochus colubris

From the whooping crane to the hummingbird, Audubon hoped to depict all North American species life-size. The two extremes posed a similar artistic challenge: how to fill the available space. Audubon showed one whooping crane but resorted to ten ruby-throated hummingbirds, in various poses—perching, flying and sipping nectar from deep within a trumpet flower. In real life, these diminutive battlers are too pugnacious to associate in such tight proximity. Audubon was trying to depict the birds in a variety of activities. The wing positions appear frozen compared to the blur of the living bird, but recent high-speed photography has confirmed that Audubon was uncannily close to the actual positioning. Capturing the explosion of colour from the iridescent patches on the throat and head of the hummingbirds is also a daunting challenge. Iridescence is not uncommon; we see it on the throats of urban pigeons, on a spreading film of pine gum on a lake, a soap bubble, the velvety green of a mallard drake's head, the light on bevelled glass or a diamond, even the blue of the sky. But the iridescence of hummingbirds is unmatched in its intensity, and unlike the blue of a dress or the red of a tomato, which are caused by pigments, the flashing colour is the result of the crystalline structure of the feathers themselves. Audubon captured the essence by calling the ruby-throats "glittering fragments of the rainbow."

Havell No. XLVII

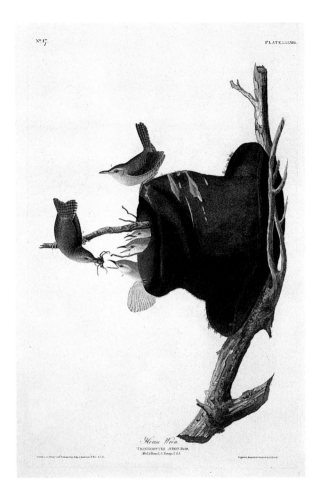

HOUSE WREN
Troglodytes aedon

Scurrying mouse-like through hedges and forest litter, its barred and mottled brown plumage blending perfectly into the surroundings, the house wren passes unnoticed, and is, therefore, far more common than might be assumed. At four and a half inches (11.4 cm), this is one of our smallest birds. It seems remarkable that so tiny a creature could produce such a loud, stuttering, gurgling song—a joy to human ears and an effective method of keeping in contact with a mate in the dense undergrowth. By tradition, the wren was considered "king of the birds," and yet in all Anglo-Saxon folktales the "king" was feminine—Jenny or Kitty Wren. Until the 1840s the wrens were considered members of the Old-World warblers, but in the second half of the nineteenth century they were given separate status. Their scientific name comes from two Greek words, *troglodutes* meaning "cave dweller" and *duo*, "enter"; literally, *Troglodytes aedon* is one who creeps into a hole. Today, troglodytes are *people* who live in caves (or should). Audubon's delightful portrait was of birds that lived in a hat. In the spring of 1812 this particular family nested outside Audubon's window at Mill Grove, Pennsylvania. The male became so trusting that he actually entered the room, sang, and allowed Audubon to hold him while his portrait was painted. The birds are, predictably, wonderful, but it is the texture of the felt hat, and the hat itself, that sets this painting apart from and above the vast majority of bird paintings.

Havell No. LXXXIII

PLATE. CII.

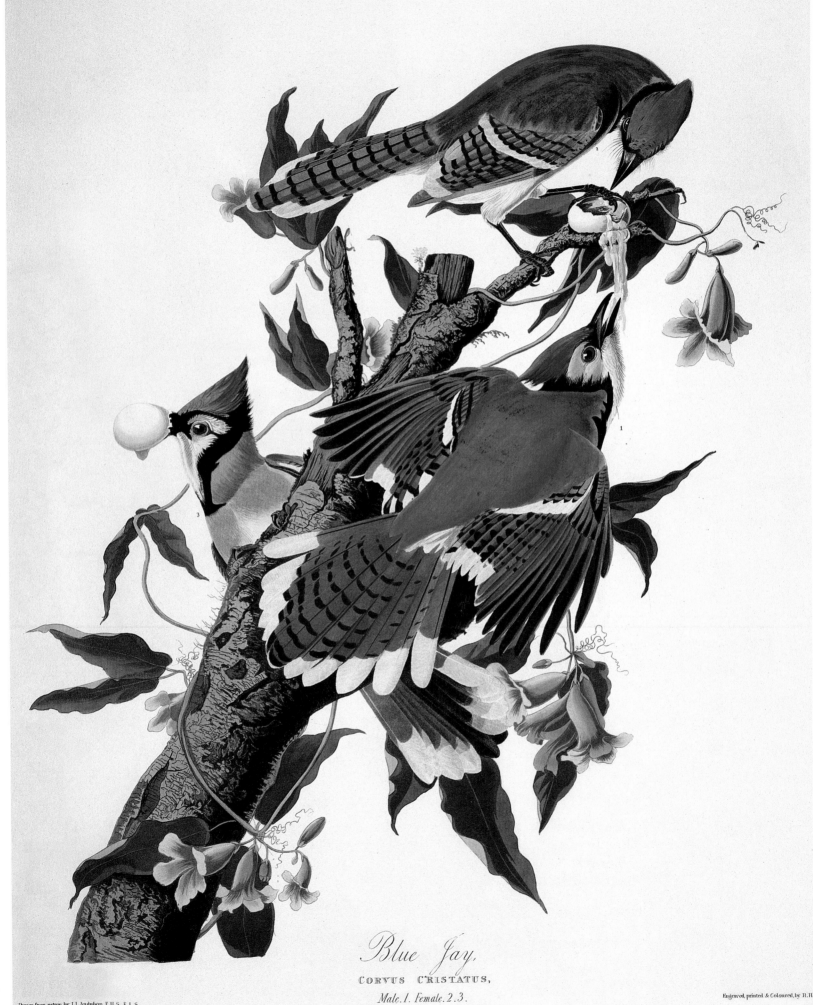

Drawn from nature by J.J.Audubon F.R.S. F. L.S.

Blue Jay,
CORVUS CRISTATUS,
Male.1. Female.2.3.

Engraved, printed & Coloured, by R.H.

BLUE JAY
Cyanocitta cristata

To Audubon, the blue jays were "rogues…and thieves." He decried their "mischief, selfishness, duplicity and malice," but claimed not to be passing judgement on them "enjoying the fruits of their knavery." Yet he chose to portray them "sucking the egg which he has pilfered from the nest of some innocent dove or harmless partridge"! Even the great field naturalist and scientist was not above ascribing human motives and values to the cycle of Nature. This antipathy towards one of our more beautiful birds was widely shared, and had been made manifest in many laws. In 1672, for instance, town records from Concord, Massachusetts, confirm that it was the will of the people "that encouragement be given for the destroying of blackbirds and jaies." Of course these same people had been dunking witches in nearby Salem. Despite their habits, blue jays have become one of the most popular subjects for today's ubiquitous "limited edition art print" market, usually being shown among dead oak leaves. Undeniably intelligent, the blue jay ranks with other members of the crow family as the "smartest" bird. It seems to communicate with a gathering of its colleagues by screaming for the sheer pleasure of it. In the early 1800s, Alexander Wilson likened its song to the squealing of an unoiled wheelbarrow. More graciously, Wilson used the old Latin name *Garrulus canadensis coerulus*, which covered his raucous loquacious nature, his northern home and the blue of the sky. Despite the fact that blue jays do not have what could be called a song, they are capable of imitating perfectly the softest sibilant sounds of the many small songbirds whose nests and nestlings supply so much of their food. They also destroy vast quantities of harmful insects, but also consume grain. They do not migrate in the truest sense of the word, but shift location depending on the food supply. Therefore, they have increasingly become a spectacular addition to urban bird feeders. In Audubon's original watercolour the plant was left unfinished. Audubon told Havell to copy the cross-vine or trumpet flower from Plate LXV, a depiction of the yellow warbler, which he called Rathbone's warbler, naming it after the Liverpool family that had befriended him in 1826. The first known painting of a blue jay appeared as a decoration in the margin of the hand-illuminated manuscript of *Les Très Riches Heures*, the breviary commissioned by the Duc de Berry in 1409. How do we explain this portrait of a North American bird a full century before John Cabot's official discovery of the North American mainland?

Havell No. CII

PLATE CLV.

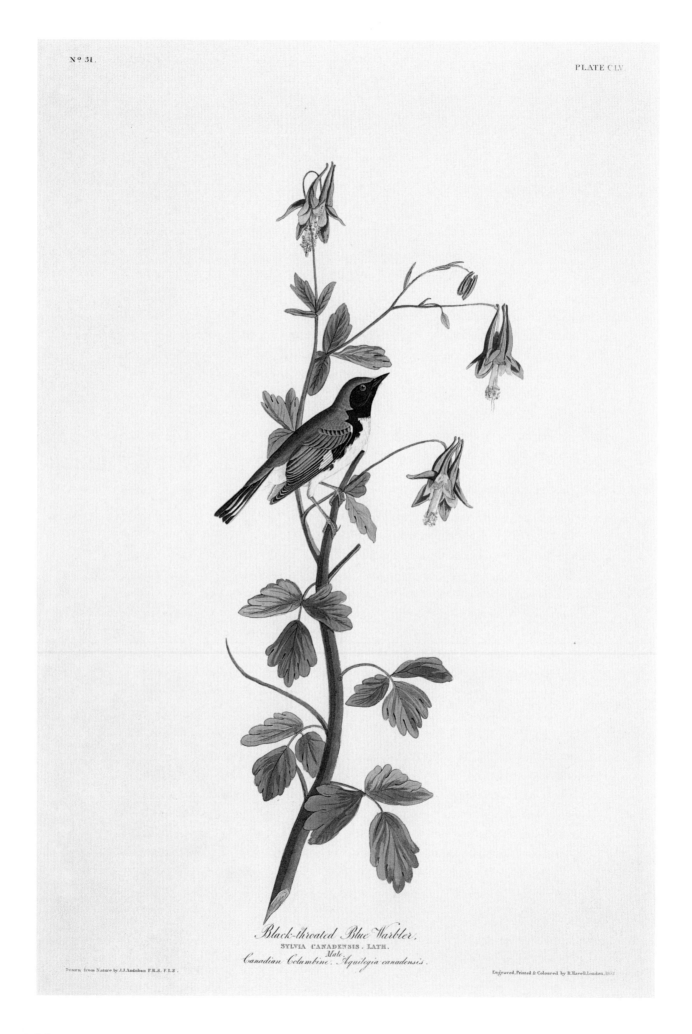

Black-throated Blue Warbler,
SYLVIA CANADENSIS. LATH.
Male.
Canadian Columbine. Aquilegia canadensis.

Drawn from Nature by J.J.Audubon F.R.S. F.L.S.

Engraved, Printed & Coloured by R.Havell,London.1832.

BLACK-THROATED BLUE WARBLER
Dendroica caerulescens

In mid-April, the black-throated blues literally hit Florida, where collisions with lighthouses on the Keys result in many casualties. The remaining birds migrate north very quickly, passing through southern Canada in early May before moving on to the heavy deciduous forests across the East from Hudson's Bay to Newfoundland. Audubon found them in "...the British Provinces, and on the Magdaleine Islands in the Bay of St. Lawrence." How appropriate, therefore, that he placed his gorgeous male on what he identified as the "Canadian Columbine," the flower so closely associated with Canada's easternmost and newest province. There is additional Canadian content: "I am indebted to the generous and most hospitable Professor MacCulloch of Pictou for the nest and eggs of this warbler." MacCulloch was at Dalhousie College. The spectacular spring plumage of the male remains in the fall, but the "confusion" lies in the drab, olive-and-yellowish-coloured female—one of the toughest field identifications. The immature plumage so closely resembles the adult female that early naturalists considered the female to be a separate species, calling her in the 1800s the pine swamp warbler. Audubon "discovered" or accepted as valid several other non-species, but overall, considering the relative lack of knowledge of geographic races and variable seasonal coloration in the nineteenth century, Audubon's contribution was extraordinary. He is credited with describing twenty-three new species and twelve subspecies. As new information became available, Audubon was usually not reluctant to admit his mistakes. He perpetuated the error of the adult female black-throated blue by giving it its own portrait in his folio, but corrected it in the miniature octavo edition of 1841, in which he combined the image with that of the male, recognizing them to be the same species. In the miniature edition he also caused Bonaparte's *Sylvicola sphagnosa* and Wilson's *Sylvicola pusilla* and his own pine swamp warbler to be "erased from our fauna." For some inexplicable reason, he also erased the text relating to the black-throated blue in the octavo; there is no description. The black-throated blues winter in a compact area of eighty thousand square miles (207,200 km^2) in Cuba and the Bahamas, where they become astonishingly tame—a trait they carry with them on their migration to the North.

Havell No. CLV

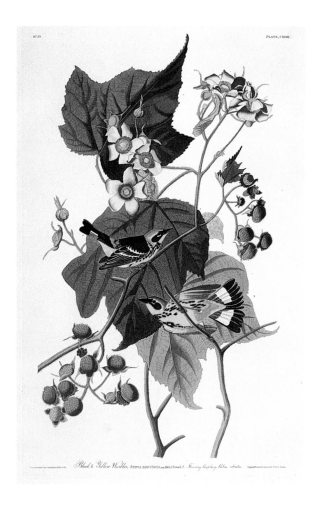

MAGNOLIA WARBLER
Dendroica magnolia

Among the warblers, there are two that can create confusion without waiting for the dull plumage of fall: the magnolia and the myrtle, which look alike and are both strikingly coloured. In 1973, to help differentiate between them, the myrtle was renamed the yellow-rumped warbler, which is what Alexander Wilson had called it back in 1800 (despite having seen the first specimen in a magnolia tree). Unfortunately, in 1829, Richardson called the *magnolia* the yellow-rumped. Both Audubon and Wilson called the magnolia the "Black and Yellow Warbler." But both the magnolia and the myrtle have yellow rumps! If the magnolia sits still long enough—which it rarely does—look for the streaked bright yellow breast and the white band across the tail, both field marks being emphasized in Audubon's lovely plate. The birds are shown on a flowering raspberry bush, one of the finest renderings of a botanical element in the entire set of plates. So numerous were the warblers in Audubon's day that he could write "that you might have fancied that an army had assembled to take possession of the country," during a period when "scarce a leaf was yet expanded, and large icicles hung along the rocky shore." Based on migration patterns, this sounds as if Audubon confused the bird with the myrtle, which arrives before the leaves are out, when insect life is still dormant. Or was it the yellow-rump?

Havell No. CXXIII

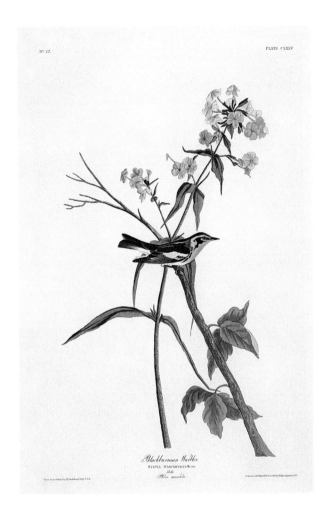

BLACKBURNIAN WARBLER
Dendroica fusca

In his *Ornithological Biography*, Audubon wrote: "On the Magdalene Islands, in the Gulf of St. Lawrence, which I visited in June 1833, I found the Blackburnian Warbler in all the brilliancy of its spring plumage, and had the pleasure of hearing its sweet song." There may be a more beautiful plate of warblers in the *Birds of America*, but there does not need to be. Audubon's rendering of a male perched expectantly on the stem of a *Phlox maculata* is charming, but obviously he felt that it could stand some improvement. In the octavo edition Audubon added a rather drab female. Science was served, but art was not. When the sunlight floods this five-inch beauty, the effect is breathtaking, as is the six- or seven-note song, which does seem impossibly loud for so small a creature. Most of Audubon's specimens and information came from Canadians, such as Sir Archibald Campbell of Frederickton (sic), New Brunswick, and President MacCulloch of Dalhousie College in Halifax (not Dalhousie "Cottage," as Audubon's printers misread his handwriting). The bird appears to have been named after Mrs. Anna Blackburn, who was born in 1740 and died in 1793. She was a supporter of ornithology and owned a museum in Fairfield, Lancashire. Her brother, Ashton, had collected birds in the United States before his death in 1790, and probably sent specimens back to England, where they were given their Latin name, originally *Sylvicola blackburniae*. Her name was also once attached to a species of rail.

Havell No. CXXXV

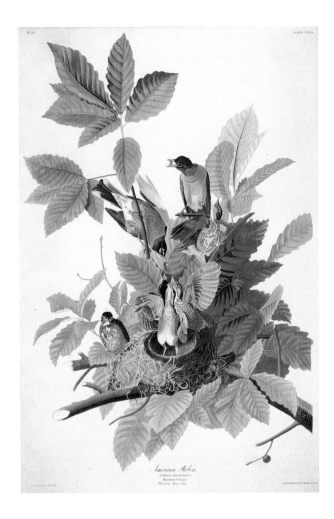

AMERICAN ROBIN
Turdus migratorius

In his 1827 *Journal* written during his trip to England, Audubon noted: "Many people tell me in cold blood that we have no birds that can sing in America... What would they say of a half-million of robins about to take their departure for the North, making our woods fairly tremble with melodious harmony?" Audubon answered his own question by reporting that he "could scarely refrain from shedding tears when I heard the song of the Robin," the first land-bird he encountered when he "stepped upon the rugged shores of Labrador." When a bird is as familiar to us as our robin, we tend to take it for granted. We overlook the fact that it is a member of the thrush family, and therefore a beautiful caroller. In spring no song is more welcome, no bird more loved on our lawns and parks. But when a robin is unexpectedly encountered in the deep forest, we are forcibly reminded that this is essentially a bird of the wilds, only some of whose members have opted for city life. In the 1830s, the birds piled up along the Gulf Coast as wave after wave descended from the North, but millions were shot across the southern United States by market hunters, even by children, and the numbers plummeted. Unfortunately for the robins, they—like all other thrushes—were delicious roasted or made into a pâté. Some gourmets claimed they were at their best when they were literally drunk from the fermented juice of berries, and being drunk made them easier to capture.

Havell No. CXXI

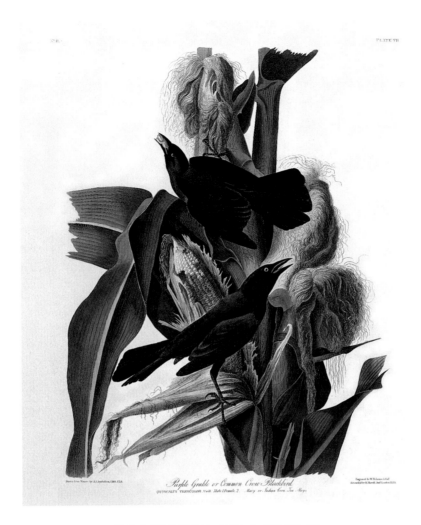

COMMON GRACKLE
Quiscalus quiscula

One of the earliest sounds of spring is the "song" of the grackle, not unkindly compared to the grating of a rusty hinge. April finds our largest blackbird posturing in the treetops, or swaggering with bold strides across the dormant lawns, its piercing, bright yellow eye taking everything in. Audubon was effusive: "The genial rays of the sun shine in their silky plumage, and offer the ploughman's eye such rich and varying tints, that no painter, however gifted, could ever imitate them. The coppery bronze, which in one light shews its rich gloss, is, by the least motion of the bird, changed in a moment to brilliant and deep azure, and again, in the next light, becomes refulgent sapphire or emerald-green." In some individuals, one colour tended to dominate, and two species were recognized, the bronze and the purple. Audubon decried its "nefarious propensities." He continued, "... the male, as if full of delight, at the sight of the havoc which he had already committed on the tender, juicy, unripe corn on which he stands, has swelled his throat, and is calling in exultation to his companion to come and assist him in demolishing it." No field on their route to the wintering grounds is safe from their predation, as Audubon so brilliantly showed. But he recognized that during the planting season the grackles consume vast quantities of grubs and worms, thereby "destroying a far worse enemy to the corn than itself." Philosophically, Audubon concluded that this was "the tithe that our Blackbird takes from our planters and farmers... and such is the will of the beneficent Creator."

Havell No. VII

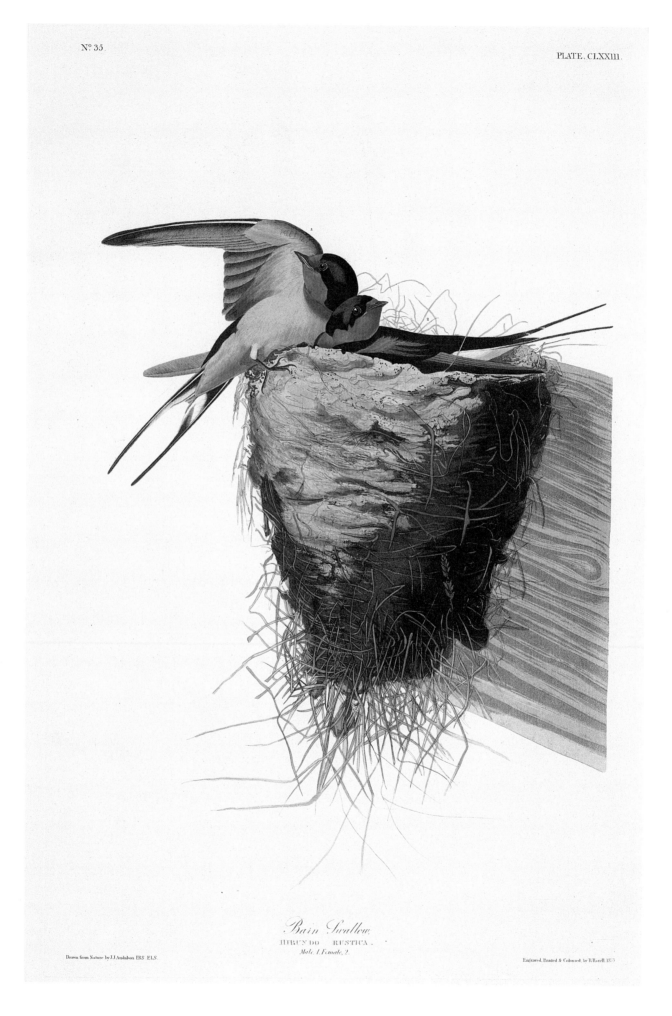

N.º 35.

PLATE. CLXXIII.

Drawn from Nature by J.J.Audubon FRS FLS.

Engraved, Printed & Coloured, by R.Havell 1833.

Barn Swallow.

HIRUNDO RUSTICA.

Male, 1. Female, 2.

BARN SWALLOW
Hirundo rustica

Audubon described "a pleasure known to few," which he enjoyed "whenever an opportunity occurs." It was to follow barn swallows into the barn to watch them attend to their nesting duties. In his accompanying text, we see Audubon as the indefatigable field naturalist, insisting on first-hand information rather than relying on the observations of others. Again and again Audubon marvelled at how happy they seemed to be. When it came to the barn swallows he could not curb his anthropomorphism. His text is filled with phrases such as: "A smart fellow roguishly challenges his neighbour," "his beloved mate ... sits on her pearly egglets" and "happy and charming little creatures." He reported them in the "Gut of Canso" on June 10, 1833, and in the Magdalene Islands on June 13, but did not encounter any in Labrador. He described their flight, which had "a lightness and ease that are truly admirable," and commented on the way an entire flock wheels acrobatically in the air. Perhaps most impressive was their fearlessness: they would attack ravens, crows, hawks—even eagles. The barn swallow has always been considered the bird of summer, and before migration was understood, its disappearance in winter baffled even the greatest minds. Boswell quotes Samuel Johnson: "Swallows certainly sleep all winter. A number of them conglobate together, by flying round and round, and then all in a heap, throw themselves under the water, and then lie in the bed of the river." Perhaps he had read the opinion of the medieval bishop of Bergen, Norway, Olaus Magnus, who assured the faithful that swallows were "frequently found in clustered masses at the bottom of northern lakes, mouth to mouth, wing to wing, and foot to foot." 160 The first important bird book in English is generally conceded to be *The Ornithology of Francis Willughby*, compiled for the Royal Society by John Ray in 1678. There were equal measures of science and superstition. Swallows, according to Willughby, were good for "Falling Sickness": "Take one hundred Swallows (I suppose here is some mistake, and that one quarter of this number may suffice) one ounce of Castoreum, one ounce of Peony roots, so much White-Wine as shall suffice. Distil all together, and give the Patient to drink three drachms fasting every morning ... Purge often." More than a medicine, swallows are an inspiration. John Burroughs, the beloved naturalist of the Hudson River, in his 1921 essay *A Midsummer Idyll* described this acrobatic flier as "the child and darling of the summer air, reaping its invisible harvest in the fields of space as if it dined on the sunbeams."

Havell No. CLXXIII

A. YELLOW-RUMPED WARBLER
Dendroica coronata

B. HERMIT WARBLER
Dendroica occidentalis

C. BLACK-THROATED GREY WARBLER
Dendroica nigrescens

On Sunday, October 25, 1836, Audubon wrote to the Rev. John Bachman in Charleston, South Carolina. With unbridled enthusiasm he announced: "I have purchased *Ninety Three Bird Skins*! Yes 93 Bird Skins! . . . Such beauties! such rarities! Such novelties! Ah my Worthy Friend how we will laugh and talk over them!" Time, geography and age were conspiring against Audubon's dream of personally exploring the western portions of America to collect all the species. With publication deadlines looming, he was forced to use skins of western birds that he had never encountered. The ninety-three skins were purchased from Kirk Townsend, who, in his *Narrative of a Journey across the Rocky Mountains*, described many species new to science. One was a warbler, which he named in honour of Audubon. Audubon returned the favour by naming one after Townsend. Both were included in the original watercolour of this multi-species plate. For simplification, two engravings were made, one with these three western warblers, including Audubon's wood warbler, and a second with four bluebirds and Townsend's warbler. In the octavo edition of the *Birds*, a further simplification resulted in a separate lithographed plate of Audubon's warbler. The multi-species plates were not as artistically or dramatically successful as the single species plates. Restive subscribers, impatient for their plates, forced the issue.

Havell No. CCCXCV

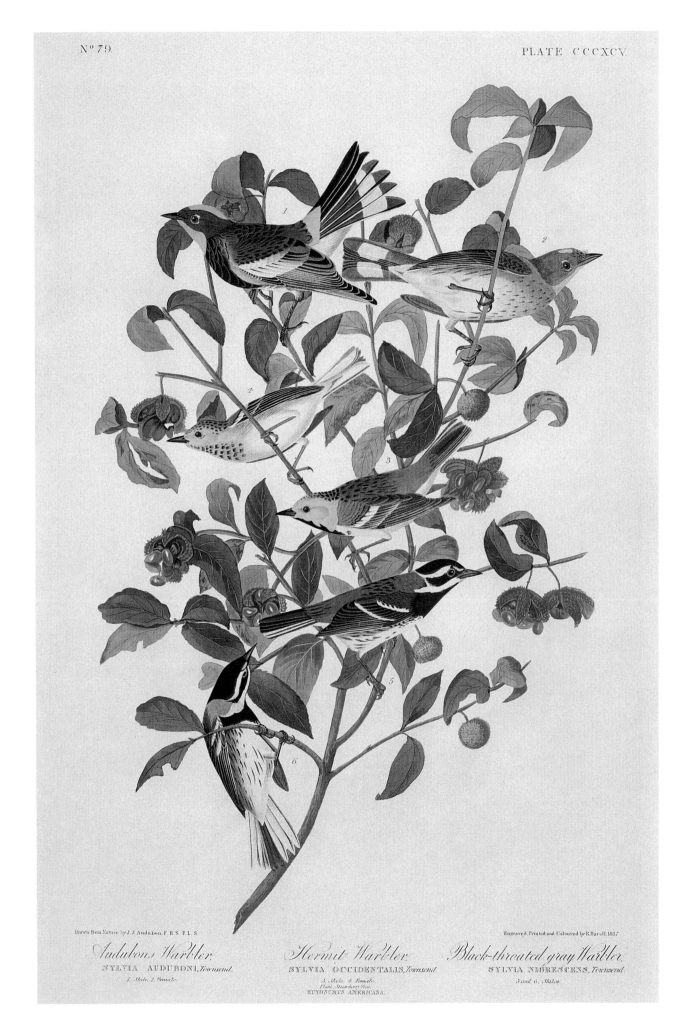

PLATE CCCXCV.

Drawn from Nature by J.J.Audubon, F.R.S.F.L.S.

Engraved, Printed and Coloured by R.Havell, 1837.

Audubons Warbler.
SYLVIA AUDUBONI, *Townsend.*
1. Male. 2. Female.

Hermit Warbler.
SYLVIA OCCIDENTALIS, *Townsend.*
3. Male. 4. Female.
Plant. Strawberry Tree.
EUVONIMUS AMERICANA.

Black-throated gray Warbler.
SYLVIA NIGRESCENS, *Townsend.*
5 and 6. Males.

"LABRADOR"–AUDUBON'S CANADIAN WILDERNESS

On June 6, 1833, Audubon set sail from Eastport, Maine, on a fully rigged 100-foot, 106-ton schooner, the *Ripley*, to explore what he called "Labrador." Under command of Captain Henry Emery, and with a group of travelling companions that included his son, John Woodhouse Audubon, and Thomas Lincoln of Dennysville, Maine, Audubon fulfilled his ambition of visiting what today is known as the Quebec Lower North Shore of the St. Lawrence River, Labrador below the Straits of Belle Isle, and Newfoundland. During the trip he stopped at islands at the mouth of the Bay of Fundy, the Magdalene Islands, islands in the Gulf of St. Lawrence, Cape Breton and mainland Nova Scotia. During the three-month voyage, despite appalling weather and bouts of awful seasickness, Audubon completed or virtually completed twenty-three paintings, and in his *Journal*, letters home and published texts, he recorded fascinating insights into the land, the vegetation, the weather, the people and, above all, the birds he encountered. It was during the Labrador trip that we find clear indications of Audubon's growing sense of dismay about the wholesale destruction of wildlife. His condemnation of the professional egg gatherers forms the subject of one of his most heated *Episodes*. Audubon had mixed feelings about Labrador. His diary is full of adjectives such as "dirty" and "dismal," but when the wind stopped and the sun came out on July 12, 1833, he could write: "A beautiful day!—for Labrador." At the end of the trip he decided that he had never left a land with so little regret. In addition to this artistic and written legacy, he is commemorated in the Audubon Islands off the Quebec shore, named by Captain Bayfield on the government survey ship *Gulnare* in 1833. The plates in this section that are identified with a small maple leaf were either painted in Canada or had significant Canadian association.

GYRFALCON
Falco rusticolus

Back in the thirteenth century, Emperor Frederick II of Hohenstaufen wrote his pioneering work, *De arte venandi cum avibus*, "On the Art of Hunting with Birds." This royal falconer claimed that the gyrfalcon "holds pride of place over even the peregrine [falcon] in strength, speed, courage, and indifference to stormy weather." Falconry was the subject of one of the longest traditions in bird art, with literally hundreds of examples of portraits, not only of the birds, but also of their proud owners. And as certain ranks of nobility reserved for themselves the exclusive use of certain species, it was essential that the artists paint the birds with sufficient accuracy that no one could mistake a peregrine for a gyrfalcon. There are boastful portraits of Prince William II of Orange, the Duke of Leeds and, uncomfortably, Hermann Goering, who appointed himself head of forests and hunting under the Third Reich—all with their gyrfalcons. Even Pope Leo X, whose pontificate lasted from 1513 to 1521, was a great enthusiast of falconry. Across the centuries the white-phase gyrfalcon has been considered falconry's ultimate status symbol. In 1866, Christian Ludwig Brehm published an *Encyclopaedia of Natural History*, extensively illustrated with wood engravings. One engraving chosen for a compendium of "Falconry in Art" was of white gyrfalcons. It is a direct copy—in reverse—of Audubon's great plate, and as was so often the case, no attribution or acknowledgment was given. The gyrfalcon is the largest of its tribe, measuring up to twenty-four inches (60 cm) in length, with a wingspan of four and a half feet (1.37 m). It is a truly northern bird, nesting around the Arctic and in Greenland. Ungava in northern Quebec is the most interesting habitat, because the whitest and the blackest gyrs, with every colour of grey in between, nest there. Audubon discovered what he thought was a new species during his 1833 trip to Labrador, mistakenly naming the dark-phase gyrfalcon the Labrador falcon. Audubon painted these birds from a single captive female specimen in London in 1837. As the two sexes are basically identical except for size (the female is larger), the painting is still true to nature.

Havell No. CCCLXVI

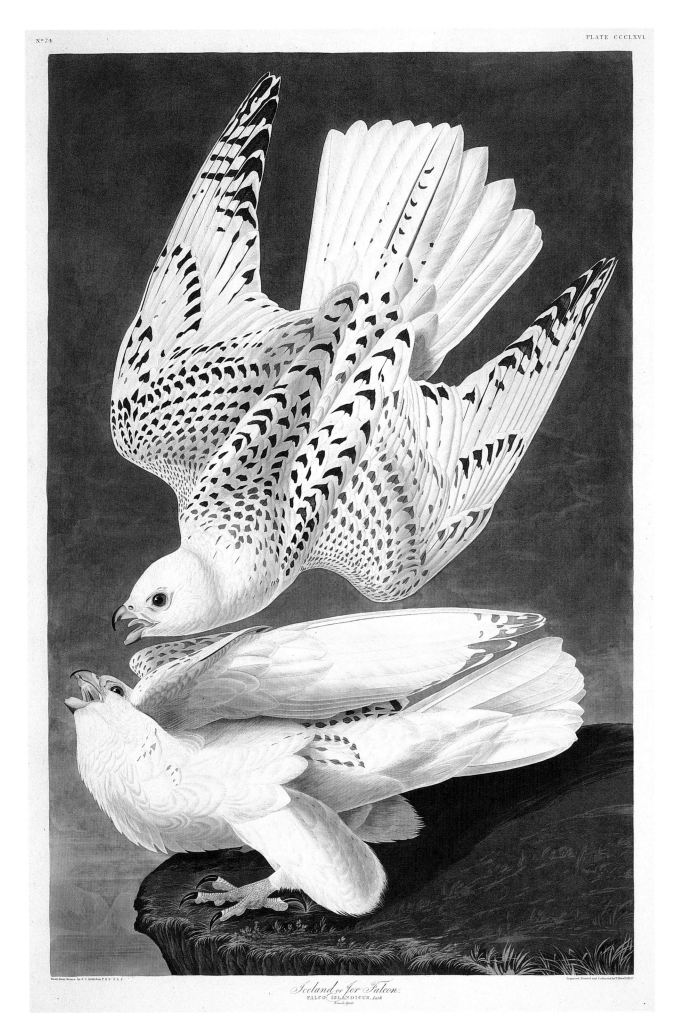

PLATE CXCVI

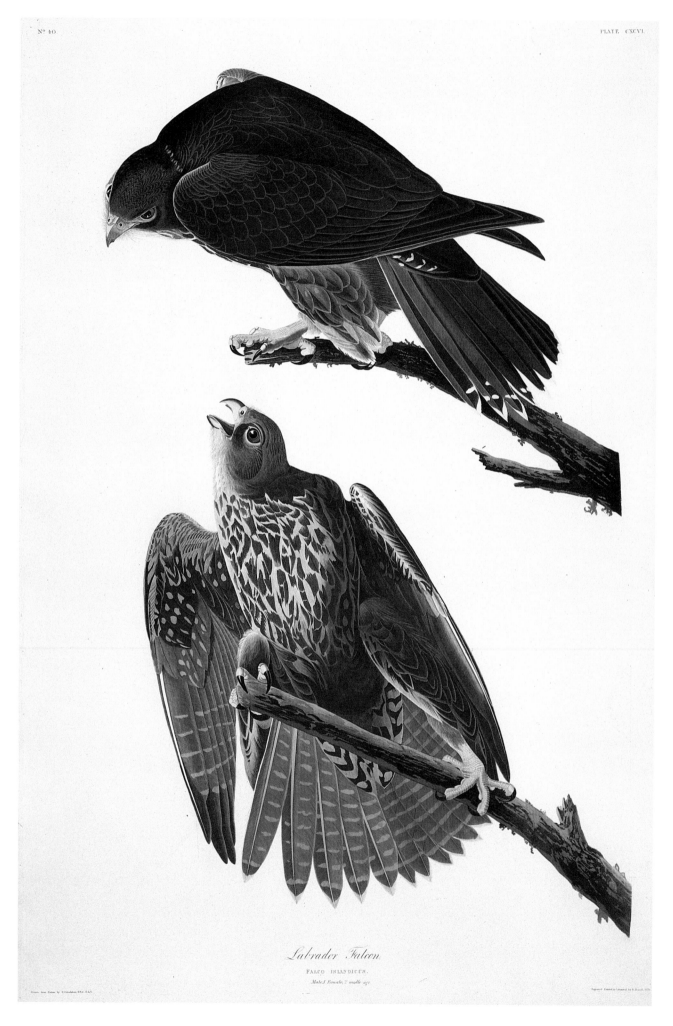

Labrador Falcon.

FALCO ISLANDICUS.

Male 1 Female 2 male age.

GYRFALCON (LABRADOR)
Falco rusticolus

Audubon wrote that two beautiful dark falcons were shot "on the 6th August 1833, while my young friends, Thomas Lincoln and Joseph Coolidge, accompanied by my son, John, were rambling by the rushing waters of a brook banked by stupendous rocks, eight or ten miles from the port of Bras d'Or on the coast of Labrador." In his *Journal* for August 10, 1833, Audubon wrote: "Who, *now*, will deny the existence of the Labrador falcon? Yes, my Lucy, one more new species is on the list of the 'Birds of America,' and may we have the comfort of seeing its beautiful figure multiplied by Havell's engravers." By the time the octavo edition appeared, Audubon realized that this "new" species was merely a dark race of the gyrfalcon, and so dropped the image from the miniature book. He caused great confusion by joining the original text intended for the Labrador falcon to the image of the white gyrfalcon, giving the false impression that he was describing the capture of the white birds. These were also seen in Labrador, but the plate of the gyrfalcon was a double portrait of a captive female he obtained in London in 1837. The most important part of the text reveals the terrible conditions under which Audubon was forced to produce his plates in Labrador: "I made my drawing of them [the dark birds] the day after their death. It was one of the severest tasks which I ever performed, and was done under the most disagreeable circumstances. I sat up nearly the whole of the night, to sketch them in outline. The next day it rained for hours, and the water fell on my paper and colours all the while from the rigging of the *Ripley*...After seventeen hours a day, the weariness of my body at night has been unprecedented." Audubon complained that at times his fingers were so cold that he had to blow on them in order to keep drawing. It was not the weather or the long hours that worried him; rather, it was that for the first time he felt his own mortality. Audubon was, at that time, forty-eight years old.

Havell No. CXCVI

PLATE. CXCIII.

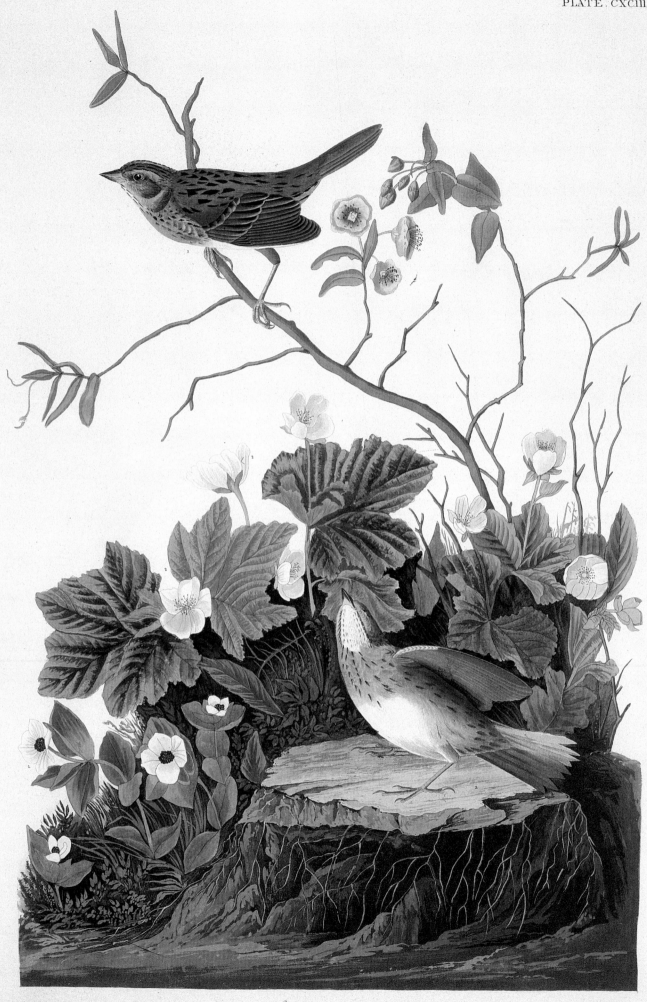

Lincoln Finch,

FRINGILLA LINCOLNII.

Male. 1. Female. 2.

Drawn from Nature by J.J. Audubon. F.R.S. F.L.S. *1. Cornus Suifsica. 2. Rubus Chamæus. 3. Kalmia glauca.* Engraved, Printed, & Coloured, by R. Havell. 1834.

LINCOLN'S SPARROW
Melospiza lincolnii

On June 27, 1833, Audubon reported in his *Journal* in Labrador that, off the mouth of the Natashquan River, a new species of finch had been shot, named and painted. One of his companions on the schooner *Ripley* was Thomas Lincoln, a young man from Dennysville, Maine, who shot the bird and "cut short its career." In his honour, Audubon first named it "Tom's Finch," but almost immediately replaced it with the more dignified last name. Before the bird had been collected, Audubon was drawn to it by what he called the most vigorous and loveliest song of any American finch. Lincoln later collected the three plants—a dwarf cornel, a cloudberry and a bog laurel—which Audubon assumed were new to science. Actually, all three had previously been described by German botanists whose work he had not encountered. Thinking that they were discoveries of the Labrador region, Audubon commented on how appropriate it was to include them as the botanical elements. From many points of view, therefore, this is a truly Canadian plate. Research in the future would show that the nesting range of the Lincoln's sparrow covers the continent to Alaska, and south through the Rockies to Colorado. All they need is a peat bog, or areas where clear-cut lumbering has taken place. Audubon described a bog with its flowers and stunted trees, and commented on the incredible clouds of mosquitoes and biting flies. He had to return to the *Ripley* to do his painting. There is some thought that the lower bird was painted by John Woodhouse Audubon, who accompanied his father to Labrador. The son painted several birds for the folio, and later was to complete for his father at least 71 of the 150 lithographed folio plates for *The Viviparous Quadrupeds of North America* (Audubon's forgotten masterpiece, and to this day the largest plates devoted to mammals).

Havell No. CXCIII

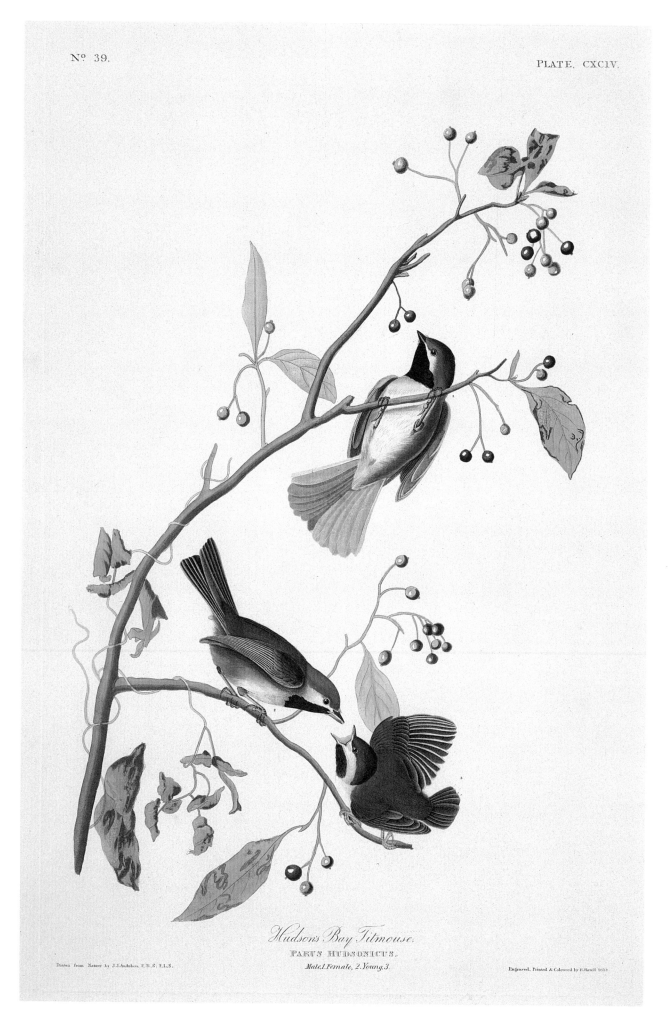

Hudson's Bay Titmouse.
PARUS HUDSONICUS.
Male,1. Female, 2. Young,3.

Drawn from Nature by J.J.Audubon, F.R.S., F.L.S.

Engraved, Printed & Coloured by R.Havell 1834

BOREAL CHICKADEE
Parus hudsonicus

This is one of Audubon's "Canadian" paintings. On the 18th of July, 1833, the schooner *Ripley* anchored off the north shore of the Lower St. Lawrence opposite the Island of Macatina. From a distance Audubon thought that he had seen a flock of a new species of titmouse. Two days later, on July 20, he landed and collected his first specimens of what today we call the boreal chickadee. He painted them on what appears to be a black chokecherry. Under perfect viewing conditions, the differences between the boreal and the black-capped chickadee are obvious, and even an untrained ear can hear that the songs are not the same, but that Audubon could tell from a considerable distance that he had stumbled on something new is another example of the remarkable eyesight and hearing for which he was famous. The lively antics of the birds are captured in this delightful portrait, but the question remains why Audubon chose to show the birds in a berry tree when their preferred habitat is in conifers. To all the early naturalists there was something special about the chickadees. Thoreau wrote on November 7, 1851: "But just then I heard a chickadee in a hemlock, and was inexpressibly cheered to find that an old acquaintance . . . was, I assumed, to be there all winter." Wilson had marvelled at their being "hardy beyond any of his size, braving the severest cold." Forbush decided that the chickadees were "a bird masterpiece." Audubon praised the black-capped for welcoming "the traveller or woodcutter with a confidence and cheerfulness far surpassing the well-known familiarity of the Robin Redbreast of Europe." The boreal, despite its brownish head and orange-tinted flanks, is difficult to distinguish in the field from the more familiar black-capped. In the north woods, the boreal can still be coaxed to perch expectantly on the finger of a child, whose eyes open wide to the discovery of nature.

Havell No. CXCIV

WILLOW PTARMIGAN
Lagopus lagopus

"The Willow Ptarmigan" was painted over three days, July 6, 7 and 8, 1833, during Audubon's voyage to "Labrador." The birds were shot by one of his travelling companions, George Shattuck of Boston, on what today is known as the Lower North Shore of the St. Lawrence River in Quebec. Audubon had hoped to encounter this northern member of the grouse family, because Theodore Lincoln, the father of another of his party, Thomas Lincoln, claimed to have shot seven near Dennysville, Maine. The death of the birds almost caused the death of the party. Audubon described in detail how he and his companions headed off across what looked like perfectly safe terrain to hunt for birds. What appeared to be solid ground turned out to be anything but: "We were forced to sit down on the dangerous sward, which at every step shook for a considerable space around." Audubon had encountered a northern "quaking bog." Because of the season, Audubon's birds were in full summer plumage, white underparts with a rich mottled brown on the back and wings. In this dress the willow ptarmigan is very similar to the rock ptarmigan. Two things, however, set them apart: their family life and their habitat. Audubon included a male and a female, still in close association with their six downy youngsters. They commonly flock together in mixed coveys of males, females and chicks, a familial trait that Audubon correctly described as unique among American grouse (normally, the male grouse abandons the family). Further to differentiate the willow from the rock ptarmigan, the birds are placed in a low-lying tundra setting, whereas his plate of the rock ptarmigan (Havell 368) shows those birds in their proper habitat amongst high mountains above the tree line. In winter the willow ptarmigan turns pure white except for the red fleshy eyebrows and the black tail tipped in white. Audubon, the sportsman rather than the naturalist, wrote that in most ways they resembled the red grouse of Scotland, and were "easily shot on account of the beautiful regularity of their flight." He further reported that vast numbers of birds were collected in winter and salted for summer use, a reversal of the norm. The numbers were still great enough that Daniel Giraud Elliot could write in the 1880s that a sledload could be captured in a single day. The birds would fly into "snares so fast that a man cannot kill and release them quickly enough." With their concealing coloration and the isolation of their habitat, willow grouse are still abundant throughout their circumpolar range.

Havell No. CXCI

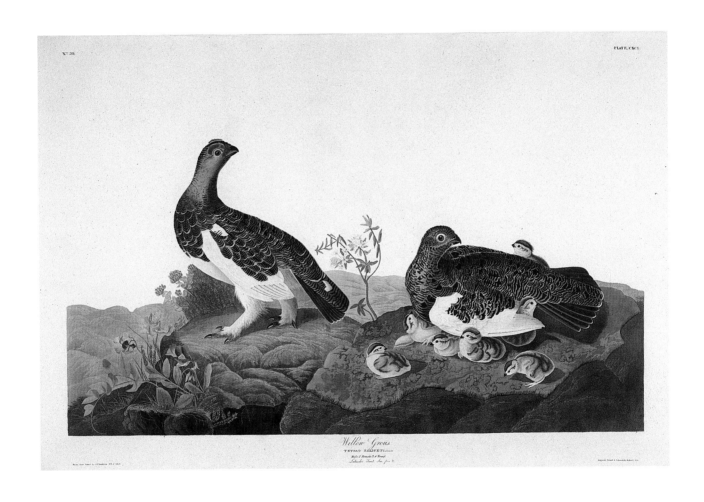

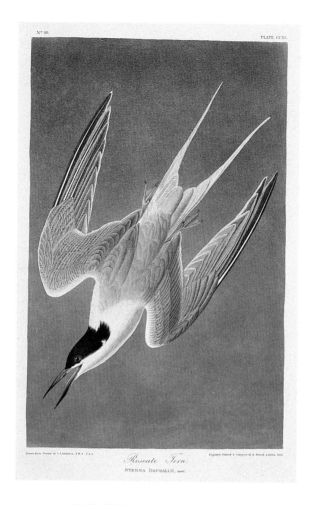

ROSEATE TERN
Sterna dougallii

On April 28, 1832, Audubon painted the roseate tern. He called them the "Hummingbirds of the Sea" and described how they plunged, their wings nearly closed, until they entered the water like a shot, in the steep dive portrayed so elegantly in this painting. The first specimen was shot and described only in 1812, in the Firth of Clyde by Dr. Patrick MacDougall, whose name minus the "Mac" is perpetuated in the Latin. The roseate was almost extirpated because of the perennial fad for feathers—indeed, entire birds' bodies—on women's hats. The Rev. William Morrell wrote a poem, "New England," after he had been sent to the Massachusetts Bay Colony in the 1620s, soon after the Pilgrims had landed at Plymouth Rock. Of the birds, he observed in un-Puritanical tones, "With these sweete dainties man is sweetly fed / With these rich feathers ladies plumed their head." By the late nineteenth century, undifferentiated terns were shot by the tens of thousands for the millinery trade. Vested interests defended the slaughter with arguments so ridiculous that it is hard to believe they were offered seriously. The newly formed Audubon Society in America, and the Royal Society for the Protection of Birds in England, led the conservation movement when the serious decline in bird populations at the hand of man could no longer be ignored. Laws were finally passed prohibiting the sale of feathers. In the octavo edition of the *Birds*, John Woodhouse Audubon added the lighthouse and the entrance of the harbour of Saint John, New Brunswick, in the background, an unusual step for a painting that had originally been made in Florida in 1832.

Havell No. CCXL

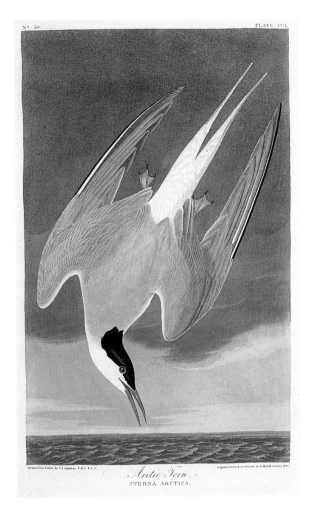

Arctic Tern.
STERNA ARCTICA.

ARCTIC TERN
Sterna paradisaea

"Light as a sylph, the Arctic Tern dances through the air above and around you."
That is how Audubon described the beautiful tern that he first encountered in
the Magdalene Islands. On June 25, 1833, he painted this portrait of the Arctic
tern diving on folded wings, a pose that he would use for the roseate tern and
others. They escaped extermination during the craze for feathers on women's hats
in the nineteenth century because from the 1860s on they were protected by var-
ious Sea Bird Acts in England. The reasons given were purely utilitarian (terns and
gulls helped fishermen find schools of fish, and helped mariners in distress find
safe harbours!), but the English statutes were essential for the protection of North
American birds because of their strange migration pattern. The birds are circum-
polar, and the routes are as complex as they are long. Terns from western North
America hug the Pacific coast all the way to Tierra del Fuego; the eastern birds,
however, fly across the Atlantic to the coasts of England and France to join their
cousins from Greenland and Scandinavia, and together they all head south along
the Atlantic coast of Africa to the Cape of Good Hope, and even Antarctica. Birds
that breed on Cape Cod, the southernmost nesting site, head north before cross-
ing over to Europe. The distances covered by some birds exceeds nine thousand
miles in each direction. The exercise must be good for them: Arctic terns live up
to twenty-seven years in the wild.

Havell No. CCL

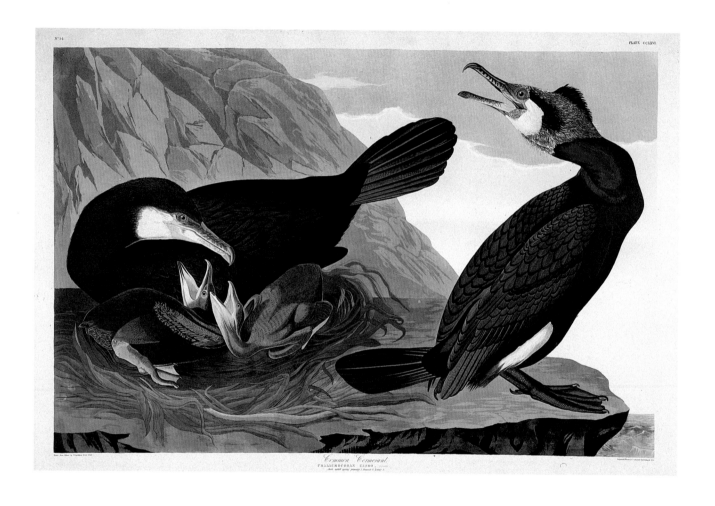

GREAT CORMORANT
Phalacrocorax carbo

Audubon opens his text, "Look at the birds before you, and mark the affectionate glance of the mother, as she stands beside her beloved younglings. I wish you could have witnessed the actions of such groups as I did while in Labrador. Methinks I still see the high rolling billows of the St. Lawrence breaking in foaming masses against the huge cliffs, on the shelves of which the Cormorant places its nest." It was on July 3, 1833, at 3:00 a.m. that Audubon witnessed the scene that he described and painted. He had seen cormorants at the entrance to the Bay of Fundy, where even today hundreds can be seen flying over the harbour of Saint John, New Brunswick, as evening falls. He encountered them along the Labrador coast and in Newfoundland. He commented on their flight, which he found "strong, swift and remarkably sustained," executed in long straight lines or at angles while skimming the surface. He was astonished at the speed with which they could swim, and wondered about their ability to float beneath the surface with just their necks extended. First-hand observation failed to explain why cormorants extend their wings after having been in the water. Audubon did not know that, lacking the oil glands that make most waterfowl's feathers waterproof, cormorants must dry their wings before re-entering or they would become waterlogged and lose much of their ability to sustain neutral buoyancy, manoeuvre under water and fly. So ingrained is the instinct to spread their wings that even the Galapagos cormorant, which has long since lost the power of flight, extends its vestigial wings to the equatorial sun. Audubon inaccurately assumed that the wing flapping was merely done for exercise. Audubon did know, accurately, that cormorant nests, "being covered with filth, were offensive to the eye, and still more to the nose."

Havell No. CCLXVI

IVORY GULL
Pagophila eburnia

Here we have yet another example of the inaccuracy of the claim that the plate was "Drawn from Nature by J. J. Audubon." Although he claimed to have seen a few from a distance in Labrador in 1833, Audubon knew nothing about this High Arctic species other than that it was reported to have been seen in Labrador and Newfoundland. Therefore, he "thought it probable that it occasionally extends its rambles as far as our eastern shores, and therefore [am] determined to include it in my Illustrations." The ivory gull is circumpolar, and was noted by virtually all the Arctic explorers of the eighteenth and nineteenth centuries. The two birds that he painted in 1835 were sent to him in London by Captain James Clarke Ross of the British navy, who had reported that nests in great numbers were found as far north as 70 degrees in the high, perforated cliffs on Cape Parry. In reality, this delicate, ghostly-white Arctic gull only occasionally comes south, limiting its movements to the leading edge of the pack ice off northern Labrador and Greenland, where it feeds on, among other delicacies, walrus and seal excrement. Such eating habits seem out of keeping for a bird with a dainty, almost tern-like flight. When their nesting grounds were invaded, however, the birds screamed and flew with such violence against the human intruders that there are reports of hats being knocked off and the sailors being forced to retreat. Several explorers described clouds of these pure white gulls in a feeding frenzy over the putrefying carcass of a whale; in their excess, the gulls plunged into the body and emerged totally smeared in blood. Eskimos were inordinately fond of the birds' flesh, and in former days would attract a fluttering horde of birds by pouring seal blood on the ice. In their eagerness to partake of the gory feast, ivory gulls were known to smash into the ice and die. In his plate, Audubon concentrated solely on the gentleness that their whiteness would imply. Given his occasional penchant for gothic drama, Audubon could have painted a far different scene had he known the other side of the ivory gull's Jekyll-and-Hyde nature.

Havell No. CCLXXXVII

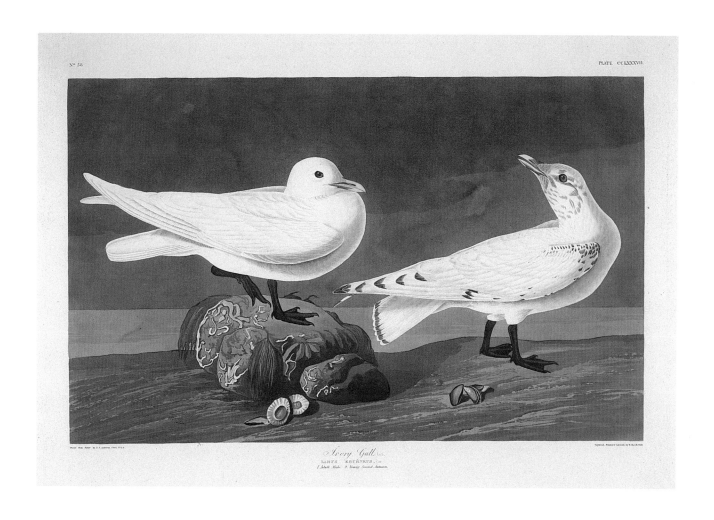

COMMON LOON
Gavia immer

Few birds are more closely associated with Canada's North than the loon. Indian myths of how the loon got its necklace form part of our common heritage. How appropriate, therefore, that this painting was actually done in Canada. While on his trip down the Lower St. Lawrence—which he called Labrador—Audubon reported that he spent all day painting the male loon, "a most difficult bird to imitate." The foul weather of July 9 and 10, 1833, the rain dripping off the rigging onto his paper, and the lack of light and ventilation in his cabin made it extremely difficult to work, let alone create art. It is easy to overlook the physical discomfort endured by Audubon when he painted. Yet he complained that he had completed *only* seventeen paintings in three weeks of gales, fog, rain and temperatures so low that he had to blow on his fingers to keep them supple. The female loon emerging from behind the rushes had been painted in Boston fourteen years earlier; as was often his practice, Audubon added her later to the final composition. In the mid-nineteenth century there was so much wildlife, so much wilderness compared to today, that neither Audubon nor anyone else would have considered the loon as symbolic of a vanishing frontier. It was a bird like many others, not good eating, but with an interesting life cycle: nesting on isolated freshwater lakes, and wintering in large rafts containing thousands of birds at sea just off the rocky coasts of the Maritimes and New England. Today, the "laughing" call of these great birds can banish all thoughts of encroaching civilization, even if just for a moment. Sigurd Olson, in his 1963 *Runes of the North*, was writing for today, not Audubon's time, when he said, "The loons were calling, I can hear them yet, echoes rolling back from the shores and from unknown lakes across ridges until the dusk seemed alive with their music. This untamed sound, the distances, the feeling of mystery and adventure filled me with joy and elation. Here to my young mind was the threshold of the wild." The original copper printing plate of the common loon is one of the seventy-eight or so that escaped a double catastrophe. Many plates were lost when the warehouse in which they were stored burned in the Great Fire of 1845 in New York; then, after trying unsuccessfully to interest museums and universities in buying the remaining coppers, Lucy Audubon was forced to sell them for scrap. The meltdown was already well advanced when the few remaining plates were saved. The copper for the common loon was one of them.

Havell No. CCVI

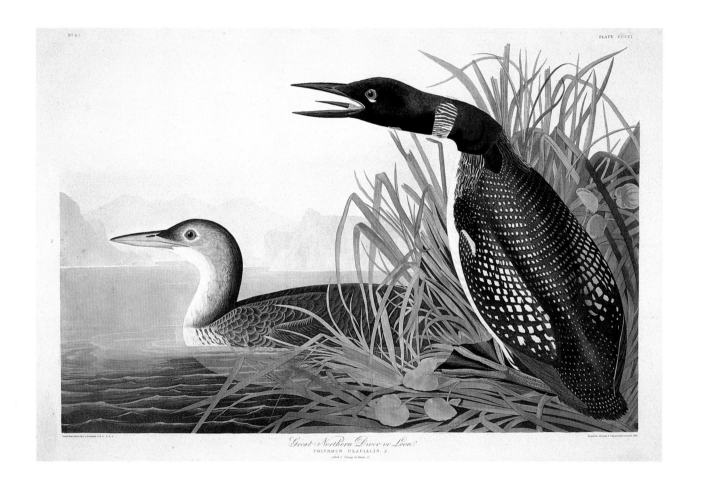

RED-THROATED LOON
Gavia stellata

On July 5, 1833, on the north shore of the Lower St. Lawrence, Audubon started this painting of what he called the red-throated diver, the name still used for the loon in Europe. (In France, *plongeur* is the direct translation of "diver"; in North America, the French word is *huard*.) Artistically, this plate is one of Audubon's masterpieces. The birds, facing outwards, expand the sense of space but remain linked by the curved blades of grasses in the background. In the highly detailed rendering of the botanical elements, even the pitcher plant "faces" outwards, and the reddish colour echoes the throat patch of the male in the centre of the group. The downy nestling is almost lost in—or protected by—the composition, its presence only obvious after the viewer's eye has been attracted to the feet of the left-hand bird. As this individual is in winter plumage, it can be assumed that Audubon added it to the composition at a later date. The legs of the land bird are placed very far back. Most Victorian museum taxidermists never saw their skins in the wild, and frequently mounted loons with legs that would have been appropriate for a perching bird. Audubon's first-hand field experience (plus the fact that he had once worked as a taxidermist) ensured that he would never faithfully copy every mistake of the bird stuffer, a lesson that many later artists never learned. Interestingly, Audubon himself collected the pitcher plant at Sandy Point, during his only stop in Newfoundland. By proclamation of Queen Victoria, the pitcher plant was named the official flower of Newfoundland in the 1880s. By proclamation of the provincial government, the last inhabitants of Sandy Point—by then an island—were relocated during the abandonment of the outports in the 1960s. The music and dancing of the ball given in honour of the naturalists on the *Ripley*, and described by Audubon, still reverberate throughout Sandy Point's crumbling houses.

Havell No. CCII

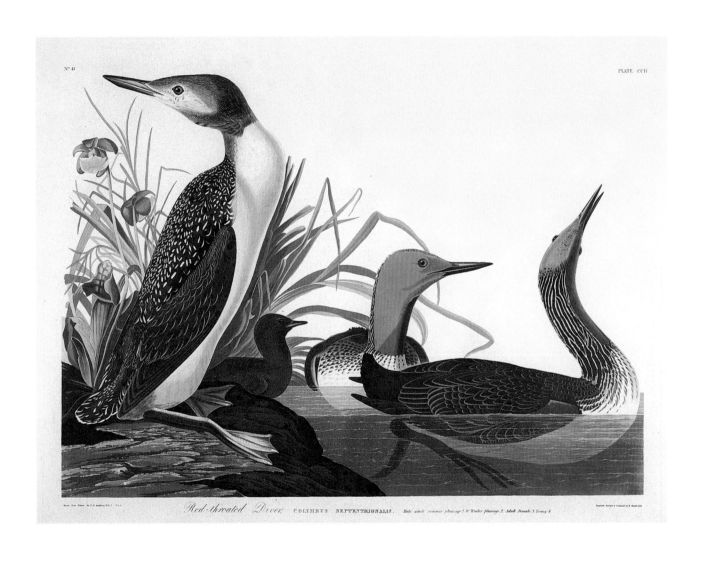

Red-throated Diver, COLYMBUS SEPTENTRIONALIS. *Male adult summer plumage 1. W. Winter plumage 2. Adult Female 3. Young 4.*

PLATE CCCLXIV.

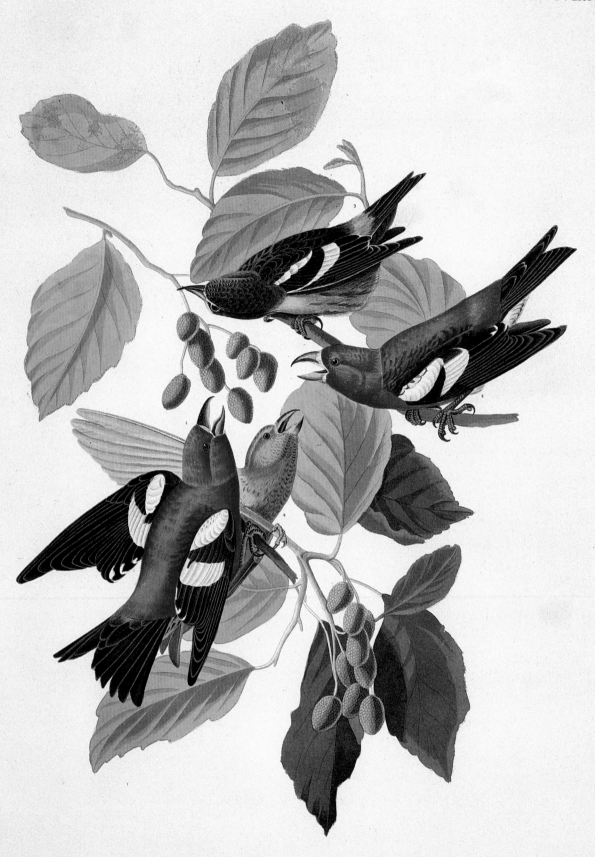

White-winged Crossbill.

LOXIA LEUCOPTERA Gm

Drawn from Nature by J.J.Audubon, F.R.S.·P.L.S.
Male adult. 1.2. Female adult. 3. Young.F. 4.
New Foundland alder.
Engraved, Printed, & Coloured, by R.Havell.1837.

WHITE-WINGED CROSSBILL
Loxia leucoptera

Audubon painted this northern species in Labrador over a six-week period in the summer of 1833. He reported that a small flock of a dozen birds landed in the top rigging of his schooner, the *Ripley*, and hitched a ride across the Gulf of St. Lawrence. The white-winged is so nearly related to the red crossbill that their life styles are virtually indistinguishable. Both species are found across the continent from ocean to ocean in the belt of northern coniferous forests, but one population somehow made it to the highlands of Hispaniola in the Caribbean. At the risk of a slight oversimplification, their respective ecological niches can be summed up by saying that the white-winged is a bird of the spruces, the red crossbill a bird of the pines. Both build nests that are so well insulated that the birds lay their eggs whenever the spirit moves, at any time between January and September. Consequently, with year-round nesting and an evergreen supply of food, the need for a traditional migration is limited, and southern appearances are as unpredictable as they are rare. It is somewhat surprising, therefore, that Audubon chose to place his birds in a mountain alder (*Alnus crispa*), even though the small cones are a source of food. In 1929, John Player & Sons issued a series of fifty cigarette cards on "Curious Beaks." Along with the boat-bill, the sickle-billed bird of paradise and the musk duck, they included a crossbill. Of the crossbill it said: "At first sight the beak of the Crossbill looks like a deformity, which might cause its owner to die of starvation." The bill tips are prolonged and cross each other when closed. Awkward as this might seem, the physics of the design make the bill eminently suited to prizing off the hard protective scales of cones, exposing the tender small seeds at their base. The males are a beautiful rose pink with white bars on their jet-black wings. The females are a deep yellow. Around lumber operations in New Brunswick the birds are so common that they are called "camp birds." Few sights are as delightful as a flock tumbling over itself through a forest, scissoring its way through a crop of cones. It is also fascinating to watch how effectively the birds can slice open galls on alder leaves, forcing the incubating pupae of gall wasps into the open only to be deftly snapped up by the bill. Perhaps because of the crossbill rather than in spite of it, both Liberia and St. Vincent chose this image for their commemorative Audubon stamps in 1985.

Havell No. CCCLXIV

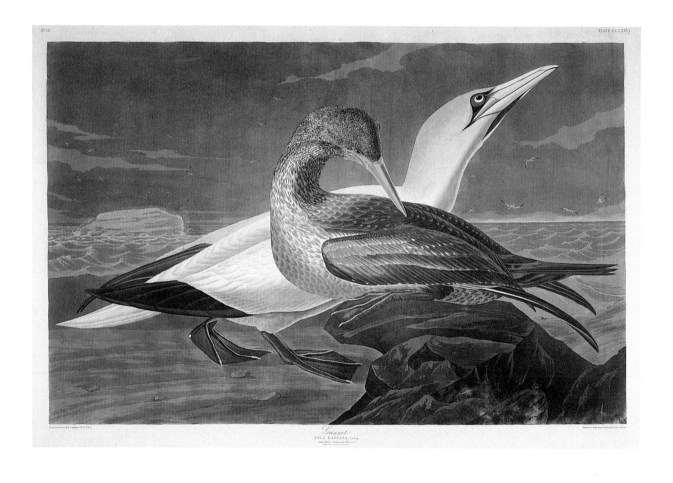

NORTHERN GANNET
Sula bassanus

By June 14, 1833, the schooner *Ripley*, out of Eastport, Maine, was approaching the Bird Rocks in the Gulf of St. Lawrence. Audubon and his companions had considered this one of the pilgrimage spots on their trip to Labrador. In the distance Audubon could see what he evocatively called a veil of gannets. A terrible gale blew up and the adventurers could not land. In fact, the small skiff carrying Audubon's son barely escaped capsizing. Audubon's disappointment was extreme. On June 22 he finished his painting of the birds, and on June 23 the background, including Great Gannet Rock, on which more than a hundred thousand gannets were nesting. His captain told of six men having clubbed 540 to death in an hour. Gleaming white, with black tips on their six-foot (1.8 m) wings and a beautiful yellow head, the birds thrilled Audubon. Most interesting is the detailed rendering of the beak, with its strange segments edged in black. No nostrils are visible. They are located *inside* the bill to prevent seawater from entering when the birds power-dive from as high as 140 feet (42 m) to capture small fish. Air sacs and a specially reinforced skull help absorb the impact. Incredibly, gannets have been taken in fishing nets from depths of fifteen to twenty fathoms (27.5 to 36 m). Inexplicably, Thomas Nuttall in his *Manual of Ornithology of the United States and Canada* (published in 1833, the year of Audubon's Labrador jaunt) stated categorically that gannets "seldom swim and never dive." *Sula* is Icelandic for a silly person. An earlier name, *Moros*, is Greek for foolish. Their clownish stare and their very awkward gait on land made both names appropriate, but it was their reluctance to defend themselves that proved their undoing. *Bassanus* is a coined word meaning "from Bass Rock" in the Firth of Forth in Scotland. Thousands of young and eggs were taken annually from Bass Rock for the market in Edinburgh. Adult birds taste fishy, and Audubon derided some Italians who subsisted on gannet flesh. On May 21, 1534, Jacques Cartier landed on Funk Island, one of the last nesting sites of the great auk, and collected gannets for food. Another island off Newfoundland, Baccalieu, is still a major nesting site. Ironically, this name is derived from the Portuguese word for cod, *bacalhau*. Since long before Columbus, Portuguese, Basque and English fished the Grand Banks for cod. The hooks of their longlines were baited with strips of gannet flesh—still a common practice when Audubon wrote his text.

Havell No. CCCXXVI

ACKNOWLEDGMENTS

Audubon's life and art have been the subject of a remarkable number of books, from reprints of his various *Journals* to compilations of his correspondence, detailed analyses of his art and science, and biographies that have been factual or vacuous. There has been a plethora of biographies of his wife, his assistants and his collaboators; and there have been detailed histories of the double elephant folio and octavo editions of *The Birds of America*, the engravers, the paper, the colourists, the printing techniques and even the subscribers. Along with dozens of reprints of the original watercolours and plates—ranging from museum-quality facsimiles to desecrations—there have been excellent catalogues produced for the many Audubon exhibitions that have taken place over the years. Special auction catalogues have been produced for the infrequent sales of individual plates. Books dealing with the history of art, especially animal or bird art, invariably contain references to Audubon. Modern travellers have retraced his steps and have documented their travels. Books have even been written on Audubon's painting of insects. Each book added insights and perspectives. It can be said that no American artist has generated the interest or the controversy that surrounds Audubon. This holds true more than a century after his death.

For this book I have drawn on more than a hundred sources, and if space constraints had not added a note of realism, there could have been as many more again. To acknowledge them all individually either in a bibliography or with footnotes would have changed the nature of the book; the layman would have been disadvantaged in favour of the academic purist. I trust that all the sources, living and dead, will accept my blanket expression of gratitude.

Some specific acknowledgments, however, are in order. David Silcox reviewed the extended captions and added extremely important suggestions. Mark Peck of the Royal Ontario Museum reviewed the text for scientific accuracy, but if any inaccuracies have escaped his eye, I accept full responsibility. My assistant, Meg Jubien, cheerfully undertook the thankless task of reviewing the various drafts.

The complete Audubon project would not have been possible without the financial support and collective vision of Canada Trust. The plates that appear in the book and in the exhibition Audubon's Wilderness Palette: The Birds of Canada are drawn from the collection of the Toronto Reference Library. My grateful thanks to the Metropolitan Toronto Library Board and their staff, in particular Frances Schwenger (C.E.O.), David Kotin and Anne Sutherland (Special Collections), Joanna Wellheiser, Ann Douglas and Karen Lenk (Preservation Services) and Donna Acheson (Photographer). Through the participation of the leading museums and art galleries, the exhibition will be viewed across Canada.

I would like to personally acknowledge Nina Wright, Janet Conover, Anne Mitchell and Michael Steinberg of Arts & Communications for their unrelenting efforts to bring to reality the many complex aspects of this project.

Michael Mouland at Key Porter Books kept essential lines of communication open between all those involved with the book. Scott Richardson embraced the project, and translated his enthusiasm into the outstanding design of the book. A special word of thanks to Doris Cowan, whose copy editing was thorough and outstanding.

THE PLATES

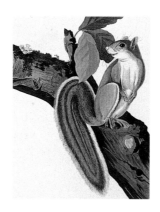

A NOTE ON THE TYPE

The principal text for this book is set in a digitized form of Bembo, a typeface originally cut by Francisco Griffo in the early sixteenth century and based on an old-style Roman face that was used for Cardinal Bembo's tract *De Aetna* in 1495. The Lanston Monotype Machine Company brought the balanced and proportioned letter forms of Bembo to North America in the 1930s.

The chapter epigraphs are set in Sackers Italian Script, the main heads in Sackers Light Roman. Both faces represent modern equivalents of the classic display fonts used by engravers and printers during Audubon's lifetime.

AUDUBON'S WILDERNESS PALETTE

Project Editor: Michael Mouland
Creative Director: CS Richardson
Electronic Formatting and Assembly: Jean Lightfoot Peters
Copy Editing and Proofreading: Doris Cowan, John Sweet
Colour Separations and Film Work: Quadratone Graphics Ltd.
Printed and Bound in Canada by Friesens